'A FOUL AND PESTILENT CONGREGATION'
IMAGES OF 'FREAKS' IN BAROQUE ART

'A Foul and Pestilent Congregation'
Images of 'Freaks' in Baroque Art

Barry Wind

ASHGATE

Published by
Ashgate Publishing Limited Ashgate Publishing Company
Gower House Old Post Road
Croft Road Brookfield
Aldershot Vermont 05036–9704
Hants GU11 3HR USA
England

British Library Cataloguing-in-Publication data

Wind, Barry
 'A foul and pestilent congregation': Images of
 'freaks' in Baroque art
 1. Abnormalities, Human, in art 2. Art, Baroque
 I. Title
 709'. 032

Library of Congress Cataloging-in-Publication data

Wind, Barry
 'A foul and pestilent congregation': Images of 'freaks'
 in Baroque art / Barry Wind.
 Includes bibliographical references and index.
 ISBN 1-85928-426-4 (hc)
 1. Art, Baroque–Themes, motives. 2. Abnormalities, Human in
 art. I. Title.
 N6415.B3W56 1997
 704.9'49616043—dc21 97-12026
 CIP

ISBN 1 85928 426 4

Printed on acid-free paper

Typeset in Palatino by Raven Typesetters, Chester
and printed in Great Britain at the University Press, Cambridge

Contents

List of figures		vii
Acknowledgements and photographic credits		xi
Introduction		1
1	'Unlike Form Oft Blended Be Into One Hideous Deformity'	5
2	The Court and its cruel pleasures: 'freaks' in Italy	19
3	'Great wonders of nature': Ribera and deformity	49
4	Spain and the 'hombre de placer'	67
5	Courtiers and Burghers: the depiction of 'freaks' north of the Alps	99
6	Enlightened attitudes: the eighteenth century and beyond	123
	Excursus: two clowns at the Spanish Court	131
	Bibliography	137
	Index of names	145
	Subject index	149

Figures

1 'Unlike Form Oft Blended Be / Into One Hideous Deformity'

1.1 The armless Thomas Schweiker: illustration from Schenk's *Monstrorum Historia*

2 The Court and its cruel pleasures: 'freaks' in Italy

2.1 Agostino Carracci: Portraits of Amon, Pietro Matto and Arrigo Peloso, c. 1598

2.2 Domenichino: *Apollo killing two Cyclopes*, c. 1616

2.3 Domenichino: *Meeting of St Nilus and Otto III*, c. 1608

2.4 Francisco Duquesnoy: *Portrait bust of Nano de Créqui*, c. 1630

2.5 Jacques Callot: *Frontispiece to series of comic 'gobbi'*, c. 1622

2.6 Jacques Callot: *The guitar player*, c. 1622

2.7 Jacques Callot: *Masked figure with twisted legs*, c. 1622

2.8 Jacques Callot: *Masked comedian playing a guitar*, c. 1622

2.9 Jacques Callot: *Duelling 'gobbi'*, c. 1622

2.10 Jacques Callot: *Duelling 'gobbi'*, c. 1622

2.11 Jacques Callot: *'Gobbo' playing a grill*, c. 1622

2.12 Jacques Callot: *'Gobbo' with suit buttoning at the back*, c. 1622

2.13 Johann Liss: *Fighting 'gobbi'*, c. 1623

2.14 Antonio Luccini: *Frontispiece to 'Compendio de Armi de Caramoggi'*, 1627

2.15 Jacques Callot: *Francatrippa*, c. 1622

2.16 Jacques Callot: *'Gobbo'* c. 1622

2.17 Baccio del Bianco: *Frontispiece: dwarfs surrounding a cartouche*, n. d.

2.18 Baccio del Bianco: *Drawing of dwarf physicians*, n. d.

2.19 Stefano della Bella: *Parade of soldiers*, 1650s

2.20 Stefano della Bella: *The Ball Game*, 1650s

2.21 After Stefano della Bella: *'Exhausted hearts'*; etching by Agostino Mitelli, 1684

2.22 After Stefano della Bella: *Military dwarfs*; etching by Agostino Mitelli, 1684

2.23 Faustino Bocchi: *Bathing dwarfs*, n. d.

3 'Great wonders of nature': Ribera and deformity

3.1 Jusepe de Ribera: *The small grotesque head*, 1622

3.2 Jusepe de Ribera: *Large grotesque head*, c. 1622

3.3 Jusepe de Ribera: *Magdalena Ventura*, 1631

3.4 Sebastián Covarrubias: *Bearded woman, from the Emblemas Morales*, 1610

3.5 Jusepe de Ribera: *Clubfooted boy*, 1643

3.6 Jacques Callot: *Captain of the rogues*, 1622–3

3.7 Jusepe de Ribera: *Dwarf and a dog*, 1643

4 Spain and the 'hombre de placer'

4.1 Velázquez: *Portrait of Calabazas*, c. 1638

4.2 Velázquez: *Portrait of Sebastián de Morra*, c. 1645

4.3 Velázquez: *Portrait of Don Diego de Acedo*, c. 1636–8

4.4 Velázquez: *Portrait of Baltasar Carlos with dwarf*, 1631

4.5 Sánchez Coello: *Portrait of Infanta Isabel Clara Eugenia*, c. 1585–90

4.6 Roderigo Villandrando: *Portrait of Philip IV*, c. 1621

4.7 Velázquez: *Baltasar Carlos in the Riding School*, c. 1635

4.8 Velázquez (attrib): *Portrait of Calabazas*, n. d.

4.9 Velázquez: *Francisco Lezcano*, c. 1636–8

4.10 Moro: *Portrait of Pejerón*, n. d.

4.11 Sebastián Covarrubias: '*Abeunt in Nubila Montes, from the Emblemas Morales*', 1610

4.12 Hopfer: *Kunz von der Rosen*, c. 1515

4.13 Juan Van der Hamen: *Portrait of a dwarf*, c. 1625

4.14 Velázquez: *Las Meninas*, 1656

4.15 Jan Molenaer: *Artist's studio*, 1631

4.16 Juan Carreño: *Portrait of the dwarf Michol*, c. 1680

4.17 Juan Carreño: *Portrait of La Monstrua as Bacchus*, 1680

4.18 Juan Carreño: *Portrait of La Monstrua*, 1680

5 Courtiers and Burghers: the depiction of 'freaks' north of the Alps

5.1 Rubens: *Portrait of Caterina Grimaldi*, 1606

5.2 Rubens: *Aletheia Talbot and her retinue*, 1620

5.3 Van Dyck: *Queen Henrietta with Jeffrey Hudson*, 1633

5.4 Adriaen Van de Venne: *The fishing for souls*, 1614

5.5 Adriaen Van de Venne: *Allegory of the twelve years' truce*, 1616

5.6 Adriaen Van de Venne: *Dancing dwarf*, 1626

5.7 Adriaen Van de Venne: '*Cripple will always lead the dance*'; illustration for Jacob Cats' *Spiegel van den Ouden ende Nieuwen Tijdt*, 1632

5.8 Adriaen Van de Venne: *Two hunchbacks*; illustration for Jacob Cats' *Spiegel van den Ouden ende Nieuwen Tijdt*, 1632

5.9 Frans Hals: *Militia Company of St George*, 1627

5.10 Jan Molenaer: *Stone-throwing dwarf*, 1646

5.11 Jan Steen: *Portrait-cum-allegory*, 1660

5.12 Jan Steen: *The Egg Dance*, n. d.

5.13 Jacques Callot: *'Gobbo' with a violin*, c. 1622

5.14 Jan Steen: *Wedding feast*, 1667

5.15 Pieter van Laer: *Tavern scene (drawing)*, n. d.

5.16 Pieter van Laer: *Interior of a tavern*, n. d.

5.17 Pieter van Laer: *Self-portrait as a conjurer*, n. d.

5.18 Pieter van Laer: *Self portrait*, n. d.

5.19 Pieter van Laer: *Self portrait (profile view)*, n. d.

6 Enlightened attitudes: the eighteenth century and beyond

6.1 Faustino Bocchi: *Dwarf in a trap*, n. d.

6.2 Faustino Bocchi: *Battle with the heron*, n. d.

Excursus: two clowns at the Spanish court

1 Velázquez: *Portrait of Don Juan*, c. 1632

2 Velázquez: *Portrait of Barbarroja*, c. 1632

3 Martinelli: *Rhetorical compositions of Don Harlequin*, 1601

Acknowledgements

This study was aided in a number of ways. I am grateful to the Department of Art History, University of Wisconsin-Milwaukee for providing funding for travel to distant libraries and for the purchase of photographs. A summer grant from the National Endowment of the Humanities to study at Brown University provided me with time and access to excellent research facilities.

I am indebted to Rolf Bagemihl, Craig Felton and David Levine for their help in securing photographs, and I am pleased to thank the various institutions and private collections for their co-operation. Special thanks are due to Ellen Keeling and the editorial staff at Ashgate for the conscientious editing of the text.

Above all, I am indebted to my wife, Geraldine. She has continually supported my work, and her critical reading of the text and her numerous suggestions were invaluable. It is with great pleasure that I dedicate this book to her.

BW

Photographic credits

The author and publisher wish to thank the following for permission to publish:

1.1, 3.4, 4.11: British Library

2.2: National Gallery, London

2.3, 2.4, 5.19: GFN, Rome

2.6, 7, 8, 9, 10, 11, 12, 15, 3.1, 3.2, 5.6, 5.13: © The British Museum

2.5, 3.6, 5.3: National Gallery of Art, Washington

2.13: Hamburger Kunsthalle, photo Elke Walford

2.14 a. b: Bibliothèque Nationale, Paris

2.17, 2.18: Gabinetto Fotografico, Uffizi

2.19: Ashmolean Museum, Oxford

2.20, 5.12, 5.14: Victoria and Albert Museum

3.3: Institut Amatller D'Art Hispanic

3.5, 5.5: Réunion des Musées Nationaux

4.1, 4.2, 4.3, 4.5, 4.6, 4.9, 4.13, 4.14, 4.17, 4.18, 1, 2, 3: Museo del Prado

4.4: Henry Little Pierce Fund, courtesy Museum of Fine Arts Boston

4.7: By kind permission of His Grace The Duke of Westminster OBE, TD, DL

4.8: © The Cleveland Museum of Art, 1997, Leonard C. Hanna Jr. Fund, 1965.15

4.10: Museo del Prado

4.15: Staatliche Museum zu Berlin, Preußicher Kulterbesitz

4.16: Meadows Foundation Funds, Meadows Museum, Southern Methodist University, Dallas, Texas

5.1: Courtauld Institute of Art, Kingston Lacy, The Bankes Collection (The National Trust)

5.2: Munich, Alte Pinakothek

5.4: Rijksmuseum, Stichting, Amsterdam

5.7, 5.8: New York Public Library

5.9: Frans Hals Museum, Haarlem

5.10: Van Abbe Museum, Eindhoven

5.11: Mauritshaus, The Hague

5.15: Kupferstich Kabinett, Staatliches Museum zu Berlin, Preußicher Kulterbesitz

5.16: Munich Staatsgemälde Sammlungen

6.1: Museo Civici, Padua

6.2: Jandi Sapi Editoriale, Milan

Introduction

In the long poem devoted to the proper principles of art, *De Arte Graphica*, published in 1668, Charles Alphonse Du Fresnoy clearly stated the Baroque concern for ideal beauty.

> Tis painting's first chief business to explore
> What lovelier forms in Nature's boundless store[1]

But if the splendid century eulogized lofty aims, if ornate palaces and great minds glittered, there was also a squalid seaminess that was readily apparent. Streets ran with a feculent gruel, and physicians believed that excrement was salubrious.[2] There was also a taste for *terata*, the term for the malformed and the deviant. Physically and mentally blemished humanity – the dwarf, the hunchback, the clubfoot, and the imbecile – were depicted with some regularity by some of the greatest artists of the period, including Velázquez, Rubens, Van Dyck and Ribera. A number of themes emerge in these depictions. On the one hand, human oddity was viewed with taxonomic interest, a delight in the unusual and the deliciously hideous. The collection of odd humans was thus consonant with the collection of other exotica – curious shells or strange animals. But unlike the 'pet rock', *terata* were subject to cruel derision and were often portrayed in portraits as imperfect foils to the fashionable courtiers who sought aggrandizement through juxtaposition. And since they deviated so vividly from nature, *terata* were frequently seen as vivid embodiments of a favourite theme of the period, 'the world turned upside down'. In this synthesis of repulsion and fascination, mockery and dread, the portrayal of these 'others' reveals a dark underside of Baroque culture that has never been thoroughly investigated or understood.

There has yet to be a comprehensive account of these images. The slim volume, *Les Difformes et les Malades dans L'Art* (1889) by Jean Charcot and Paul Richer, is both cursory and obviously out of date. Similarly, Erica Tietze-

Conrat's *Dwarfs and Jesters in Art* (1957) is a broad-sweeping survey which only briefly touches on the seventeenth century. More recently, the exhibition held at the Prado, *Monstruos, Enanos, y Bufones en la Corte de los Austrias* (1986), considers the dwarf and other examples of aberrant nature in seventeenth-century Spanish painting. But this catalogue, containing a brief introductory essay, is also generalized in nature. And the specialized studies on individual Baroque masters either pay little attention to these images or view the depiction of *terata* with an empathy tinged by twentieth-century rather than seventeenth-century conceits.

To place these images within a proper context, I have now gathered material from diverse sources – medical treatises, literary texts, popular ballads, and court documents. In Chapter 1 I discuss the *topoi* for the mentally and physically infirm established in antiquity and codified through the Middle Ages and the Renaissance. The delight in anomalies recorded by Aristotle (*Problemata*), Pliny (*Natural History*, VII), and Longinus (*On the Sublime*) is juxtaposed with the derisive attitudes noted by such authors as Cicero (*De Oratore*) and Juvenal (*Satires*). Negative attitudes towards the deformed are elaborated in the Middle Ages. A case in point is another *Summa Theologica*, written at the beginning of the thirteenth century and attributed to Alexander of Hales. Here we are told that deformity was the consequence of sin. This view is held even by the scientific community. The treatise by the late sixteenth-century physician Ambrose Paré *On Monsters and Marvels* of 1573 allied dwarfs, hunchbacks, and cripples with 'signs of some forthcoming misfortune'. And these examples of odium can easily be multiplied. A plethora of seventeenth-century treatises – Aldrovandi's *Monstrorum Historia* (1642) and Juan Nieremberger's *Curiosa y Oculta Filosofía* (1643) are but two – reveal attitudes of derision and revulsion.

Subsequent chapters deal with the representation of *terata* in Italy, Spain and Northern Europe. Chapter 2 treats depictions of hunchbacks, dwarfs and other physical anomalies by Agostino Carracci, Domenichino, Duquesnoy, Callot, Della Bella, Antonio Luccini and Baccio del Bianco. These artists, reflecting ideas linked to the Roman and Florentine court, produced portraits and suites of comic dwarfs, and intruded *terata* upon mythological or historical narrative. Domenichino, for instance, intentionally mocks a dwarf kept at the Aldobrandini court, presenting him in chains before a scene of cyclopes. The seventeenth-century biographer Passeri specifically calls attention to the derisive nature of this portrayal. And the amusement is underscored by Domenichino's contrast of the traditionally gigantic cyclopes – here depicted as diminutive – with the enlarged image of the dwarf. Here the world has been turned upside down, a common motif found in pictorial, literary and emblematic imagery dealing with *terata*. In addition to incorporating new material on the popular *commedia dell'arte* to explicate Callot's depictions of

hunch-backed dwarfs, this section also analyses the images of the other artists in relationship to literary texts, carnival songs and art-theoretical thought.

Chapter 3 considers the variety of Ribera's images of *terata*, ranging from etchings of grotesque heads to paintings of a clubfoot, a dwarf and the bearded Magdalena Ventura. This chapter presents hitherto unnoticed analogues between Ribera's imagery and medical treatises, as well as relationships to the *commedia dell'arte* and the emblematic tradition. The portrait of Magdalena Ventura, for example, a trenchant reminder of 'the world turned upside down', is linked to Sebastián Covarrubias' *Emblemas Morales* (1610).

Chapter 4, focusing on Velázquez, also includes new work on other Spanish painters, Van der Hamen and Carreño, who portrayed dwarfs and freaks. The traditionally sympathetic readings of these images of court performers is belied by literary and documentary evidence that viewed these 'hombres de placer' (men of pleasure) as 'knaves', 'fools' and 'little worms' who would be made intoxicated to ensure their ability to amuse the court. Velázquez's use of visual puns and various emblematic references underscores the mocking aspects in many of his pictures of these court entertainers. Even in the magisterial *Las Meninas*, Velázquez consciously contrasts the firm – the infanta and her retinue – and the infirm, the dwarf attendants.

Chapter 5 treats the representation of *terata* in seventeenth-century Northern European art. The traditional courtly portraits by Rubens and Van Dyck, mockingly contrasting the upright aristocrat and the misshapen dwarf, are considered, as well as the humorous narratives with dwarf performers painted by Jan Steen, and the emblematic use of hunchbacks, cripples and dwarfs presented in the moralizing depictions of Van de Venne and Molenaer. The amusing and sometimes poignant self-images of the hunchbacked painter Pieter van Laer are also treated. A concluding chapter considers the shift in presentation of *terata* in the eighteenth century that was engendered by the Enlightenment. Not only is there a marked decline in the numbers of *terata* kept at court, but a more sympathetic and gently humorous image of the dwarf is presented. Additionally, a treatise such as William Hay's *Deformity, An Essay* (1754) replaces the derisive and negative attitudes traditionally held with poignant requests for understanding. Correspondingly, images by Faustino Bocchi, an early eighteenth-century Lombard painter influenced by English art and a specialist in the painting of dwarfs, become more compassionate. An excursus deals with two portraits of clowns by Velázquez, Don Juan and Barbarroja, which were hung in the so-called room of the jesters at the royal palace. These figures are not *terata per se*. They do, however, belong to the ambience inhabited by *terata*, and reflect the mocking and parodic elements that are their lot.

The title of this book comes from *Hamlet* Act II, ii. The melancholy prince

decries the nature of perfection and sees around him a 'foul and pestilent congregation'. The imperfect specimens of humanity that we see depicted in these pages are vivid reminders of a perceived noxious assembly that was an inherent part of seventeenth-century culture.

Notes

1. C.A. Du Fresnoy, *De Arte Graphica (The Art of Poetry)*, W. Mason trans., York, 1783, 5. For an illuminating discussion of the idealizing nature of art criticism in the period see E. Panofsky, *Idea, a concept in art theory*, J.S. Peake trans., Columbia, South Carolina, 1968.

2. On the belief in the health-inducing aspects of excrement see H. Kamen, *Spain in the Later Seventeenth Century*, London and New York, 1980, 167.

'Unlike Form Oft Blended Be / Into One Hideous Deformity'

In his turbulent play of monarchical treachery, *Richard III*, Shakespeare presents a paradigm of the early modern view of deformity. In Act I, scene i, the misshapen Richard triumphantly proclaims his evil as a consequence of his disfigurement.

> But I, that am not shaped for sportive tricks
> Nor made to court the amorous looking glass . . .
> I, that am curtailed of this fair proportion,
> Cheated of feature by dissembling nature,
> Deformed, unfinished, sent before my time
> Into this breathing world, scarce half made up,
> And that so lamely and unfashionable
> That dogs bark at me as I halt by them – . . .
> Have no delight to pass away the time,
> Unless to spy my shadow in the sun
> And descant on mine own deformity
> And therefore . . .
> I am determined to prove a villain . . .

Richard's loathsome 'persona' provokes revulsion. Lady Anne, in Act I, scene ii, compares him to 'adders, spiders, toads' and decries this 'lump of foul deformity'. But Shakespeare reveals many other aspects of Richard, ranging from sinister fascination with his strangeness to a perception of Richard as a jocular court fool. At 'two hours old,' we are told in Act II, iv, Richard could gnaw a crust, thus demonstrating an astonishing deviation from the norm.[1] In playful bantering with the young Duke of York, (Act III, i), Richard is likened to a clown who bears an ape on his shoulder. Additionally, he is capable of reversing the normative order of things, turning the world upside down through words and actions. He suggests in Act I, scene iv that he is a saint, but he reveals himself as a devil. He viciously twists words, compromising their meaning.

> Thus like the formal vice Iniquity
> I moralize two meanings in one word (III, i)

And in Act I, scene iii he gleefully disguises his misshapen body with the product of 'some score or two of tailors'.

Shakespeare's vision of deformity, ranging from taxonomic curiosity and evil omen to derision and revulsion, is conditioned by a set of received views stemming from antiquity and the Middle Ages. But it is not only Shakespeare who reveals these attitudes. Indeed, it is an attitude with wide cultural resonance in the early modern period, informing not only literary texts, popular ballads and medical treatises, but also seventeenth-century depictions of the deformed, mentally infirm and physically bizarre. In the following survey we will trace the foundation and embellishment of these conceits to see how these *topoi* are established and codified.

In the *Generation of Animals* and the *Problemata*, Aristotle, in his characteristically thorough way, discussed the problem of '*terata*', the Greek term for the deviant and the malformed. Aberrant births resulting in freakish deformities were merely the result of the confusion of semen or an arbitrary deviation from Nature.[2] These anomalies could be celebrated and sought after. In a long encomium to human diversity in Book VII of the *Natural History*, Pliny stated: 'the power and majesty of the nature of the universe at every turn lacks credence if one's mind embraces parts of it only, and not the whole'.[3] In the next chapter he discussed the panoply of diversity, ranging from androgynes to umbrella-footed tribesmen, from bearded women to dwarfs.[4]

The desire for the unusual in the ancient world resulted in the avid collection of human oddities. As Horace noted: 'the abnormal and unusual capture and transfix the eyes'.[5] The emperor Domitian attended public entertainment accompanied by a boy clad in flaming scarlet, whose head was abnormally small.[6] And among the oddities favoured by the Romans were dwarfs. Julia, the granddaughter of Augustus, kept as 'a pet' the dwarf Canopas.[7] Tiberius had a pet dwarf who accompanied his buffoons at the dinner table.[8] Longinus recorded that dwarfs were deliberately kept in cages to stunt their growth further, and thus satisfy the great interest in distortion.[9] In his *Controversiae*, Seneca elaborated on the practice of using the deliberately deformed to satisfy the appetite for oddities. Children were intentionally maimed: 'Finding a different savagery for each, this bone breaker cuts off the arms of one, slices the sinews of another: one he twists, another he castrates.'[10] Idiocy was also cultivated. A pithy epigram by Martial underscores the fascination with the non-normative and the keen disappointment when intelligence instead of cretenism was discovered. 'He has been described as an idiot. I bought him for twenty thousand sesterces. Give me back my money Gargialianus: he has his wits.'[11]

The entertainment potential of human oddity, in fact, was a commonplace in antiquity. Hermaphrodites were used as 'entertainments', and Pompey the Great devoted theatrical decorations to various human oddities.[12] The clown-ish, humpbacked Maccus was pressed into service as a character on the Roman stage.[13] In the *Carousal* Lucian gave a piquant description of 'a tough little dwarf' who served as a comic performer.

The host ordered the clown to come in and say something funny in order to make his guests still merrier. In came an ugly fellow with his head shaven except for a few hairs that stood straight on his crown. First he danced doubling himself up and twisting himself about to cut a more ridiculous figure.[14]

And Tacitus recorded how the deformed Vatinius, 'among the foulest prodi-gies of that court', not only entertained Nero with his scurrilous wit, but also was the target of mockery.[15] Accordingly, like many of the misshapen pets at court, Vatinius embodied both subservience and familiarity.

The interest in the unusual aroused sentiments which went beyond diver-sion or taxonomic curiosity. Plutarch moralized against

a sort of people at Rome who, being unaffected with anything that is beautiful and pretty either in the works of art or nature, despise the most curious pieces in painting or sculpture and the fairest boys and girls that are exposed for sale, as not worth their money: therefore they much frequent the monster-market, looking after people of distorted limbs and preternatural shapes, of three eyes and pointed heads

> Where kinds of unlike form oft blended be
> Into one hideous deformity.

All of which are sights so loathsome, that they themselves would abhor them were they compelled often to behold them.[16]

With the interest in uglification also came derision. Plautus acutely remarked: 'No one is curious who is not malevolent.'[17] Indeed, a number of Roman writers suggested that deformity provoked laughter. In his analysis of the risible, Cicero claimed that 'loud laughter' is 'levelled against ugliness or some physical defect', thus allowing for cruel humour at the expense of the deformity of others.[18] Juvenal mockingly recorded the derisive sobriquet of the giant Atlas for a dwarf or the burlesque nickname of Europa, the fair beloved of Jupiter, for a deformed woman.[19] Statius described a knot of battling dwarfs in mock-heroic combat which provoked the laughter of 'Mars and bloodstained Valour'.[20] And Seneca discussed the grim intentional dis-figurement of a child in terms of the potential to excite laughter. 'In yet another, he stunts the shoulder blades, beating them into an ugly hump, look-ing for a laugh for his intentional cruelty.'[21]

This sinister side of the fascination with deformity is echoed in another response to *terata* in antiquity. Often they were associated with malevolent omens and strange portents. Pliny, for example, linked the event of the

Marsian war to a monstrous birth.[22] Despite his daughter Julia's proclivities, Augustus, according to Suetonius, despised dwarfs and other malformed creatures. 'But dwarfs and such as were in any way deformed, he held in abhorrence as *lusus naturae* (nature's abortions), and of evil omen.'[23] If Augustus believed that the misshapen were augurs of the malign, others found that they offered a fetishistic protection. The plethora of small bronzes of hunchbacks, dwarfs, and cripples in Graeco-Roman art suggests an apotropaic quality. Their very deformity served as a charm against the evil eye.[24] But the ominous associations of deformity with malignity are poignantly exemplified by Livy who recorded how such children were put to death because they were manifestations of a breakdown in the cosmic order.[25] Accordingly, Roman law declared: 'A father shall immediately put to death a son recently born, who is a monster, or has a form different from that of the human race.'[26] The singular aberrance of form of these *terata* excluded them from human status.

St Augustine's *City of God*, written at the beginning of the fifth century, provides a transition between the pagan world to which Augustine was heir and the Christian attitude towards *terata* that he advanced. Like Pliny, Augustine saw *terata* as a manifestation of variety, acknowledging that deviations from the norm occurred in humanity.[27] But these deviations were reflections of God's will and delight in variety. 'For God, the creator of all, knows where and when each thing ought to be, or to have been created, because He sees the similarities and diversities which can contribute to the beauty of the whole'.[28] Here Augustine echoes Isaiah's assertion (45:18) that God made nothing in vain. On the other hand, Augustine's God could not have been especially pleased with deformity. At the time of the Resurrection, physical blemishes would be eliminated among the elect.[29] Indeed, physical anomalies must have been abhorrent to Augustine as well as to God. 'For all bodily beauty consists in the proportion of the parts ... where there is no proportion the eye is offended, either because there is something awanting, or too small, or too large.' Accordingly, the saved would be images of God's perfection.

Shall He not be able to remove and abolish all the deformities of the human body, whether common ones or rare and monstrous, which though in keeping with this miserable life, are yet not to be thought of in connection with the future blessedness; and shall He not be able so to remove them that, while the natural but unseemly blemishes are put to an end, the natural substance shall suffer no diminution? ... And thus there shall be no deformity resulting from want of proportion in that state in which all that is wrong is corrected, and all that is defective supplied from resources the creator wots of, and all that is excessive removed from destroying the integrity of the substance.[30]

Augustine recognized, as well, that deformity produced reactions that ranged from revulsion to mockery. In his discussion of the Resurrection, he con-

demned unbelievers who 'with horror and derision cite monstrous births'.[31] Yet another church father, St John Chrysostom, in his commentary on Timothy, castigated the impious courtiers who kept 'buffoons and dwarfs, and make these errors of nature serve for their pleasure'.[32]

But if unbelievers responded with dread and ridicule, true believers were also fascinated and entertained by *terata*. In the *Otia Imperiale* by Gervaise of Tilbury, compiled for Otto IV between 1209 and 1218, the Holy Roman Emperor was treated to the marvels of the world, including an elaborate account of monsters and aberrations which was designed to 'keep a drowsy emperor awake'.[33]

The primary attitude towards *terata* in the Middle Ages, however, was negative. The physically misshapen or the mentally infirm were regarded as creations of the devil.[34] Indeed, in his decree of 1234, the *Liber Extra*, Pope Gregory IX denied higher orders to any candidate disfigured by a blemish or deformity.[35] Art and literature of the period reflected these conceits. The *Rohan Hours*, dated 1419–1427, provides a case in point. In one vivid miniature, Moses curses the physically infirm, decrying the misshapen as tools of the devil who are distant from the path of God.[36] And the fourteenth-century poet Eustache Deschamps wrote: 'a man with deformed limbs is misshapen in mind, full of sins and vices'.[37] The *Summa Theologica,* attributed to Alexander of Hales, a Franciscan master residing in Paris at the beginning of the thirteenth century, provides a trenchant reminder of the pejorative attitude towards deformity. Indeed, for Alexander deformity was a consequence of sin, and conversely heightened the idea of beauty and perfection. 'By their contrast with human monstrosities, rational creatures are made more praiseworthy and of greater beauty and they are the greatest adornment of the universe.' But Alexander also added: 'And the harmonious beauty of rational creatures unites with the ornament of monstrous men to provide a special kind of beauty coming from the blending of opposites.'[38]

The disparaging attitude towards deformity was particulary apparent in the long, late medieval discourses devoted to the problem of pygmies. In his compendium *De Animalibus,* the thirteenth-century scholiast Albertus Magnus considered pygmies as imperfect and sub-human. Lacking in reason and sensible speech, they were not only shameless, but also dishonest.[39] Another thirteenth-century commentator, Petrus de Alvernia, argued in the *Quaestiones disputatae* that pygmies were deficient not only in size, but also in modesty. Accordingly, they were not to be considered human.[40]

The antique and medieval texts, viewing *terata* as curiously fascinating manifestations or as objects of mockery and repugnance, provide a fulcrum for the plethora of early modern writings relating to the deformed. These texts elaborate upon the earlier discourses on *terata*, associating the misshapen with evil portents, nature's wondrous variety, disdain and derision. Consider, for

1.1 The armless Thomas Schweiker: illustration from Schenk's *Monstrorum Historia*

example, Simon Gryneus' preface to his *Nova Orbis* of 1532, which discussed *terata* as part of a stupefying mosaic of nature's creativity,[41] or his contemporary, Joannes Boemus, to whom nothing was impossible for God. Even *terata* were examples of His power.[42] This view was stated eloquently by Montaigne in an essay devoted to the monstrous. 'What we call monsters are not so to God, who sees in the immensity of His work the infinity of forms that He has comprised in it.'[43] This attitude was affirmed in the comprehensive *Monstrorum Historia* of 1609 by the physician Johann Georg Schenk. One of the illustrations to this treatise (Figure 1.1) shows the armless Thomas Schweiker writing with his feet: 'Deus est mirabilis in operibus suis' (God is remarkable in his works). Accordingly, Schenk's 'monster' celebrates God's wonderful, infinite variety.

Of course, there was also a seduction of the unusual resulting in a conscious search for the aberrant. In Fortunus Liceti's encyclopaedic discussion of *terata*,

De Monstrorum, published in 1616 and subsequently reissued in 1634, 1665 and 1680, we are told: 'There is nothing so quick under the sun which causes more surprises and admiration than the monstrous, and it is not without reason that men universally desire to know their essence.'[44] That essence was recorded by taxonomic and encyclopaedic accounts of aberrant births and deformities in Italian, German and Spanish treatises. Della Porta's *Della Fisionomia dell' Uomo* of 1610 presented with vivid fascination accounts of the physically deformed.[45] Similarly, Ulisse Aldrovandi's *Monstrorum Historia*, published in Bologna in 1642, cited a variety of physical anomalies, including excessive hairiness and dwarfism.[46] Of course, Pliny, Aristotle and Albertus Magnus were cited as sources, and Aldrovandi's association of human ailments with moral flaws demonstrates his reliance upon traditional *topoi*.[47] In Germany, Johann Schenk's *Monstrorum Historia*, published in Frankfort in 1609, reviewed similar ground, lumping together dwarfs and monstrous horned children in a discussion of the unusual.[48] Additionally, the allure of the monstrous found expression in seventeenth-century Spain in Juan Nieremberger's popular *Curiosa y Oculta Filosofía*. Repeating the commonplace concerning monstrous births as a reflection of the sins of the parents as well as citing Albertus Magnus, Nieremberger remarked upon a natural curiosity for human aberrations.[49] Such curiosity is also revealed in the systematized collection of pictures that documented the misshapen. An unusual birth in Firmi in 1624 attracted the attention of no less a connoisseur than Cassiano dal Pozzo. Indeed, a picture of the child was sent to Cassiano's friend, Francesco Barberini.[50] Nor was this the only image of deformity in Barberini's collection. Liceti noted a number of works in his possession,[51] and the 1649 inventory of Barberini's collection reveals a monstrous head presumably by Leonardo da Vinci.[52] In France, Pierre d'Estoile, an avid collector, bought two pictures of *terata* in 1609, adding to an already large collection devoted to the unusual.[53]

Popular prints devoted to *terata* attest to a wide interest. In France they were called 'Canards', and twenty broadsheets were published between 1600 and 1631.[54] In Spain, popular broadsheets presenting monstrous births were produced throughout the seventeenth century.[55]

Terata were also exhibited as public entertainments. In Valencia, for example, *terata* were shown in 1577 and again in 1581, a monster acrobat performed in 1615, an enormously fat woman was exhibited in 1616, and an armless man in 1619.[56] In England, Samuel Pepys found *terata* and a tour of Bedlam equally entertaining.[57]

Obviously the fascination with *terata* could provide financial reward. The physician Ambrose Paré, in his *On Monsters and Marvels* of 1573, recorded how the indigent parents of a deformed child 'carted around to several cities in Italy to collect money from the people who were burning to see this new

spectacle of Nature'.[58] An early seventeenth-century treatise written by Joannes Marcus-Marci reported on the intentional creation of dwarfs by means of a magical unguent composed of the grease of the smallest animals. These dwarfs were then offered to the aristocracy at great profit.[59] And, of course, the money-making possibilities of the freakish and misshapen are immortalized in Shakespeare's *Tempest* (III, i), when the besotted Trinculo, spying the deformed Caliban, wishes that he were in England to 'gain a piece of silver' from the display of this bizarre figure. A collection of advertisements, now in the collection of the British Library, records how these human oddities were purveyed in the seventeenth century. 'This is to give Notice to All Gentlemen, Ladies and others, Admirers of Curiosities' reads one puff proclaiming the arrival of a dwarf with extremely long arms. This one-foot nine-inch wonder 'will go to any Gentleman's House if requir'd'. In 1677, at 'Mr Croomes', a sixteen-year-old girl who was only eighteen inches high was exhibited. The girl, 'Reads very well, sings, whistles, and all very pleasant to hear.' At the booth at Lincoln's Inn Fair a black dwarf from the West Indies was paired with an entertaining dancing marmoset from the East Indies, clearly indicating how human and sub-human could be cruelly intertwined.[60]

Along with curiosity also came standard attitudes of derision and disdain. The deformed had violated the laws of Nature. Indeed, as Paré dispassionately wrote, the humpbacked, the crippled, the misshapen and the dwarf were monsters, 'things that appear outside the course of Nature (and are usually signs of some forthcoming misfortune)'.[61] Paré even presented cautionary examples of the evil propensities of the malformed. A monstrous woman, who presumably had two heads, was given money 'on account of the novelty of such a strange and new spectacle'. Nevertheless she was ultimately driven away from her home, the Duchy of Bavaria, because she was capable of spoiling fruit.[62] An armless man was a robber and a murderer who was 'hanged and fastened to the wheel'.[63] Paré dolefully concluded: 'It is not good that monsters should live among us.'[64] This is an early modern physician writing, but his medical objectivity is clouded by perceptions that were codified long before. Nor is Paré unique in viewing deformity as a malign portent. The literature of the period is redolent with these accusations, and scientists as well as theologians stressed this aspect of the monstrous. In Book V of his *De conceptu et generatione humanis* of 1554, the Swiss physician Jacob Roeff stated that deformity was the result of divine punishment.[65] Jean Landrey's taxonomy of the extraordinary, *Tératologie*, published in 1603, linked *terata* to God's wish to move men to penitence.[66] In his *De Ortu Monstrorum Commentarius* of 1595, Martin Weinrich, a professor at Breslau, considered monsters as useful in terms of their instruction about the ways of nature, but their ugliness and imperfection related to God's curse on the earth.[67] And the theologian Arnauld Sorbin, in his *Tractatus de Monstres* of 1570, viewed *terata* not only as a

reflection of parental sins, but also as a general demonstration of the world's moral monstrosity.[68]

These ideas, sequestered in the esoteric treatises of the period, were also common in more accessible form. In Belleforest's late sixteenth-century edition of Pierre Boaistuau's *Histoires Prodigieuses*, an ever popular compendium of marvels first published in 1560, not only were monstrous births linked generally to incontinence and sin, but also the specific birth of a monstrous child in Piedmont reportedly brought calamity to the country.[69] The seventeenth-century Italian poet and philosopher Tomasso Campanella associated dwarfs and the misshapen with sloth and weakness.[70] The English philosopher Francis Bacon devoted an essay to deformity, claiming that the deformed disgraced nature by their lack of human feeling. Although Bacon allowed that a deformed person could by discipline and virtue alter his nature, the correlation between mind and body presumed that mental defect was the natural companion of deformity.[71] Some years later, John Sadler's *The Sicke Womans Private Looking-Glasse*, published in 1636 and intended as a gynaecological handbook allowing woman to avoid asking embarrassing questions of their physicians, matter-of-factly stated that 'the outward deformity of the body is often a signe of the polution of the heart...' Indeed, for Sadler, the misshapen were to be excluded from 'the presbytereall function in the Church: and that which is of more force than all, God himselfe commanded Moses not to receive such to offer sacrifice amongst his people'.[72]

English popular ballads reinforced this attitude. In a ballad describing the birth of a deformed child in the Isle of Wight in 1554 we are warned:

> All ye that dothe beholde and see this monstrous
> sighte so strange
> Let it to you a preachyinge be from synfull life to change
> For in this latter dayes trulye, the Lord straunge
> sights doth showe
> By tokens in the heaven's hy, and on the yearth below.[73]

Another ballad relating the birth of a monstrous child to a good Christian couple underscores the conceit of God's message to reform.

> But here to see above the rest
> A monster to beholde
> Proceeding from a Christian brest
> Too monstrous to be told . . .
> But there thou haste by Printing Arte
> A signe therof to se
> Let eche man saye within his harte
> It precheth now to me
> That I should seke to lyve henceforth
> In Godly lyfe always

For these be tokens now sent forth
To preach the later daye ...
By reading stories we shall fynde
In scripture and elles where
That when such thinges come out of light
God's wrath it did declare ...
The ponder wel betymes, long past
The sequel of such sightes
And call to God by prayer in hast
From sinne to change our myndes
Repent, amende both hygh and lowe
The word of God embrace
To lyve thereto, as we should doe
God gyve us all the grace.[74]

Popular tracts are no less disdainful. In the encyclopaedic English translation of Pierre Boaistuau's *Histoires Prodigieuses*, published in 1569, Edward Fenton viewed the deformed as 'abhominations' which 'do for the most part discover unto us the secret judgement and scourge of the ire of God, by the things that they present, which maketh us to feel his marvellous justice so sharpe, that we be constrained to enter into oure selves, to knock with the hammer of our conscience, to examine our offenses, and have in horrour our misdeedes ...'[75] But in addition to engendering 'terror and admiration', for Fenton these *terata* also represented Nature turned 'arsiversie'.[76] The reversal of natural order, presenting the deformed and misshapen as embodiments of 'the world turned upside down', is indeed a commonplace which informs the cultural attitudes of the era. Cardinal Vitelli, for example, held a banquet in 1566, described by Blaise de Vigenère, where thirty-four dwarf servants, all 'conterfaict et difformes', had their deformity camouflaged by their rich garments.[77] Accordingly, they perfectly represented the ironic conceit of reversibility. So too did two dwarfs at the court of Henry II of France and Philip II of Spain. Henry's dwarf was given the twitting sobriquet 'Grand Jean' (Big John), while Philip's pet dwarf was nicknamed 'Montagna' (Mountain).[78] Or consider the 'pig-faced woman of Holland' celebrated in two ballads published in 1640. She is described as a 'dainty lasse' who is 'loving, courteous, and effeminate'. She is 'compleat in every part, save only a head like a swine'.[79] Thus this seventeenth-century Miss Piggy had her feminine virtues controverted by her disturbing face and by eating habits which were not very refined. She slurped from a silver trough.

Implied with the conceit of 'the world turned upside down' are the humour and derision that coalesce around the deformed. Leonardo, for example, echoed the ideas of the piquant contrast of beauty and ugliness voiced by Alexander of Hales, when he saw in the protean power of the painter the ability to conjure up images of beauty that could stimulate love and images of

ugliness that aroused revulsion and compassion. But he also saw how these images of deformity were clearly risible.

How the painter is master of all sorts of people and of all things: If the painter wishes to see beauties which will make him fall in love with them, he is a lord capable of creating them; and if he wishes to see monstrous things that frighten or those that are grotesque and laughable, or those that arouse real compassion, he is their lord and their creator.[80]

Leonardo, of course, was not alone in associating deformity with the risible. As we have seen, there are antique and mediaeval precedents for this view. It is found, as well, in a number of Renaissance and Baroque texts. Ariosto, for example, linked a dwarf, a fool and a madman in a playful company to provide *'sollazzo'* (amusement).[81] And the poet of the marvellous, Giambattista Marino, devoted a poem in his *'Ritratti Burleschi'* of 1619 to the sub-human risibility of the dwarf. Not only was the dwarf descended from an ape, a stinging insult in a pre-Darwinian society, his small size was ridiculed in a series of absurd comparisons. Pestles appear colossal to him. If a pumpkin fell upon him it would be a stroke of extremely bad fortune. Even the dung beetle appears large by comparison.[82] In Spain, a theatrical procession in Madrid held in 1667 included a *'mostro ridiculo'* accompanied by dwarf entertainers and harlequins.[83] And in England, the cavalier poet Sir William Davenant ridiculed the court dwarf of Charles I, Jeffrey Hunter, in a pair of poems, the *Jeffereidos*. Davenant compared the dwarf to a maggot, placed him in mock-heroic grandeur on a lap-dog charger, and had him fight a duel of honour with a turkey.[84] These examples of ridicule, as we will see in the subsequent chapters, can be easily multiplied. They are augmented by popular prints such as the documentation of a deformed birth which took place in Venice in 1575. The event is labelled 'Nova et ridiculosa'.[85]

One would expect, given the sensationalist aspects of *terata*, that they would obviously engender interest in popular prints and ballads. But great artists of the seventeenth century working in Italy, Spain and England – Velázquez, Domenichino, Ribera, Rubens, and Van Dyck – painted the physically and mentally anomalous. Their images often record a court ambience that delighted in collecting deviant bodies. But their depictions owe much to the legacy of accumulated *topoi* which accrued to humanity outside the canonical norm of nature. It is never pleasant to glimpse the dark underside of human nature, but this troubling legacy of revulsion and malign fascination, condemnation and derision, resonates in some of the finest work of Baroque art.

Notes

1. This telescopes and reiterates the extensive account of Richard's aberrant birth recorded in Holinshed's Chronicles. See W. Shakespeare, *The Complete Works*, G.B. Harrison ed., New York, 1952, 221.

2. Aristotle, *Generation of Animals*, 4, 4, 772 b, Loeb Classical Library ed., A.L. Peck trans., Cambridge and London, 1963, 443, 439. *Problemata*, 10, 61, 898 a, Loeb Classical Library ed., W.S. Hett trans., Cambridge and London, 1961, 247.

3. Pliny, *Natural History*, VII, i, Loeb Classical Library ed., H. Rackham trans., Cambridge and London, II, 1942, 511.

4. *Ibid.* VII, ii, iv, xv, 517, 522, 531, 555.

5. Horace, *Epistles*, I, 6, *Complete Works*, C. Kraemer ed., New York, 1936, 321. Cf. C. Barton, *The Sorrows of the Ancient Romans*, Princeton, 1993, 87.

6. Suetonius, *Lives of the Twelve Caesars*, 12, 4, A. Thomson and T. Forrester eds, London, 1914, 491.

7. Pliny, *Natural History*, VII, xv, 555.

8. Suetonius, *Lives of the Twelve Caesars*, 3, 61, 230.

9. Longinus, *On the Sublime*, 44, Loeb Classical Library ed. A.O. Prickard trans., Oxford, 1926, 79.

10. Seneca, *Controversiae*, Loeb Classical Library ed., M. Winterbottom trans., Cambridge and London, III, 1974, 10, 4, 2, 423.

11. Martial, *Epigrams*, vii, xiii, Loeb Classical Library ed., W.C.A. Ker trans., Cambridge and London, II, 1978, 30.

12. Pliny, *Natural History*, VII, iii, 529.

13. K.M. Lea, *Italian Popular Comedy*, Oxford, 1934, I, 226–7

14. Lucian, *The Carousal*, Loeb Classical Library ed., A.M. Harmon trans., London and New York, 1927, I, 431.

15. Tacitus, *Annals*, xv, 34, M. Grant trans., New York, 1993, 360.

16. Plutarch, 'On Curiosity', 10, *Complete Writings*, VII, *Miscellanies*, 2, N.W. Goodwin ed., New York, 1906, 437.

17. Plautus, *Stichus*, 208, H. Petersmann ed., Heidelberg 1973, 59. 'Nam curiosus nemo est qui non sit malivolus.'

18. Cicero, *De Oratore*, Loeb Classical Library ed., II, lxvi, E.W. Sutton and H. Rackham trans., Cambridge and London, 1988, III, 399–401.

19. Juvenal, *Satires of Juvenal and Persius*, Loeb Classical Library ed., G.G. Ramsay trans., viii, Cambridge and London, 1957, 161.

20. Statius, *Silvae*, Loeb Classical Library ed., I, 6, J.H. Mozley trans., Cambridge and London, 1961, 69.

21. Seneca, *Controversiae*, 10, 4, 2, 423.

22. Pliny, *Natural History*, VII, iii, 529.

23. Suetonius, *Lives of the Twelve Caesars*, II, 83, 132.

24. A.J.B. Wace, 'Grotesques and the Evil Eye', *The Annual of the British School of Athens*, X, 1903–1904, 109–10.

25. J. Friedman, *The Monstrous Races in Medieval Art and Thought*, Cambridge and London, 1981, 179.

26. *Ibid.*

27. Augustine, *The City of God*, Loeb Classical Library ed., xvi, B.M. Dods trans., New York, 1950, 531.

28. *Ibid.*

29 *Ibid.*, xxii, 19, 842–3.

30. *Ibid.*, 841–2. This idea is replicated in the medieval commentary on Augustine, *The Two Cities*, by Otto of Freising. See Friedman, *The Monstrous Races*, 121.

31. *Ibid.*, xxii, 12, 837.

32. J. Ceard, *La Nature et les Prodiges*, Geneva, 1977, 42.

33. Friedman, *The Monstrous Races*, 118.

34. M. Gusinde, 'Kenntnisse und Urteile Pygmaen in Antike und Mittelalter', *Nova Acta Leopoldina*, 25, 162, 1962, 12.

35. R. Mellinkoff, *Others: Signs of Otherness in Northern European Art of the Late Middle Ages*, Berkeley and Los Angeles, I, 1993, 114.

36. *Ibid.*, and reproduced II, vi, 1.

37. *Ibid.*, I, 115.

38. Friedman, *Monstrous Races*, 185, 187.

39. Gusinde, 'Kenntnisse und Urteile Pygmaen', 14–15.

40. *Ibid.*, 18–20.

41. Ceard, *La Nature et les Prodiges*, 273.

42. *Ibid.*, 274

43. M. Montaigne, *Essays*, II, 30, in *The Complete Works*, D. Frame trans., Stanford, 1957, 539.

44. Ceard, *La Nature et les Prodiges*, 443.

45. G. Della Porta, *Della Fisionomia dell' Uomo*, M. Cicognari ed., Parma, 1988, 158–9, 258–9, 434–5, 440–1, 499, 513, 515.

46. U. Aldrovandi, *Monstrorum Historia*, Bologna, 1642, 16–19, 38–40.

47. *Ibid.*, 38–9, 256.

48. J. Schenk, *Monstrorum Historia*, Frankfort, 1609, 2–5.

49. J. Nieremberger, *Curiosa y Oculta Filosofia*, Madrid, 1643, 3rd ed., 63, 66–7, 70.

50. F. Liceti, *De La Nature, Des Causes, Des Différences des Monstres*, F. Houssay trans., Paris, 1937, 46.

51. *Ibid.*, 47.

52. M.A. Lavin, *Seventeenth Century Barberini Documents and Inventories of Art*, New York, 1975, 243. The Barberini collection included a wide variety of things for encyclopaedic reasons. See K. Pomian, *Collectionneurs, Amateurs et Curieux, Paris, Venise: XVIᵉ–XVIIIᵉ Siècle*, Gallimard, 1987, 61–80.

53. D. Wilson, *Signs and Portents: Monstrous Births From the Middle Ages to the Enlightenment*, London and New York, 1993, 80–1.

54. Ceard, *La Nature et les Prodiges*, 476.

55. J. Parrondo *et al.*, *Estampas, Cinco Siglos de Imagen Impresa*, Madrid, 1982, 130–1.

56. J.E. Varey, *Historia de Los Títeres en España*, Madrid, 1957, 116.

57. Wilson, *Signs and Portents*, 86.

58. A. Paré, *On Monsters and Marvels*, J.C. Pallister trans., Chicago and London, 1982, 9. Cf. also Jean Riolan's description of the profit gained from exhibiting the deformed in his *De Monstro nato Lutetiae* of 1605 cited in Ceard, *La Nature et les Prodiges*, 453, and the misshapen Savoyard who exhibited himself in Switzerland in 1525 recorded by Liceti, *De La Nature*, 34.

59. M. Monestier, *Les Nains*, Paris, 1977, 56.

60. *A Collection of Advertisements*, British Museum Library, n.p.

61. Paré, *On Monsters and Marvels*, 3, 46–7.

62. *Ibid.*, 9.

63. *Ibid.*, 37.

64. *Ibid.*, 9.

65. Ceard, *La Nature et les Prodiges*, 294.

66. J. Landrey, *Tératologie*, Clermont, 1603, 1.

67. Ceard, *La Nature et les Prodiges*, 444–5, 447.

68. *Ibid.*, 266–7.

69. P. Boaistuau, *Histoires Prodigieuses*, F. de Belleforest ed., Paris, 1593, 30, 918, 959.

70. T. Campanella, *Poesie*, M. Vinciguerra ed., Bari, 1938, *Madrigale*, 8, 61.

71. F. Bacon, *Essays*, XLIV, M. Scott ed., New York, 1908, 200–1.

72. Appended in Paré, *On Monsters and Marvels*, 175.

73. Wilson, *Signs and Portents*, 41.

74. *Ibid.*, 42.

75. *Ibid.*, 53.

76. *Ibid.*

77. E. Martin, *Histoire des Monstres*, Paris, 1880, 338.

78. *Ibid.*, and A. Canel, *Recherches sur les Fous des Rois de France,* Paris, 1873, 132.

79. Wilson, *Signs and Portents*, 89.

80. A.P. McMahon, *Leonardo's Treatise on Painting*, I, Princeton, 1956, 24.

81. L. Ariosto, *Satire,* V, 124, in *Opere Minori*, C. Segre ed., Milan and Naples, 1954, 553.

82. G.B. Marino, 'La Galeria', *Opere*, A. A. Rosa ed., Milan, 1967, 421–2.

83. Varey, *Historia de Los Titeres*, 263 and Figure 14.

84. W. Davenant, *The Shorter Poems and Songs from the Plays and Masques*, A.M. Gibbs ed., Oxford, 1972, 37–43.

85. Wilson, *Signs and Portents*, 52.

The Court and its cruel pleasures: 'freaks' in Italy

The literature devoted to the odd and misshapen testifies to an alienating repulsion and a sinister fascination, a cruel derision and a gelid dread. The Baroque depiction of these 'others' reinforces these conceits. Of course, there were depictions of dwarfs and the physically deviant prior to the seventeenth century. Mantegna's image of a dwarf making a vulgar hand gesture in the Camera degli Sposi, Mantua, a gesture doubtless characteristic of presumably base character, is but one example. But, perhaps as a corollary to the expansive range of Baroque subject matter – still-life, genre and landscape – there was an intensified interest in depicting the 'other' in the seventeenth century. Indeed, with more than random frequency, artists in Italy, particularly in images for the courtly audience that kept human oddities as part of an entertaining retinue, exploited these ideas in paintings, prints and drawings.

Around 1598 Agostino Carracci painted a triple portrait of three extraordinary members of the court of Cardinal Odoardo Farnese (Figure 2.1).[1] On the left, standing in an exaggerated *contrapposto*, is a dwarf named Amon.[2] His diminutive stature is underscored by the enormous parrot perched on his wrist and the spaniel which comes up to his chest. On the right, the grimacing head of 'Pietro Matto' (Crazy Peter) thrusts forward. But the fulcrum of the painting is the central figure of a young man whose excessively hirsute face earned him the sobriquet of 'Arrigo Peloso' (Hairy Harry). A monkey clambers on Hairy Harry's shoulder and grooms the hair of his brutish friend. A pug dog pokes between Harry's legs, and a solemn-looking ape companionably clasps the dog's paw.

In an illuminating article Roberto Zapperi has discussed how these three figures reflect a taxonomic interest in the unusual and the Farnese delight in being entertained by the 'other'. Crazy Peter, like the lunatic type described by Garzoni in his *Hospital of Incurable Madmen*, made melancholy flee from the hearts of men. Hairy Harry wears the costume of his native Canary Islands, a

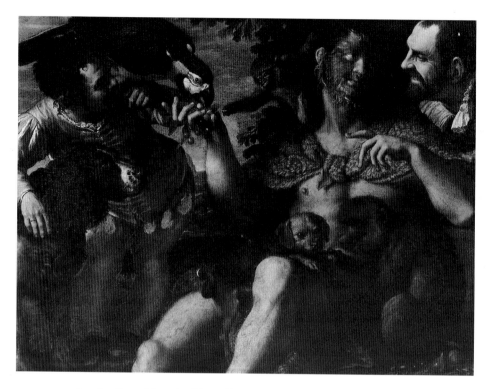

2.1 Agostino Carracci: Portraits of Amon, Pietro Matto and Arrigo Peloso, c. 1598

cape known as a 'tamarco'. Accordingly, he is differentiated from European civilization not only by his plethora of hair, but also by his manner of dress. Amon the dwarf, clothed in a jester's fringed outfit, is smiling. His name, a corruption of Rodomonte, the fractious Saracen ruler described by Ariosto in *Orlando Furioso* as proud and irascible, exemplifies the comic conceit of 'the world turned upside down'. This diminutive figure is anything but threatening.[3]

If Zapperi has clearly connected the picture to Farnese's collecting habits and his amusements, he is less convincing in reading the image in elevated terms.[4] As will become evident, Carracci is not dignifying Amon, Arrigo and Pietro. Nor is he depicting a kind of ideal harmony of men and animals as Zapperi suggests. Actually, Agostino is employing *topoi* that reinforce derisive commonplaces. Surely Carracci was familiar with the discussion of portraiture by his fellow Bolognese, the Cardinal Gabriele Paleotti. The learned theologian, whose treatise was published in 1582, distinguished between portraits that were made for mockery and those of dignified sitters. Worthies, of course, do not appear with apes and parrots. Indeed, Carracci's portrait

may conform to Paleotti's generic classification of portraits of 'buffoni' which also included 'pimps' and 'guzzlers' – all embodiments of 'infamy'.[5] Carracci may also have been responding to Ariosto's description of an entertaining gathering of a dwarf, a fool and a madman.[6]

It is Hairy Harry, the central figure in the composition, and perhaps its most striking, who demonstrates how the presumed dignity of the portrait is compromised in many ways. The monkey climbing on his shoulder, picking at his hair, is a motif traditionally associated with fools and folly. This image is found not only in Northern prints and drawings, but also in a painting of a fool, *The Man with a Monkey* of c. 1590 in the Uffizi by Agostino's brother, Annibale.[7] Hairy Harry's hand gesture also reinforces the mocking tone of the painting. His extended, slightly bent index finger points at Amon. Zapperi suggests, in accord with his sympathetic reading, that this demonstrates refinement.[8] But the gesture is associated in a seventeenth-century manual, *The Chirologia: On the Natural Language of the Hand*, with disapproval.[9] As one *teras* reproves another, Carracci presents in a witty way yet another facet of 'the world turned upside down'. In fact, Hairy Harry finds a counterpart in characters of the topsy-turvy world of the carnival and *commedia*. The hirsute savage appeared as the 'wild man' in popular comedies as well as in licentious carnival processions.[10] As a paradigm of the hairy, untamed savage, Hairy Harry also embodies the negative traits associated with the type, which included an unbridled lubriciousness.[11] His animal companions underscore this association, since apes and dogs were notoriously lustful creatures.[12] The pug dog cradled in Harry's thighs may be a piquantly salacious reference. The glistening cherries dangling from Harry's right hand, and the fig at the haunch of the solicitous ape, also have sexual connotations and embellish the animal, sub-human persona of Hairy Harry.[13]

Hairy Harry, Amon the dwarf and Crazy Peter belonged to Cardinal Farnese. The dogs and apes belonged to him as well. All of these creatures piqued his curiosity and provided entertainment which ranged from simple jesting to the scatological. Carracci's portrait embodies these ideas.

A member of the Carracci school, Domenichino, interjected the portrait of a court dwarf into a mythological scene, *Apollo killing two Cyclopes* (Figure 2.2), a picture in a series painted 1616–1618 for the Aldobrandini family.[14] The dwarf is fretful. His costume is dishevelled, as one stocking falls rumpled at his right ankle. And his cross-handed pose is traditionally associated with idleness.[15] Domenichino, I believe, has provided a witty visual contrast between the background narrative and the mournful dwarf. The cyclopes, traditionally gigantic creatures, are portrayed by Domenichino as fearful and diminutive victims in comparison with the looming figure of the dwarf. Yet the dwarf, chained with an iron collar and pointedly juxtaposed to another lower life form, the cat, is enslaved by the very products of the cyclopean forge.

2.2 Domenichino: *Apollo killing two Cyclopes* c. 1616

As Richard Spear has demonstrated, visual wit is a component of Domenichino's style. Not only does it resonate in his caricatures, but it is also manifest in serious religious paintings like the *Martyrdom of St Andrew* in San Andrea della Valle where, when a rope breaks, a straining muscular executioner flops on his back.[16] But beyond Domenichino's interest in witty juxtapositions lies the cruel joke that initiated the ironic visual contrast found in the Aldobrandini painting. Passeri's biography of Domenichino recounts the circumstances.

The Aldobrandini to mortify the dwarf had him depicted in the guise of a slave with an iron collar around his neck . . . and with such a mocking depiction, with his hands bound, with iron at his neck, without trousers, and among kitchen leftovers, and a cat tearing at a roasted quail as a dinner companion, this was a mark of humiliation . . . On the day of unveiling the painting in the Stanza, the Cardinal and the Aldobrandini princes, who were his brothers, ordered a sumptuous festivity for the family in their court, and commanded everyone to enter the Stanza in the manner of a Bacchanal, dancing before the prepared table. The dwarf, bolder than anyone else, and unaware of Domenichino's deed, led all the others. The place where his portrait had been placed was covered over (this was arranged by the Princes), and after the merry group had made some turns around the table, the curtain covering the feigned window was lowered at a prearranged signal suddenly revealing the dwarf. This provoked laughter (this being the desire of the Aldobrandini) and with such mockery and derision the wretch became speechless.[17]

Like Lucian's dancing dwarf in *The Carousal*, the Aldobrandini dwarf was considered part of the entertainment. He is a butt of courtly laughter, and his placement within the Aldobrandini cycle is a pertinent visual reminder of his debased status.

Domenichino also depicted a dwarf in an important commission obtained for him by the Farnese at the Abbey of Grottaferata. The cycle of frescoes, dated 1608–10, is devoted to the lives of St Nilus and St Bartholomew.[18] Yet within the context of the serious narrative action, a fresco depicting the *Meeting of St Nilus and Otto III* (Figure 2.3), a *teras* is incorporated into the scene. Passeri wrote a lengthy description of the fresco, but did not discuss the dwarf. Instead, he focused on incidental details like the trumpeters.[19] But Domenichino's placement of the dwarf, close to the emperor Otto, suggests that this is not a random choice. Indeed, the dwarf's inclusion has a formal and iconographic resonance. On the one hand, Domenichino, whose debt to Raphael's *Repulse of Attila* is very clear in this work, may be turning also to the Raphaelesque *Vision of Constantine* where the court dwarf of Ippolito de Medici, Gradasso Berratai, comically intrudes upon the sudden revelation of the cross to Constantine.[20] Additionally, I suspect that in both pictures Raphael and Domenichino are employing traditional derisive conceits. Domenichino uses military trappings to underscore the dwarf's diminutive stature. He carries a sword and shield which loom above him. These martial

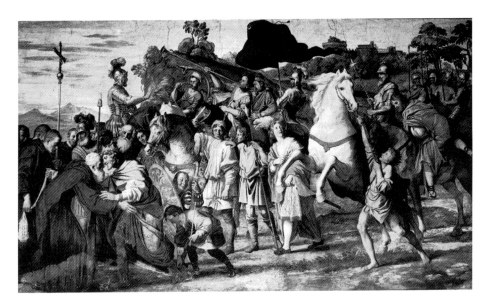

2.3 Domenichino: *Meeting of St Nilus and Otto III*, c. 1608

instruments are contrasted to his non-threatening size. The horse behind the
dwarf also towers above him. The horse's elegant trapping sports a fierce
lion's head, the ferocious nature of the beast intentionally juxtaposed to the
benign, smiling dwarf. In the Raphaelesque *Vision of Constantine* the dwarf is
also incongruously decked out in military garb.

For Bellori the addition of such anecdotal details, and the range of emotions,
heightened the verism of Domenichino's scene.[21] However, these contrasts not
only comically reinforce the dwarf's size and nature, they also reflect
Domenichino's interest in depicting a range of humorous contradictions.
Accordingly, the non-belligerent dwarf with accoutrements of warfare com-
plements the amusing contrast which takes place behind him. Here a group of
excited trumpeters, cacophonously blasting the still and solemn air of the
meeting of St Nilus and Otto, are resolutely told to stop by an armoured war-
rior. Domenichino's antitheses – the dignified soldier and the frenetic trum-
peters, the smooth Raphaelesque beauty of the kneeling page and the
wrinkled ugliness of the dwarf – speak to a conscious system. If Domenichino
was interested in creating an 'ideal beauty', consonant with Agucchi's classi-
cizing theories, he is also interested in an 'ideal ugliness' reminiscent of
Leonardo's delight in contrasting the beautiful with the 'monstrous' and
'laughable'.[22] Indeed, this conceit is elaborated by Domenichino's contempo-
rary, Tomasso Garzoni. In *Il Seraglio de gli Stupori del Mondo*, published in 1613,
Garzoni remarked upon the necessity for ugliness to determine the beautiful.[23]

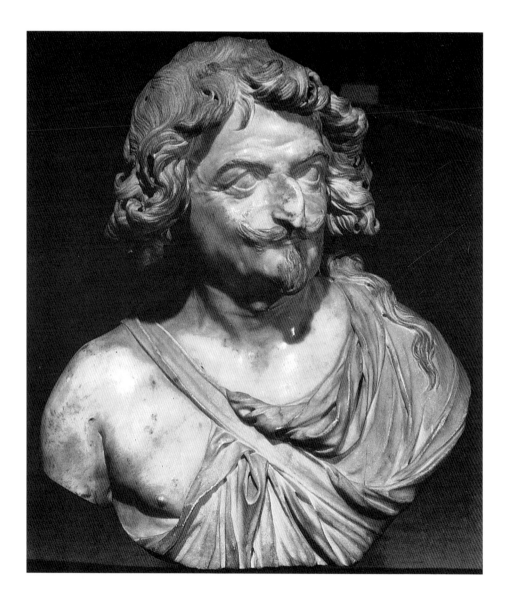

2.4 Francisco Duquesnoy: *Portrait bust of Nano de Créqui*, c. 1630

Terata make only two appearances in Domenichino's extensive oeuvre, which had as its primary aim the representation of the great and noble. Similarly, Francesco Duquesnoy, praised by Bellori for occupying 'a sublime place in art', is best known for his elevated devotional sculpture, his sober tombs or his sweet putti.[24] However, in 1633, Cardinal Antonio Barberini was given by Charles Sieur de Créqui, the Duc de Lesdiquières, Duquesnoy's portrait bust of the French court dwarf, the so-called Nano de Créqui (Figure 2.4).[25] This celebrated dwarf accompanied Charles Sieur de Créqui to Rome. He, according to a contemporary account, 'was the marvel of all Rome as much for the smallness of his stature, as for the perfect proportions of his limbs', and he received a golden chain from the Spanish ambassador.[26] A life-size painting of the dwarf, now lost, but possibly recorded in Aldrovandi's *Monstrorum Historia*, shows him atypically in an ornate costume with his hand on his hip like some swaggering grandee.[27] Duquesnoy's portrait, however, takes on a more derisive tone. Lavin has pointed out that Duquesnoy's image has wittily adapted the formidable type of Caracalla.[28] But I believe there is more than that. Instead Duquesnoy is using the type as a means to convey ironically the impotence of the dwarf. In a delicious piece of irony the dwarf assumes the emperor's formal guise. Yet he is not the fear-inspiring, grimacing emperor. The *nano*'s lively features clearly distinguish him from the ferocious imperial ruler. Additionally, the diminutive size of the bust, only 19 inches, is unlike the heroic proportions given to other portrait busts. Consider, for example, Bernini's contemporary portrait of Scipione Borghese which is 33 inches high. The notoriously brutal emperor has been transmuted into an amiable dwarf.[29] Surely Duquesnoy's learned patron would have smiled at this learned role reversal.

If the odd and misshapen provided amusement and fascination for Roman courtiers, they were similarly viewed by the sophisticated Florentine court. Indeed, a collection of dwarfs and hunchbacks provided entertainment at public festivals and privately 'in camera'. On 6 July 1612, the feast day of St Romulus, for example, a tournament of hunchbacks was held, complemented by a narrative written by Paolo Baroni.[30] Doubtless, this joust of ill-favoured hunchbacks, incongruously placed in a military context, was yet another manifestation of 'the world turned upside down'. Indeed, parodic jousts were often associated in Tuscany with carnival, the quintessential affair of the reversible world.[31] On 16 January 1615 Duke Cosimo II devoted the evening to playful manifestations of 'the world turned upside down'. Dwarfs and clowns were brought into his room and plied with drink, their drunken antics bringing him pleasure in a game described by a contemporary as 'a rovescino' (upside down).[32] In this fun-loving court, Cosimo and his courtiers also amused themselves by weighing dwarfs on the Pitti Palace's large kitchen scales.[33]

The Florentine penchant for images of deformity is widely manifest. In the sixteenth century dwarfs appear as decorative motifs on fountains or retain their diminutive size in small bronzes. Accordingly, in the Boboli gardens the paunchy, immobile dwarf Morgante is perched on a sluggish tortoise.[34] Even the official court portraitist, Bronzino, was drafted into service to paint a dwarf. His portrayal of the dwarf Morgante as a huntsman resonates with a studied derision. In this parodic image the dwarf, undressed in heroic nudity, adopts the pose of a noble ruler. But his nobility is compromised by his ripples of fat, his awkwardly out-turned feet, and the owl, symbol of folly, perched on his shoulder. Even his name, Morgante, derived from Pulci's burlesque epic dealing with a giant, contributes to this comic tone.[35]

In the seventeenth century, artists continued to delight Florentine patrons with depictions of deformity. Santi di Tito's son, Tiberio, painted a portrait of a dwarf in the Boboli gardens surrounded by other court pets, a bevy of lap-dogs.[36] At the end of the century an anonymous artist depicted the dwarf Gabriello Martinez confronting two cranes. In the juxtaposition of the threatening birds and the dwarf the artist is probably making a witty allusion to Homer's comic description of the battle between pygmies and cranes.[37] The dwarf holds a frog as an apotropaic symbol. This may be yet another witty Homeric reference, an allusion to the comic conflict between mice and frogs.[38] Additionally, there was an enduring pleasure in decorative images of the mis-shapen. These range from Alfonso Parigi's design for the drinking cup in the shape of a dwarf to a jewel fashioned as a comic dwarf soldier.[39] But the Florentine penchant for ill-made humanity extends beyond decorative knick-knacks and an occasional portrait. Prints and drawings by Callot, Baccio del Bianco, Antonio Luccini, and Stefano della Bella attest to a continual fascination with the comically grotesque.

The Lorrainese artist, Jacques Callot, worked in Florence from 1614–21. In addition to his involvement with various aspects of Medici theatrical performances and spectacles, Callot had a lively interest in the *commedia dell'arte* and the grotesque.[40] But it was only upon his return to Nancy in Lorraine that a 'ricordo' of his Florentine experience was made manifest. In a series of twenty-one prints, dated about 1622, Callot presented a series of comic 'gobbi' – dwarfs and hunchbacks. The frontispiece to the series (Figure 2.5), announcing 'varie figure Gobbi fatto in Firenze l'anno 1616', clearly articulates Callot's Florentine inspiration. But the inscription proclaiming 'execudit Nanceii', and his use of Lorrainese paper for the prints, confirms the series' origin in Nancy.[41] Perhaps these prints were a demonstration of Florentine exotica for a Lorrainese, and, ultimately, a wider European audience.

Félibien described Callot's emphasis on defect and deformity as consciously amusing.[42] Indeed, the frontispiece of the series combines deformity with scatology. A collection of smiling gnomish hunchbacks surround a figure

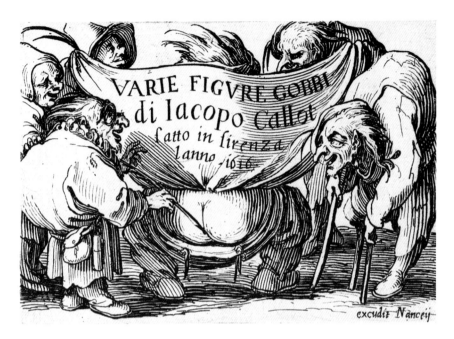

2.5 Jacques Callot: *Frontispiece to series of comic 'gobbi'*, c. 1622

whose trousers have dropped. A hook-nosed *gobbo*, decked out in a fancy ruff, pokes a slender reed-like object into the crevice of the trouserless figure's buttocks. Two of the *gobbi* have snub noses, a trait which, according to Erasmus, is linked to stupidity and clownishness.[43] One *gobbo* is maimed; his double deformity, a hunchback and missing leg, conforms to the traditional conceit that the misshapen are fools. Indeed, in an early sixteenth-century play, the Figure of Foolish Display (*Folle Bobance*) opens the action with a call to her kindred fools, including hunchbacks and the maimed.[44] This conceit could be synthesized with the prejudice recorded in the medical literature of the period. Giovanni Battista della Porta, commenting on the noxiousness of physical imperfection, found the *gobbo* the most pertinent example.[45]

Callot doubtless saw *gobbi* at the Florentine court, and there are drawings of dwarfs from this period as well as two musical *gobbi* from the suite of *Capricci* dated c. 1617.[46] But Callot included a deprecating self-portrait in his series of *gobbi*, indicating that the prints are not simply veristic depiction.[47] Indeed, the dependence upon naturalistic observation is augmented by visual and literary archetypes. There is a long visual tradition that lies behind these seventeenth-century *gobbi*. In antiquity, clownish hunchbacks were depicted, for example, in the temple of Venus at Pompeii, where a comic farmhouse is attended by dwarf and hunchback labourers.[48] Callot did not know this image, but Roman

sculpture, which was accessible, had its cadre of hunchback clowns.[49] However, a more likely source for Callot lies in the French tradition. The decorative border of a sixteenth-century series entitled *Noce de Michaud Crouppière* is enlivened by dwarfs and hunchbacks.[50] And in 1565 Richard Breton published *Les Songes Drolatiques de Pantagruel*. Purporting to be a work of Rabelais, this collection of satirical jibes also contained images of comically grotesque hunchbacks.[51]

Of course, in the light of Callot's interest in the stage, his depiction of *gobbi* may have been dependent also upon theatrical and literary prototypes. One such character was the notorious 'Gobbo de Rialto'. Associated with satiric verses in the sixteenth century, the 'Gobbo' was by the seventeenth century the 'protector of buffoons and the captain of all fools'.[52] And Callot must have had ample opportunity to see hunchback performers. In 1582 the Gelosi company staged a play in Mantua, acted entirely by hunchbacks, to the immense amusement of the duke.[53] An early seventeenth-century engraving by Giovanni Fiorimi shows the comic wedding festivities of 'Gobbo Nan' and 'Simona' attended by standard *commedia dell'arte* characters like 'Pedrolino' and 'Buratino'.[54] The print and the notice of the hunchback performance are but two examples of what must have been commonplace. Indeed, a late seventeenth-century apologist for the *commedia*, Andrea Perrucci, summarized centuries of *commedia* sensibility when he wrote in his *Dell'Arte rappresentativa premeditato ed all'improvvisso*: 'ridiculous antics consist in exaggerations and deformities of nature'.[55]

Callot's series of *gobbi*, indeed, owes much to the *commedia dell'arte*. The frontispiece, with its vulgar scene of nib and backside, recalls a popular *commedia* 'lazzo'. In this piece of comic stage business a character with his rump exposed has the clown Pulcinello write on it.[56] In fact, Callot's hook-nosed *gobbo* with the nib recalls the physical type of Pulcinello described by Perucci.[57] A number of references to the *commedia dell'arte* are also found in the individual figures in Callot's series. Some *gobbi* don masks traditionally associated with the *commedia*, thereby exaggerating their comic grotesqueness. The *guitar player* (Figure 2.6) and the *Masked figure with twisted legs* (Figure 2.7) are examples. Many, sporting elaborately feathered caps and pom-pom buttons, relate to the *commedia* types depicted in Callot's *Balli di Sfessania*. The *Masked comedian playing a guitar* (Figure 2.8) and two images of duelling *gobbi* (Figures 2.9, 2.10) recall the characters Razullo, Scaramuccia and Fricasso.[58] The *gobbo* playing a grill like a violin (Figure 2.11) clearly finds an analogue in *commedia* buffoons. A drawing by Callot's contemporary, Jacques de Gheyn, shows a *commedia zanni* strumming a grill, and a print by Fruijtiers depicts a hunchback clown with a grill.[59] Callot also uses a *gobbo* to present the traditional conceit of 'the world turned upside down'. Accordingly, one *gobbo*'s elaborate pom-pom buttons (Figure 2.12) are not placed in the front, but run

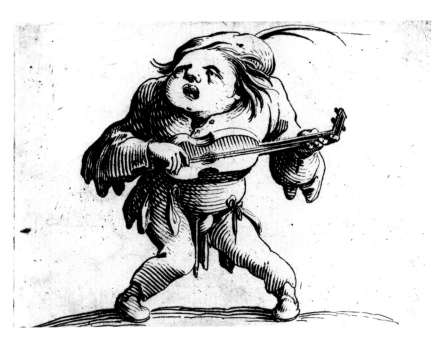

2.6 Jacques Callot: *The guitar player*, c. 1622

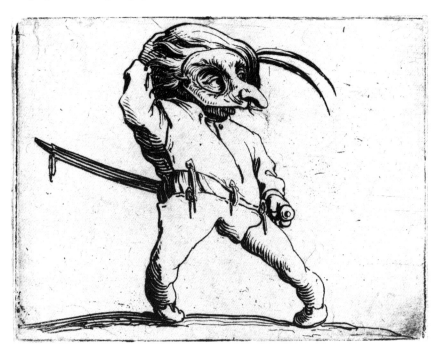

2.7 Jacques Callot: *Masked figure with twisted legs*, c. 1622

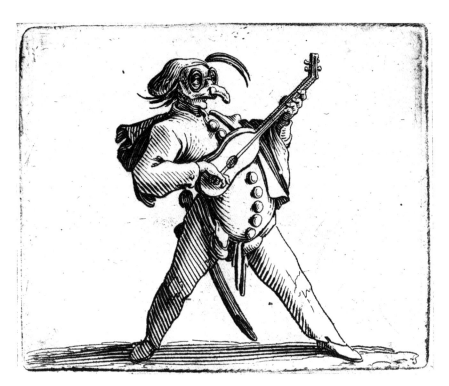

2.8　Jacques Callot: *Masked comedian playing a guitar*, c. 1622

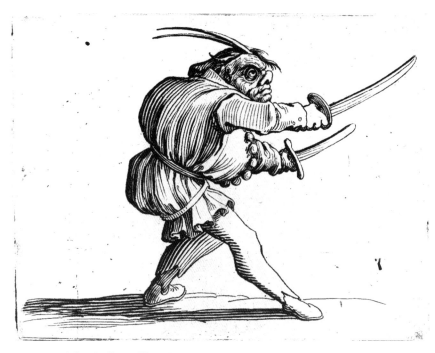

2.9　Jacques Callot: *Duelling 'gobbi'*, c. 1622

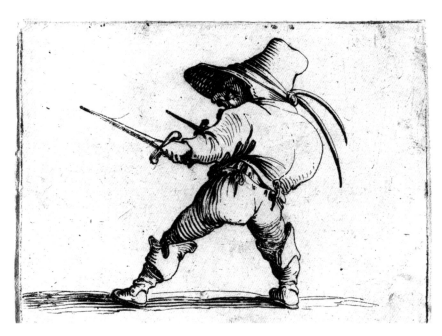

2.10 Jacques Callot: *Duelling 'gobbi'*, c. 1622

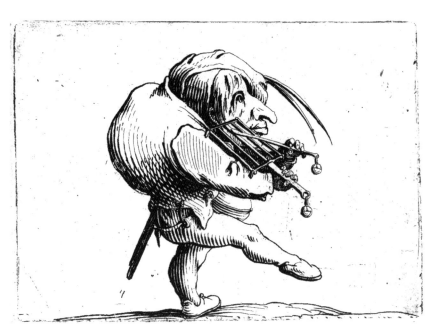

2.11 Jacques Callot: *'Gobbo' playing a grill*, c. 1622

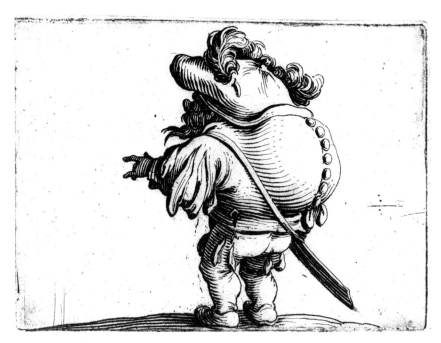

2.12 Jacques Callot: *'Gobbo' with suit buttoning at the back*, c. 1622

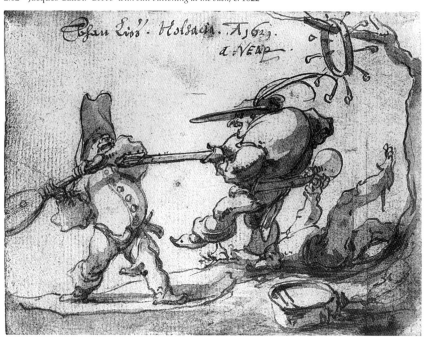

2.13 Johann Liss: *Fighting 'gobbi'*, c. 1623

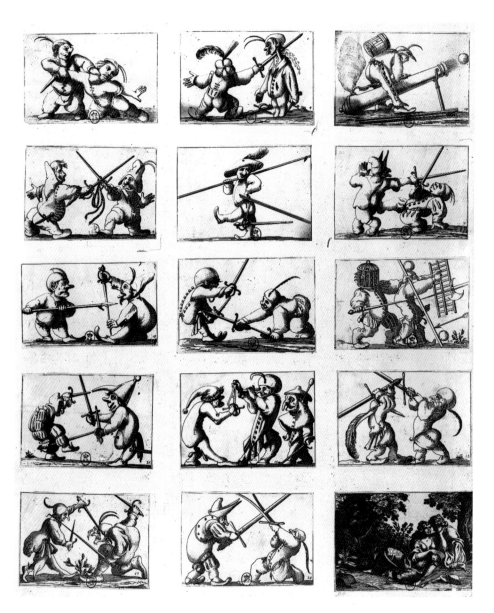

2.14a and 2.14b

Antonio Luccini: *Frontispiece to 'Compendio de Armi de Caramoggi'*, 1627

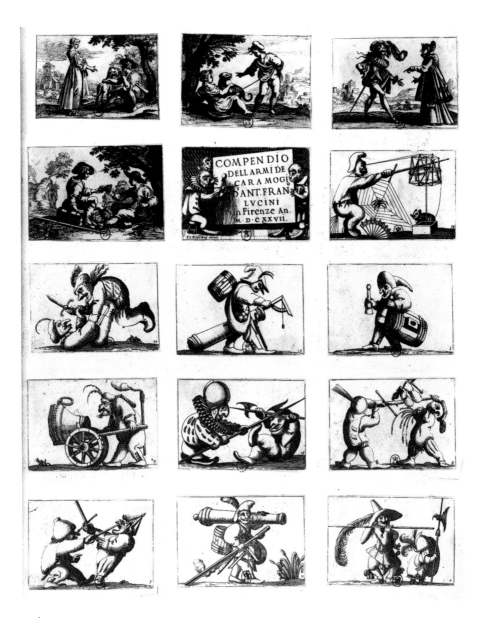

2.14b

down his curving back. Dressing obviously required a *gobbo* valet. The *gobbo*'s gesture, extending his forefinger and little finger, is a common sign of folly as well as derision.[60] Thus, confirming his place in the topsy-turvy world, the figure of mockery is also a mocker.

The impact of Callot's suite of *gobbi* was far-ranging. One immediate response may be a fluid drawing by Johann Liss depicting two *gobbi* battling with musical instruments, and one who has fallen down, jug in hand, obviously drunk (Figure 2.13). The drawing, signed and inscribed that it was done in Venice, formed part of an 'album amicorum', a book of drawings and souvenirs given to friends.[61] If the circumstances, signature and locale of the drawing are evident, the dating of the work remains problematical. The date has been read as 1629 and more recently as 1621.[62] A reading of 1621 would predate Callot's prints, and an elaborate explanation, suggesting that Liss saw trial prints or drawings that Callot made in Florence, has been advanced to justify this dating.[63] However, the blurred last digit of the date, read as a nine and as a one, also can be read as a three. This date would be consonant with Liss's stay in Venice and also would allow for a plausible response to Callot's prints.[64]

In 1627, the Florentine Antonio Luccini produced a series of etchings primarily devoted to the military antics of *gobbi*.[65] The frontispiece to the set (Figure 2.14) announces that it is a 'compendium of arms-bearing by dwarfs' ('Compendio de Armi de Caramoggi'). Since the inscription is held by monkeys, the clownish intent of the cycle is clear. Luccini depicts *gobbi* fighting with one another or parading with arms. The *gobbi* are also viewed in a less martial mode, playing chequers, bowls, or a kind of *gobbi* golf. Callot's influence is clearly seen in the duelling *gobbi* where the militant *gobbo* in a striped costume strikes a pose reminiscent of Francatrippa from Callot's *Balli di Sfessania* (Figure 2.15). The paunchy *gobbo* bearing a cannon echoes Callot's overstuffed military *gobbo* (Figure 2.16). In another pair of duelling *gobbi*, one, recalling Callot's figure, has pom-pom buttons running down his back. Additionally, his helmet is apparently a bucket. Another *gobbo* discharges a cannon comically placed between his legs. Here, Luccini may have adapted the idea from Callot's *commedia dell'arte* Capitano Babeo, whose sword prominently protrudes from his groin.[66] For at least one of his images, Luccini depends upon a motif that has a long tradition. His juxtaposition of a snail and a *gobbo* stems from medieval images contrasting a dwarf and the even more diminutive snail for comic effect, relating to the topsy-turvy world.[67] And a jaunty marching *gobbo* carrying a pike is like a parodic version of Jacques de Gheyn's elegant soldiers from his famous series devoted to arms.[68]

Likewise, in two prints, the Florentine Valerio Spada also responded to Callot. One depicts a collection of dwarf musicians. In the other, a militant dwarf dressed in classical armour routs a fleeing dwarf. A female dwarf in the

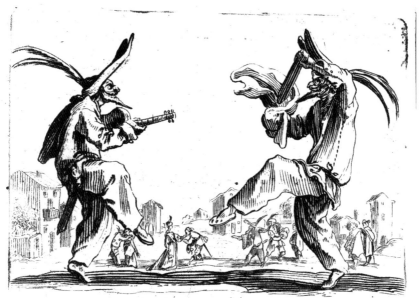

Franca Trippa. Fritellino.

5

2.15 Jacques Callot: *Francatrippa*, c. 1622

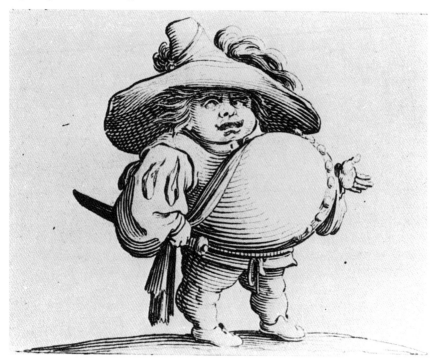

2.16 Jacques Callot: *'Gobbo'*, c. 1622

centre of the composition reacts with histrionic terror.[69] We know that Spada was interested in comic parodies.[70] Perhaps, in this three-figured drama, Spada has created a parodic version of the myth of the irascible Mars chasing Venus' lover, Adonis.[71]

Another Florentine, Baccio del Bianco, best known for his theatre sets, also depicted amusing images of dwarfs. In fact, Baldinucci singled him out as 'eccellente' in his representation of 'caramogi', which he found quite bizarre and unique.[72] According to Baldinucci, Baccio made drawings of dwarfs as well as two paintings depicting dwarf glass-makers and dwarf cobblers.[73] The paintings have not survived, but there are a number of drawings, now in the collection of the Gabinetto del Disegni in Florence, which reflect the Florentine fascination with comic deformity.[74] Regrettably, the drawings are undated, but since a book of payment for the Guardaroba of San Domenico, dated 1637, lists 'various dwarfs' by the artist, it is clear that Baccio was already depicting dwarfs by the 1630s.[75] Baccio represents *gobbi* dwarfs as gluttons, jousters, and musicians.[76] A frontispiece (Figure 2.17) depicts dwarfs surrounding a car-touche. Their contorted postures – they balance the cartouche like grotesque animated bookends – recall the poses struck by the *commedia* figures from Callot's *Balli*. Their finger gestures, little finger and index finger extended, are, as we have already seen in Callot's imagery, the signs of folly and mockery. Below the cartouche a dwarf covers his face with his hand, a device tradition-ally associated with fools.[77] Above, a horn-blowing dwarf underscores the conceit of mockery, since this is a motif associated with insult.[78]

In one particularly amusing drawing (Figure 2.18) a group of dwarf physicians minister to a painfully wizened old man. Their large hook-noses and costumes, like those of the 'dottore', again point to the ambience of the *commedia dell'arte*.[79] As one dwarf struggles with a huge clyster, we are reminded not only of the *commedia* fascination with these instruments, but also of the 'reversible world' where proportions are distorted and normal-sized objects become immense.[80] Baccio's interest in the *commedia* is certainly not fortuitous, and it is manifest in at least one drawing inspired by the comic theatre, a Punchinello who cooks a miniature Punchinella in a frying pan.[81] In another drawing, Baccio collects a cadre of clownish dwarfs wearing outsize hats. One dwarf's hat bears the inscription 'The Spire and his followers'. The world has once again been comically reversed. The dwarf now has an archi-tectural nickname associated with great height.[82] A *commedia dell'arte* motif also intrudes in the depiction of the dwarf in the centre of this drawing. His cloak-muffled face is a motif mimicking the ridiculous zanni.[83]

Yet another Florentine, Stefano della Bella, also did a series devoted to vari-ous dwarf activities, an album of twenty-three drawings probably dating from the 1650s. Regrettably, only twelve of the drawings are extant.[84] The surviving drawings demonstrate a microcosm of human activity in this 'piccolo mondo',

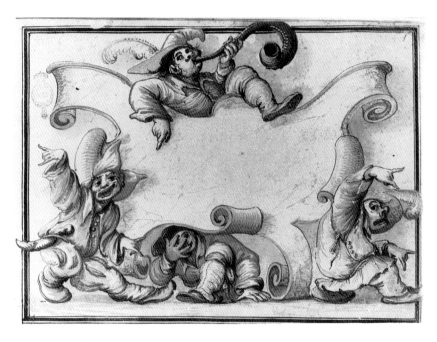

2.17 Baccio del Bianco: *Frontispiece: dwarfs surrounding a cartouche*, n. d.

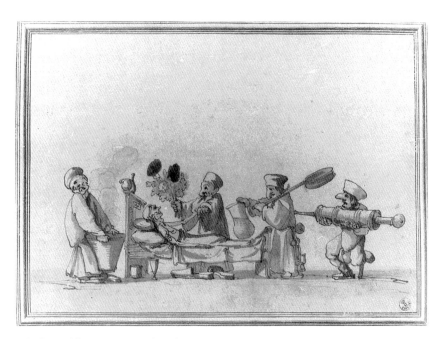

2.18 Baccio del Bianco: *Drawing of dwarf physicians*, n. d.

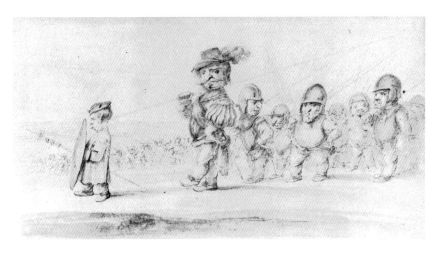

2.19 Stefano della Bella: *Parade of soldiers*, 1650s

ranging in subject matter from dwarf falconers to dwarf knife-grinders, from dwarf highwaymen to dwarf pashas. It is clear that della Bella is reflecting traditional conceits in his images of these dwarfs. The drawing of dwarf fruit-vendors is a case in point. The dwarfs, offering their wares to women at a window, suggest not only the occupational drawings of dwarfs by Baccio del Bianco, depicting comic butchers and sausage-makers, but also the lubricious ambience of the carnival.[85] Indeed, the carnival festival songs of tradesmen take on a particularly salacious cast. Consider, for example, the song, full of double entendre, sung by the Florentine company of key-makers as they passed by the ladies on their balconies.

> Our tools are fine, new, and useful
> We always carry them with us
> They are good for anything
> If you want to touch them you can.[86]

Similarly, a song about dentists, whose 'hard iron' prepares them for 'poking with love', has an explicit sexual content, as does the carnival song about apples coated with hoarfrost.[87]

In the *Parade of soldiers* (Figure 2.19), in Oxford, two armoured dwarfs, standing truculently arms akimbo, are comically ferocious. But the militant dwarfs hardly represent a threat. The central figure, a dwarf decked out in plumed hat and military sash, struts like a 'capitano', the boastful cowards of the *commedia*. Indeed, his elaborate moustache and pointed beard recall the guise of Capitano Spezzafer, the ridiculously-named Captain Breakiron.[88]

In della Bella's 'piccolo mondo' dwarfs also have time for recreation. In the

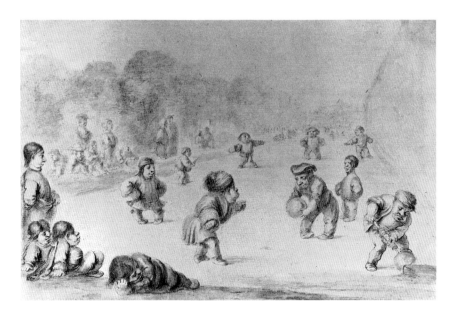

2.20 Stefano della Bella: *The Ball Game*, 1650s

Ball Game (Figure 2.20), a study from the album now in the Victoria and Albert Museum, dwarfs are spectators and participants at a vast park. But this light-hearted genre scene may have a subsidiary lubricious content. On the right, a dwarf pumps a ball with air, a motif which has obscene connotations in emblematic literature.[89] Accordingly, the tranquil mood is subverted by a bawdy intrusion reminding us that dwarfs are inhabitants of a derisively risible world. Viatte characterizes these drawings as 'cold and grating . . . The dwarfs are monstrous personages engaged in apparently normal activities and living in a monstrous world'.[90] Indeed, the drawings speak to the malign humour that characterizes the perception of *terata* in the period.[91]

Della Bella did another series of dwarfs which survive in etchings by Agostino Mitelli, dated 1684.[92] The dwarfs are presented in military guise and as lovers, thus depicting two absurdly incongruous dwarf activities. One print (Figure 2.21) pairs two courtly dwarfs, identified by a mocking inscription as 'exhausted hearts', with two music-making dwarf peasants. The guitar-playing male has the knock-kneed stance that Callot used for some of his *gobbi* musicians. The inscription beneath the frolicsome dwarf peasants ironically reads: 'Inaudible beauty'. In other images we find military dwarfs, their names redolent of the conceit of 'the world turned upside down'. The pike-bearing 'Great Corporal Deformity' is flanked by a dwarf called 'Affable Grimace' and a fife-playing 'Smokey Collapse' (Figure 2.22).[93] Two clumsy dancing dwarfs are labelled 'very nimble lovers', and a peg-legged dwarf firing a musket is

sHanca cuori . *Bdezze inaudite .*

2.21 After Stefano della Bella: *'Exhausted hearts'*; etchings by Agostino Mitelli, 1684

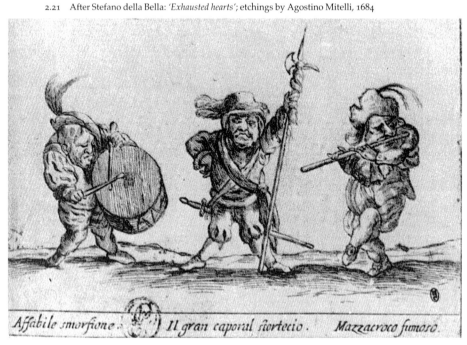

Affabile smorfione . *Il gran caporal fiortecio .* *Mazzacroco fumoso.*

2.22 After Stefano della Bella: *Military dwarfs*; etchings by Agostino Mitelli, 1684

called 'the very beloved Ganymede'. This putative hunter may be a parodic inversion of Virgil's elevated description of Ganymede the hunter.[94] Similarly, two particularly ugly dwarfs are given the sobriquet 'Venus and Adonis'. In this playful deviation from expected norms we once again view the 'reversible world'.[95]

The Florentine penchant for images of deformity continued into the early eighteenth century. Some surviving drawings by Anton Domenico Gabbiani and Pietro Micheli da Torrita depict gluttonous dwarfs, drunken dwarfs and dwarfs with a clyster.[96] But Faustino Bocchi, lauded by the critic Lanzi as 'eccellente' in the depiction of dwarfs, translated this interest into painting.[97] His career, lasting from around 1689 until his death in 1741, was extensive. And although only a few of his works can be securely dated, there are some pictures which can be placed in the Florentine court ambience, where he served in the last decades of the *seicento*.[98] A depiction of *Bathing dwarfs* (Figure 2.23) is probably one of them.[99] The dwarfs frolic in an arcadian setting. Their tinyness is underscored by the meticulously depicted large clematis. On the right, two lecherous dwarfs gaze upon a reclining female, a kind of parodic inversion of *seicento* pictures representing Venus spied upon by shepherds or satyrs.[100] Only a little over twelve inches high, this diminutive painting complements the size of the dwarfs. But in an amusing inversion of proportions, Bocchi also did paintings of dwarfs on a grand scale. The *Rustic Feast* in the Pitti Palace, a picture nearly six feet by eight feet, teems with dwarfs. Here the dwarfs are divided along class lines. In the mid-ground, elegantly dressed dwarfs enjoy the delights of a country outing. In the background, on the left, dwarf peasants brawl or fall prostrate from overindulgence. But whatever their social class, ugliness and bestiality are consciously exaggerated. One dwarf has the face of a cat. Another dwarf is portrayed as a porcupine. In some of the details Bocchi seems to be amalgamating court amusements with elements of the *commedia dell'arte*. On the right of the composition, a company of dwarfs is hoisted on a scale-cum-frying pan. Early in the seventeenth century the Florentine court amused themselves by weighing dwarfs on large kitchen scales, a practice that may not have been forgotten at the end of the century. The frying pan is also associated with the *commedia dell'arte*, as Baccio del Bianco's drawing depicting Punchinello frying a tiny Punchinella demonstrates. The group of rabbits in the centre of Bocchi's composition, animals notorious for their licentious behaviour, may provide a subtext for his image.

Bocchi continued to paint pictures of dwarfs well into the eighteenth century. But as his work matured the amusing images of deformity become tinged with a poignancy that is antithetical to the cruel amusement that seems to characterize seventeenth-century depictions. This change, and the reasons that lie behind it, remain to be elaborated in the concluding chapter of this study.

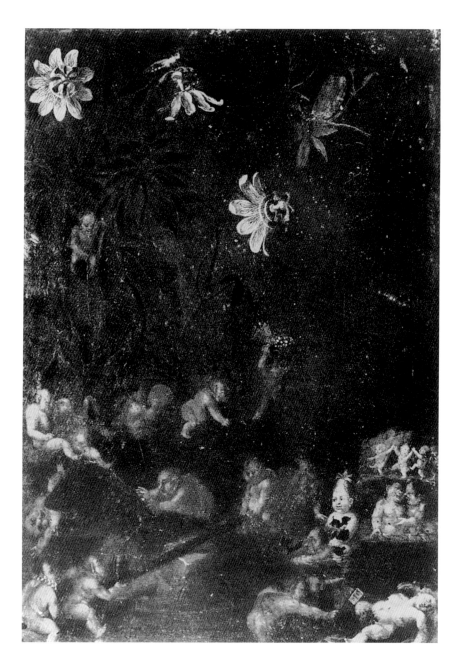

2.23 Faustino Bocchi: *Bathing dwarfs*, n. d.

Notes

1. For the dating of this work see D. Benati in *The Age of Correggio and the Carracci*, Washington, 1986, 261.

2. The pose is reminiscent of the burlesque halberdier in Annibale Carracci's *Butcher Shop*. For the comic elements of this painting see B. Wind, 'Annibale Carracci's *Scherzo*: The Christ Church *Butcher Shop*', *Art Bulletin*, LVIII, 1976, 93–96. But for a differing interpretation of the painting see R. Zapperi, *Annibale Carracci*, Turin, 1989, 45–69.

3. R. Zapperi, 'Arrigo le Velu, Pietro le Fou, Amon le Nain et Autres Bêtes: Autour d'Un Tableau d'Agostino Carrache', *Annales Economies Sociétés Civilisations*, 40, 1985, 307–27.

4. *Ibid.*, 317.

5. G. Paleotti, *Discorso Intorno alle Imagine Sacre e Profane*, (Bologna, 1582) in P. Barocchi, *Trattati d'Arte del Cinquecento*, Bari, 1960, II, 336, 340.

6. Ariosto, *Satire*, V, *Opere Minori*, 553.

7. H. Janson, *Apes and Ape Lore*, London, 1952, 211 and D. Posner, *Annibale Carracci A Study in the Reform of Italian Painting Around 1590*, London and New York, 1971, II, 26.

8. Zapperi, 'Arrigo le Velu, Pietro le Fou, Amon Le Nain . . .', 317.

9. J. Bulwer, *Chirologia: On the Natural Language of the Hand* (1644), J.W. Cleary ed., Carbondale and Edwardsville, 1974, 130. Bulwer's discussion of hand gestures is derived from such classical sources as Ovid, Livy and Quintillian. *Ibid.*, xx–xxi.

10. S. Sumberg, *The Nuremberg Schembart Carnival*, New York, 1966, 98–103. Incidentally, Hans Sachs, in his *Scheinpart-spruch*, associated the hairy 'wild-man' with a dwarf. *Ibid.*, 99. The interest in hairy *terata* is also manifest in the gallery of Ulisse Aldrovandi, which contained two portraits of an excessively hirsute father and daughter. The inscriptions attached to the images emphasized their sub-human, ape-like nature. L. Bolzoni, 'L'Invenzione dell'Aldobrandini per la sua Villa di Campagna', in *Documentary Culture: Florence and Rome from Grand Duke Ferdinand I to Pope Alexander VII*, E. Cropper, G. Perini F. Solinas eds., Bologna, 1992, 346.

11. Friedman, *The Monstrous Races*, 204, R. Bernheimer, *Wild Men in the Middle Ages*, Cambridge, 1952, 121–75, Della Porta, *Della Fisionomia dell' Uomo*, 434.

12. Janson, *Apes and Ape Lore*, 261–86 and Wind, 'Annibale Carracci's *Scherzo*', 95.

13. D. Bax, *Hieronymus Bosch his picture-writing deciphered*, Rotterdam, 1979, 251. G.P. Lomazzo, *Trattato dell'arte de la Pittura*, VI, lxii, Milan, 1584, 480.

14. On this picture and the cycle painted for the Aldobrandini by Domenichino and his assistants see R. Spear, *Domenichino*, New Haven and London, 1982, I, 195–8.

15. Bulwer, *Chirologia*, 37–38 and S. Koslow, 'Frans Hals' Fisherboys: Exemplars of Idleness', *Art Bulletin*, LVII, 1975, 418–32.

16. Spear, *Domenichino*, I, 38–39.

17. G.B. Passeri, *Le Vite de pittori, scultori ed architetti*, Rome, 1772, 13–14.

18. For this cycle see Spear, *Domenichino*, I, 159–71.

19. Passeri, *Vite*, 7.

20. For Domenichino's dependence upon Raphael's picture see Spear, *Domenichino*, I, 162. For the dwarf in the *Vision of Constantine* see F. Hartt, *Giulio Romano*, New York, 1981, 47.

21. G. Bellori, *Vite de'pittori, scultori e architetti moderni*, Rome, 1672, 297.

22. On his appropriation of Agucchi's theories see Spear, *Domenichino*, 29–31.

23. T. Garzoni, *Il seraglio de gli Stupori del Mondo*, Venice, 1613, 62.

24. Bellori. *Vite*, 269. M. Fransolet, *François Duquesnoy*, Brussels, 1941, is the standard monograph on the artist.

25. On the dating of the Nano see I. Lavin, 'Duquesnoy's "Nano di Créqui" and Two Busts by Francesco Mochi', *Art Bulletin*, LII, 1970, 133.

26. *Ibid*. The real delight that the aristocratic clergy took in human oddity is also manifested by Cardinal Antonio Barberini's collection of dwarfs, including Gaspare Moretto and Botolino. They are depicted on the left side of Sacchi and Miel's painting for the Barberini, *Urban VIII Visiting the Gesu*, (Rome, National Gallery) dated 1641. See P. Pecchai, 'Nani e Buffoni in Roma nel Seicento, Botolino e Moreto', *Strenna dei Romanisti*, MMDCCI, April 1948, 101–5.

27. On the painting see Lavin, *ibid.*, who was unaware of Aldrovandi's (*Monstrorum Historia*, 40) image of the dwarf.

28. Lavin, *ibid.*, 136.

29. On Caracalla see Dio, *Roman History*, Loeb Classical Library ed., H. Foster trans., Cambridge and London, IX, lxxviii, 1955, 291, 301.

30. A. Solerti, *Musico, Ballo e Drammatica alla Corte Medicea dal 1600 al 1637*, New York and London, 1968, 65.

31. J. Heers, *Fêtes des Fous et Carnavals*, Paris, 1983, 222.

32. Solerti, *Musico, Ballo e Drammatica*, 86.

33. J. Blanchard in D. Russell, J. Blanchard, J. Krill, *Jacques Callot, Prints and Related Drawings*, Washington, 1975, 77.

34. B. Wiles, *The Fountains of the Florentine Sculptors and Their Followers*, New York, 1973, 90. H. Keutner, 'Der Giardino Pensile der Loggia dei Lanzi und seine Fontane', *Kunstgeschichtliche Studien für Hans Kaufmann*, Berlin, 1956, 240–51.

35. For the Bronzino portrait see L. Campbell, *Renaissance Portraits*, New Haven and London, 1990, 145. For Pulci's comic epic see L. Pulci, *Morgante*, F. Ageno ed., Milan and Naples, 1955 and particularly X, 65, 147–8, XII, 46, XV, 48, XX, 11, 126 for piquant descriptions of Morgante.

36. M. Mosco in M. Mosco and S. Trkulja, *Natura Viva in Casa Medici*, Florence, 1985, 85.

37. M. Poggesi in *ibid.*, 112.

38. For this comic epic see H. Wölke, *Untersuchungen zur Batrachomyomachie*, Meisenheim am Glan, 1978.

39. A.M. Spina, *Giulio Parigi e Gli Incisori della sua Cerchia*, Naples, 1983, 156 and Figure 29.

40. D. Russell, *Jacques Callot*, 59–79.

41. *Ibid.*, 78.

42. A. Félibien, *Entretiens sur les vies et sur les ouvrages des plus excellens peintres anciens et modernes*, Trevoux, 1725 ed., III, 375.

43. M. Sullivan, *Brueghel's Peasants*, Cambridge, 1994, 82.

44. B. Swain, *Fools and Folly During the Middle Ages and the Renaissance*, New York, 1932, 102–3.

45. G. Della Porta, *Della Fisionomia dell' Uomo*, 258.

46. P. Chone *et al.*, *Jacques Callot*, Paris, 1992, 231, 238.

47. Callot's malign self-image may be the result of an insidious melancholy recorded in a letter to Domenico Pandolfi, 5 August 1621. See Chone, *ibid.*, 51–52. Cf. however, Russell, *Jacques Callot*, 77 who suggests that the *gobbi* are based upon observable reality.

48. T. Wright, *History of Caricature and the Grotesque in Literature and Art*, (1865), New York, 1968, 34.

49. K.M. Lea, *Italian Popular Comedy*, I, 226.

50. J. Porcher, *Les Songes Drolatiques de Pantagruel*, Paris, 1959, v and pl. 2

51. *Ibid.*, iii and *Oeuvres de Rabelais, Songes Drolatiques de Pantagruel*, E. Johanneau ed., Paris, 1823, 263, 415. D. Ternois, *L'Art de Jacques Callot*, Paris, 1962, 134, also mentioned the *Songes Drolatiques*.

52. A. Moschetti, 'Il Gobbo di Rialto', *Nuovo Archivio Veneto*, 5, 1893, 5–93, especially 35. Perhaps the name of Shakespeare's clownish servant in *The Merchant of Venice*, Launcelot Gobbo, derives from this character.

53. K. Richards and L. Richards, *The Commedia dell'Arte, A Documentary History*, Oxford, 1990, 76.

54. P. Duchartre, *The Italian Comedy*, New York, 1929, 67.

55. Cited in Richards, *The Commedia Dell'Arte*, 136.

56. *Ibid.*, 176.

57. *Ibid.*, 137.

58. G. Kahan, *Jacques Callot, Artist of the Theater*, Athens, 1976, 93–94, has called attention to the relationship of these *gobbi* to the *Balli*.

59. Duchartre, *The Italian Comedy*, 32, 217.

60. On this gesture see Bulwer, *Chirologia*, 138–9. The negative connotations of this gesture must be part of a long tradition. Cf. also the use of this gesture by a fool depicted mocking Christ in the *Stuttgart Psalter*, dated in the first half of the ninth century. Mellinkoff, *Others: Signs of Otherness in Northern European Art*, I, 89, II, iii, 114. *Gobbi* also appeared in carnival processions, thus confirming their link to 'the world turned upside down'. Cf. the race of nude hunchbacks discussed by M. Boiteux, 'Carnaval annexé: Essai de lecture d'une fête romaine', *Annales Economies Sociétés Civilisations*, 32, 1977, 363.

61. On this drawing see L.S. Richards, *Johann Liss*, Cleveland, 1975, 139–40.

62. *Ibid.*, 140.

63. *Ibid.* If a general interest in *gobbi* inspired both Callot and Liss, as has been alleged, then one would expect many more Venetian depictions of *gobbi*. Cf. also J. Bean, 'Johann Liss', *Master Drawings*, XIV, 1976, 66 n. 2, who notes the possibility that Venice should be read as Naples. This undocumented trip would then date the drawing during Liss's Roman sojourn, and therefore after the publication of Callot's prints.

64. On Liss's chronology and his activity in Venice see R. Spear, 'Johann Liss Reconsidered', *Art Bulletin*, LVIII, 1976, 590.

65. For these prints see F. Viatte, 'Allegorical and Burlesque Subjects by Stefano della Bella', *Master Drawings*, XV, 1977, 360–1.

66. See P. Chone *et al.*, *Jacques Callot*, 222, figure 159.

67. G. Cocchiara, *Il Mondo alla Rovescina*, Turin, 1963, 200–1, lists manuscripts in Paris, London and Genoa which contain this motif.

68. I.Q. van Regteren Altena, *Jacques de Gheyn, Three Generations*, The Hague, 1983, II, 75–78. Callot also did drawings of pike-bearing figures for Florentine theatrical productions. See Chone, *op.cit.*, 204–5, figures 111, 115.

69. J. Lieure, *Jacques Callot*, New York, 1969, II, figures 283–4.

70. Thieme-Becker, *Kunstler-Lexicon*, Leipzig, n.d., XXXI, 319. A manuscript of Tasso parodies by Spada was formerly in the Biblioteca Riccardiana in Florence.

71. Cf. Giulio Romano's elevated version of this theme in the Sala di Psiche. F. Hartt, *Giulio Romano*, figure 260.

72. F. Baldinucci, *Notizie de'Professori del disegno*, V, 1847 ed., 31–32.

73. *Ibid.*, 32.

74. There is a drawing of dwarf glass-blowers illustrated in M. Rossi, *Ritratti in Barocco, La festa nella Caricatura toscana nel Seicento*, Locarno, 1985, 49, figure 10.

75. M. Gregori, 'Nuovi accertamenti in Toscana sulla Pittura Caricata e Giocosa', *Arte Antica e Moderna*, 13/16, 1961, 416 n. 15.

76. *Ibid.*, figures 192 b, 192 d, 193 c.

77. Cf. a painting of a fool in the collection of Wellesley College illustrated in P. Vandenbroeck, *Beeld Van de Andere Vertoog over Het Zelf*, Antwerp, 1987, pl. II.

78. Rossi, *Ritratti in Barocco*, 34.

79. On the *commedia* and the clyster see Duchartre, *The Italian Comedy*, 336 and Callot's use of the motif in his *Balli di Sfessania*, P. Chone, *Jacques Callot*, 223, figure 167.

80. On the delight in reversible size relationships see H. Grant, 'Images et Gravures du Monde À L'Envers dans leurs relations avec la pensée et la litérature Éspagnoles', *L'Image du Monde Renversé et ses Représentations Littéraires et Para-Littéraires de la Fin du XVIe Sìecle du Milieu du XVIIe*, J. Lafond and A. Redondo eds, Paris, 1979, 28.

81. Gregori, 'Nuovi accertamenti in Toscana. . .', 416 n. 15. Cf. Rossi, *Ritratti in Barocco*, 51, who also links Baccio's work to the *commedia*.

82. The motif of 'the world turned upside down' is present also in a number of other drawings by Baccio. In a depiction of three dwarfs one saws a glass of wine, another urinates on a roasting fowl, and a third has caged a fish (Rossi, *op.cit.*, figure 12). Or in a depiction of a card party, elegantly dressed women and a dwarf prelate engage in an activity unsuitable to their station. See Rossi, *ibid.*, figures 5 and 33–34. The spire also had comically licentious connotations. See M. Bakhtin, *Rabelais and His World*, Cambridge and London, 1968, 310.

83. Duchartre, *The Italian Comedy*, 324. For a description of other drawings by Baccio see Gregori, 'Nuovi accertamenti in Toscana. . .', 400–10, who also allies the comic nature of these drawings to poetic burlesques in the manner of Berni's *Capitoli*. See also M. Rossi, *Ritratti in Barocco*, 28–79, who views the drawings in terms of the *commedia dell'arte* and the tradition of carnival.

84. F. Viatte, 'Allegorical and Burlesque Subjects by Stefano della Bella', 354. Cf. also three drawings in the Uffizi attributed to Della Bella depicting comically amorous dwarfs. A. Tempesti, 'Caramogi di Stefano della Bella', *Itinerari, Contributi alla Storia dell'Arte in memoria di Maria Luisa Ferrari*, I, Florence, 1979, 117–26.

85. Rossi, *Ritratti in Barocco*, pl. 7, 8.

86. P. Burke, *Popular Culture in Early Modern Europe*, London, 1978, 186.

87. *Canti Carnascialeschi del Rinascimento*, C. Singleton ed, Bari, 1936, 41–42. On the apple song see Rossi, *Ritratti in Barocco*, 117. Rossi (41–42, 57–60) has also connected the carnival to Baccio del Bianco.

88. Duchartre, *The Italian Comedy*, 223.

89. Cf. the emblem in the Dutch riddle-book, *Nova Poemata*. A ball pumper is accompanied by the inscription: 'I saw that he had between his two legs a certain something well equipped and passably pretty. He was embracing this thing in such a way that he made it show its hole with each blow. . .' See J. Moffitt, 'The Fifteen Emblematic "Genre Scenes" in the *Nova Poemata* (1624)', *Konsthistorisk Tidskrift*, LVIII, 1989, figure VII, 160–1. On the Florentine interest in Northern imagery see Gregori, 'Nuovi accertamenti in Toscana. . .', 414.

90. Viatte, 'Allegorical and Burlesque Subjects by Stefano della Bella', 356.

91. Della Bella's name has also been associated, but incorrectly, with four prints depicting dwarfs. These may be by Collignon. See A. de Vesme and P. Massar, *Stefano della Bella*, New York, 1971, 72–73.

92. The Mitellis are free versions of prints by Collignon after Della Bella. See De Vesme and Massar, *Ibid.*, 162–3.

93. 'Smokey Collapse' (Mazzacroco Fumoso) may be a name traditionally associated with fools. In his notes on Lorenzo Pignoria's *De Servis*, Cassiano dal Pozzo uses the term when discussing jesters. I. Herklotz, 'Cassiano dal Pozzo's Bemerkungen zu Lorenzo Pignoria's *De Servis*', *Documentary Culture Florence and Rome*, 121.

94. For Virgil's description of Ganymede see *Aeneid*, V.P. Dickinson trans., New York, 1961, 101.

95. The conceit of uglifying the antique is not new in Italian art, and is found, for example, in the sixteenth-century series of *Pagan Deities* by Martino Rota. For these see Posner, *Annibale Carracci*, I, 69 and figure 66.

96. Rossi, *Ritratti in Barocco*, figures 22, 25, 26, 27.

97. L. Lanzi, *Storia Pittorica dell'Italia*, III, Milan, 1825, 276.

98. On the vexed chronology of his works see M. Olivari, *Faustino Bocchi e l'arte di figurar pigmei*, Milan, 1991, and more recently B. Wind, 'Piccolo Ridicolo: A Little Bit on Bocchi', *Arte Lombarda*, 108/109, 1994, 124–7. On Bocchi in Florence see Olivari, *op.cit.*, 13.

99. Olivari, *op.cit.*, 80–81.

100. Cf. *ibid.*, 80. Olivari also connects the picture to the theme of Susanna and the Elders.

'Great wonders of nature': Ribera and deformity

Bernardo de Domenici, the garrulous eighteenth-century historian of Neapolitan art, remarked upon 'alcune teste deformi intagliate per ischerzo' (some deformed heads engraved as a joke) made by Jusepe de Ribera.[1] Only two prints depicting heads ravaged by warts and goitres now survive, but De Domenici's trenchant comment about the joking nature of Ribera's depiction of the grotesque is certainly in accord with received attitudes concerning deformity. In addition to prints, Ribera also produced paintings and drawings of anomalous and disfigured humanity.

In the etching, *The small grotesque head* (Figure 3.1), signed and dated 1622, Ribera explored facial deformity with ruthless persistence. Large tumours on the neck, and stray hairs protruding from the chin of this man's forbidding countenance, are rendered in fascinating detail. Indeed, the preparatory drawing for the print, now in a private collection, demonstrates that Ribera has made the etched image more blemished by adding extra warts to the cheek.[2] What impelled Ribera to depict this disfigured image? In part, he may be referring to Leonardo, whose own fascination with human oddity provoked the excited observation, 'Giovanina – fantastic face is at St Catherine's hospital', as well as a series of drawings devoted to facial deformity.[3] Indeed, Ribera's own drawings of grotesque heads, one riddled with warts and goitres (now in a private collection), and one with mountainous goitres (now in Cambridge), also reflect his fascination with the unusual.[4] Since Ribera's interest in physiognomy in the early 1620s, demonstrated by his studies of noses and mouths, directly stems from Leonardo's conceits, the idea of emulating Leonardo in the *Small Grotesque Head*, and in his other depictions of deformity, may not be fortuitous.[5]

Ribera was also attracted to Bolognese art, and his stay in Parma under the protection of the Farnese doubtless fostered an interest in the bizarre.[6] Perhaps Annibale Carracci's now lost recreational drawings of various physiognomic

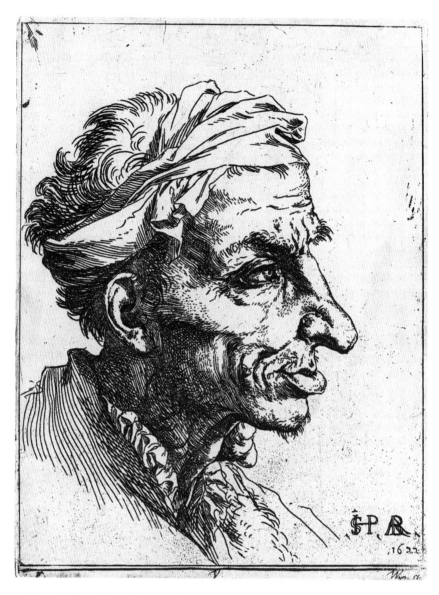

3.1 Jusepe de Ribera: *The small grotesque head*, 1622

anomalies – 'a fat nose, a large mouth, or a hunchback' – cited by Malvasia also provided Ribera with useful prototypes.[7]

But there are other factors that lie behind Ribera's image. The fascination with *terata* and physiognomy evidenced by the medical texts of the early seventeenth century may have created a market for such prints. Such books as Geronimo Cortes' *Phisonomia y varios secretos de naturaleza*, first published in 1601 and subsequently reissued in 1603 and 1609, and Carolus Montecuccoli's translation of the antique treatise on physiognomy by Polemo, reflect this interest in Spain and Italy.[8] Two early seventeenth-century medical tracts actually find analogues in Ribera's work. Ludovico Settala's treatise on moles, published in Milan in 1626, demonstrates a scientific interest in blemishes that parallels Ribera's. And Prospero Aldorisio's treatise on laughter, *Gelotoscopia*, published in Naples in 1611, may have spurred another of Ribera's physiognomic exercises, his depiction of laughing mouths.[9] But it was the currency in Naples of Giovanni Battista della Porta's treatise on human physiognomy, a tract that devoted several pages to human oddity and ugliness, referring to all disfigurements as noxious, that could have piqued a special interest.[10]

Of course, Ribera's uncompromising naturalism in the depiction of facial disfigurement can be viewed in terms of a tradition of literal and declarative realism. Consider, for example, the heroic warts on the cheek of Federico da Montefeltro in Piero della Francesca's portrait of this warrior duke, or Van Eyck's portrait of Jodocus Vyd, the donor of the Ghent altarpiece. But Ribera's etched head does not belong to an important patron like Montefeltro, who may have insisted, like the emperor Julian, on being portrayed with all of his blemishes.[11] Instead, the scruffy bandanna links Ribera's figure to the low-life executioners who wear this type of rag in pictures by Caravaggio and his followers.[12]

Since Ribera's figure comes from the lower strata of society, his vividly rendered image of facial disfigurement can be viewed in terms of prevalent negative visual and literary attitudes. A long visual tradition associated facial blemishes with evil. The tormentors of Christ were sometimes afflicted with warts, amplifying their ugliness. The executioner in the *Sforza Hours* of c. 1490 is disfigured by warts and a pendulous goitre. The mockers of Christ in the Karlsruhe *Passion* of c. 1440 are covered with facial warts. And Dürer's *Christ among the Doctors* of 1506 in the Thyssen collection pointedly contrasts the idealized beauty of Christ with the warty face of the disputing doctor.[13] There is also a long literary tradition linking facial deformity to evil character. Tacitus associated the moral decay of the emperor Tiberius with his ulcerous face and frightening physiognomy, and Horace specifically allied warts to vice.[14] This conceit became a commonplace. In his *Specchio di Croce*, written in the early fourteenth century, the prelate Domenico Cavalaca condemned the wart-ridden person for not being virtuous.[15] Satiric writers were no less

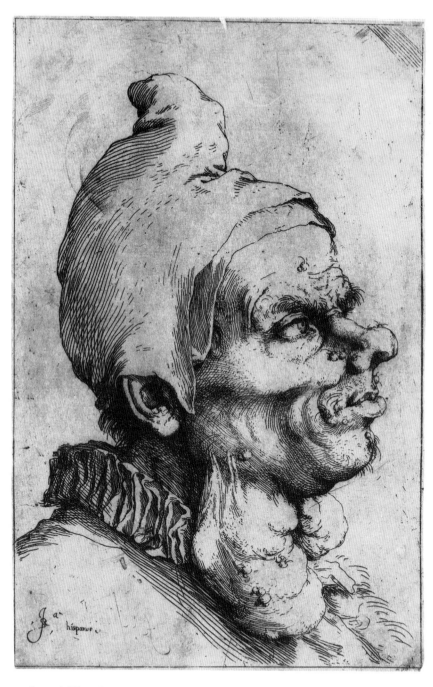

3.2 Jusepe de Ribera: *Large grotesque head*, c. 1622

censorious. Francesco Berni's comically derisive sonnet addressed to a house-wife eulogizes her soft elephantine skin, her gluttonous appetite, and her warts.[16] And in his *La Fiera*, published in 1618, Michelangelo Buonarotti the Younger ironically described a prideful but deformed figure who was goitrous and warty.[17]

Ribera's etching of the *Large grotesque head* (Figure 3.2), dating from c. 1622, presents an even more repulsive visage than the *Small grotesque head*. It has long been recognized that this plate was originally part of a series of instructional anatomical exercises for students. At some point Ribera decided to abandon the project, but the faint remains of an eye appear at the upper left, partially erased yet still visible near the peak of the cap.[18] He was then able to fill the large sheet, over two-thirds of a foot high and almost half a foot wide, with a head that confronts us with monstrously pendulous three-inch goitres and massive almost half-inch warts. Once again Ribera heightened the blemishes in the transition between preparatory drawing and final print. The drawing, its whereabouts unknown, presents a face distorted by huge goitres and an excessively protruding lower lip.[19] But in this print, as in the *Small grotesque head*, Ribera has added a plethora of warts and scraggly hairs bristling from the nose and chin, as well as a more bulbous nose. He has also given the figure an elaborate ruff. This elegant collar pointedly contrasts to his repugnant features and seems decidedly out of place. But this ruff is consonant with the costume of *commedia dell'arte* clowns, and thus provides a clue to the persona of Ribera's figure. In fact the deformed Pulcinello, albeit without warts and goitres, also sports a refined ruff, as shown in prints by De Gheyn and Fruijtiers.[20] The curious funnel-like hat worn by Ribera's figure also links him to the *commedia*. This type of hat has been associated with entertainers, buffoons and fools from the Roman *mimus* to the seventeenth century.[21] The figure's prominent goitres underscore the connection to folly, stupidity and the *commedia*. This deformity had a long association with the slow-witted and with clownish behaviour. Aristotle considered those afflicted with goitres to be dull-witted.[22] In the Middle Ages goitrous cretins performed as clowns during carnival.[23] Medieval manuscripts, such as the *Reun Model Book* of the thirteenth century or the *Psalter of St Lambrecht* of the fourteenth century, linked goitres with fools.[24] Literary descriptions of goitres underscored this association. The early Renaissance writer Francesco Sacchetti, who enjoyed a certain popularity in the seventeenth century, devoted one of his tales to the foolish gullibility of goitrous peasants.[25] Similarly, Baldassare Castiglione associated goitres with fools, a perception corroborated in the medical literature of the period by Paracelsus, who emphatically declared 'all goitrous persons are more disposed to foolishness than to cleverness'.[26] Aldrovandi's taxonomic discussion of human disfigurement, the *Monstrorum Historia* of 1642, considered goitre a cursed affliction which could even stem from a

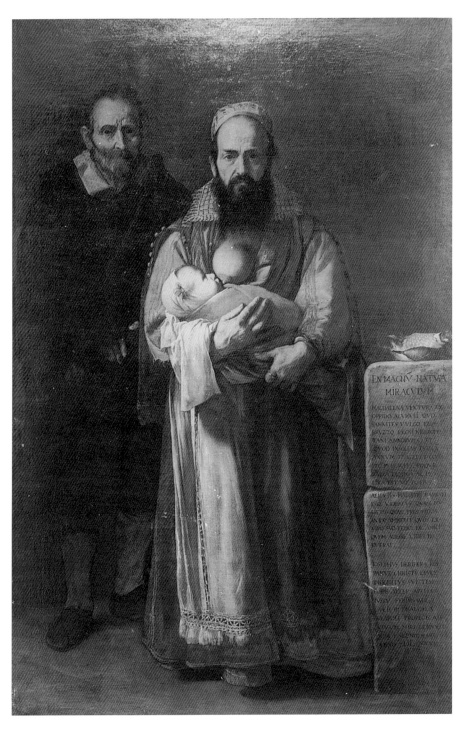

3.3 Jusepe de Ribera: *Magdalena Ventura*, 1631

putrefying sensual humour lodged in the gullet.[27] It is not surprising then that the ridiculous and randy *commedia dell'arte* clown, *zanni*, sported an artificial goitre in order to mark him as even more laughable.[28]

The *Large Grotesque Head* may not be Ribera's only foray into the imagery of the *commedia*. A drawing dating from the later 1620s, entitled *Fantastic Scene* and now in a private collection in Madrid, demonstrates Ribera's continuing interest in the *commedia dell'arte*. Here the strutting soldier, probably the character of the *capitano*, is assaulted by numerous tiny figures. One balances on his sword as if it were a tightrope. Another pulls at his exaggerated nose, and several clamber atop his hat. These diminutive figures are reminiscent of the tiny Punchinella that could fit in a frying pan, part of the *commedia* repertoire that Baccio del Bianco also explored.[29]

Ribera's prints of *terata* were intended for a wider market. His over-life-size painting of a bearded woman, Magdalena Ventura, dated 1631 (Figure 3.3), was commissioned by Don Fernando Afán de Ribera y Enríquez, the third duke of Alcalá. The Duke of Alcalá was an inveterate collector of art, but he was also a learned humanist whose curiosity was wide-ranging. Described as another Maecenas, the duke had books dedicated to him by the playwright Lope de Vega, the humanist and antiquarian Roderigo Caro, and the learned doctor Alonso Nuñez de Llerena, who wrote a treatise on throat inflammations, *De Gutturis et faucium ulceribus anginosis*.[30] The duke had acquired a vast library, which according to the Sevillan chronicler, Ignacio Góngora, had 'so many volumes of all science and humanistic letters, manuscripts, and ancient medals that it competes with the most illustrious in the world'.[31] His passion for learning was well-known. A contemporary remarked that he was 'so enamored of letters that there was not a single moment in which he was not occupied in public affairs that he did not employ in reading and study, not only of literature, but also the other sciences'.[32] Ribera's portrait of the bearded woman, a pictorial document of the bizarre and the marvellous, is but one manifestation of the duke's extensive interests.[33] Indeed, in a record of his visit to Ribera's studio on 11 February 1631, the Venetian ambassador noted the duke's excitement with both Magdalena and the portrait.

In the rooms of the viceroy there was an extremely famous painter who was making a portrait of an Abruzzi woman, married and the mother of many children, who has a completely masculine face, with a beautiful black beard more than a *palmo* long and a very hairy chest. His excellency wanted me to see her, thinking it was a marvellous thing, and truly it is.[34]

The inscription on the stele to the left of Magdalena, written in Latin, the language of the intelligentsia, confirms the interest in strange phenomena. Large letters boldly proclaim '**THE GREAT WONDER OF NATURE**'. This

announcement is followed by a long factual description of Magdalena's history, coupled with information concerning the commission and a self-aggrandizing encomium for Ribera.

Magdalena Ventura, from the town of Accomoli in central Italy, or in the vulgar tongue, Abruzzi, in the kingdom of Naples, aged 52 years, the unusual thing about her being that when she was 37 she began to become hairy and grew a beard so long and thick that it seems more like that of any bearded gentleman than of a woman who had borne three sons by her husband, Felici de Amici, whom you see here. Jusepe de Ribera, a Spanish gentleman of the Order of the Cross of Christ, and another Apelles in his times, painted this scene marvellously from life on the orders of Ferdinand II, Third Duke of Alcalá, Viceroy of Naples, on the 16th February 1631.

The inscription's declarative statement that the picture was painted 'marvellously from life' is attested by Ribera's unrelenting naturalism. The astonishing array of textural effects ranges from the rough wrinkled visages of Magdalena and her disconsolate husband to the delineation of the delicate fringe on her apron. And the insistent light, highlighting the figure of Magdalena and the child she holds, affirms the tangible volume of their forms. But if nature is vividly present in so many of the realistic details, it is also subverted by the shocking presentation of Magdalena's bare breast being offered to a suckling infant. Since she is 52, clearly beyond child-bearing years, and also of diminished sexual attractiveness, the infant is doubtless not hers. But Magdalena's interaction with the child can reinforce her feminine nature, and the bobbin and the spindle on the stele, attributes of feminine industry, underscore this conceit.[35]

On the other hand, the beard is traditionally associated with masculine force. The Church Fathers were very clear about this. Clement of Alexandria, for example, viewed the beard as a manifestation of man's superiority, counselling men to grow beards to demonstrate their difference from women, and Augustine considered the beard a proper 'manly adornment'. This gave rise to the proverbial statement: 'A beard suits a man'.[36] In Burchardus de Bellevaux's *Apologia de Barbis*, a medieval compendium of beard lore, it was explicitly stated that it was 'against the accustomed course of nature for a woman to be bearded'.[37] The sixteenth-century physiognomist, Jean Indagine, also commented on the manly character of bearded women.[38]

The pointed contrast between the masculine, bearded Magdalena and her feminine duties of nursing and spinning doubtless alludes once more to the familiar idea of 'the world turned upside down'. Magdalena, the tender nurturer, is also virile and full-bearded, thus confirming the strange tricks that nature can play in an uncertain world. These inversions apply particularly to *terata*. Consider, for example, the popular print depicting the legless girl, Catherina Mazzina, a *teras* exhibited in Rome in 1585. The inscription beneath

CENTVRIA II. 164

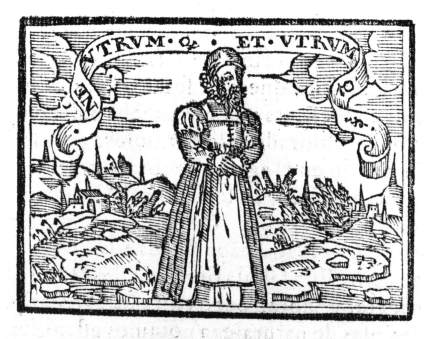

EMBLEMA. 64

3.4 Sebastián Covarrubias: *Bearded woman, from the Emblemas Morales*, 1610

the print informs us that 'This monstrous girl . . . is about eight years and with a beautiful face and handsome body yet without legs and thighs'.[39] Again, in his diary entry of 15 September 1657, John Evelyn remarked upon:

The hairy woman, twenty years old whom I had before seen when a child. She was born at Augsburg, in Germany. Her very eyebrows were combed upwards and all her forehead as thick and even as grows on any woman's head; a very long lock of hair out of each ear neatly dressed. She also had a most prolix beard and mustachios, with long locks growing on the middle of the nose, like an Iceland dog exactly the colour of a bright brown, fine as well-dressed flax. She was now married and told me that she had one child and it was not hairy nor were any of her relations. She was very well-shaped and plaid well on the harpsichord.[40]

These *terata*, like Magdalena Ventura, belong to the reversible world, where feminine charm and beauty – pleasing shape, musical talent – and deformity exist in uneasy antithesis.

The bearded woman also possessed sinister negative connotations which extended beyond the idea of marvel and the conceit of the reversible world. Della Porta's influential physiognomic treatise associated bearded women with 'very bad habits' and 'lechery'.[41] Additionally, in one of Sebastián Covarrubias' *Emblemas Morales* of 1610 (Figure 3.4) the bearded woman, in her confusion of sexual roles, becomes a paradigm of the abominable. The accompanying inscription declares in Latin: 'Neutrumque et Utrumque'(Neither one nor the other). The vernacular Spanish text which explicated the emblem concludes: 'I am lowly like a horrid and rare monster, view me as wicked and an evil omen'.[42]

The fascination with *terata* also gripped the Duke of Alcalá's successor in Naples, the Count of Monterrey. An inventory of the count's collection taken in 1653 lists a painting 'of a monstrous naked child' by Ribera.[43] Unfortunately the painting is now lost, but its high value – 1,000 reales, equivalent to a painting in the collection attributed to Raphael – underscores the special interest in human oddity.[44]

In 1643 Ribera painted another image of deformity, the *Clubfooted boy* (Figure 3.5), now in the Louvre. Probably commissioned by Ramiro Felipe de Guzmán, the Viceroy of Naples, this picture is apparently neither a document of bizarre curiosity nor a patently derisive depiction of the infirm.[45] To be sure, in his decisively naturalistic manner Ribera has carefully delineated the swollen club foot of this anonymous Neapolitan street urchin.[46] But the boy sports a jaunty smile, carries his crutch like a military pike, and holds a *cartellino* that proclaims: 'Give me alms for the love of God'.

To be sure, beggars and vagrants were the targets of church repression and some vilifying *seicento* texts. Gregory XIII wished Rome clear of beggars; the able-bodied were to be banished, and the infirm were to be maintained at the monastery of St Sisto. Sixtus V desired all those who persisted in begging to be severely punished. And Innocent X suggested that all beggars should be incarcerated in the Apostolic Palace of S. Giovanni Laterano.[47] The papal attitude was underscored by popular literary attacks on what was perceived as a dangerous beggar class. In a suite of twenty-four sonnets, *Il paltoniere*, written in 1629, the Bolognese poet Baldassare Bonifaccio described beggars as 'putrid vermin or dirty snails'.[48] The Italian redaction of *Lazarillo de Tormes*, Barezzo Barezzi's *Il picariglio castigliano, cioe vita del cativello Lazariglio di Tormes*, published in 1635, is similarly unsympathetic. Beggars were viewed as merely 'dirty dogs' who should be quarantined in some isolated colony.[49] The scathing attack on beggars by Giacinto de Nobili, *Il Vagabondo overo sferza de Bianti e Vagabondi*, published in 1627 with papal sanction, underscores an antipathy which borders on loathing. Discussing thirty-four types of vagabonds, Nobili decried their practices. Among the charlatans were 'Ascioni', fraudulent madmen, and 'Accaponi', those who falsely ulcerated

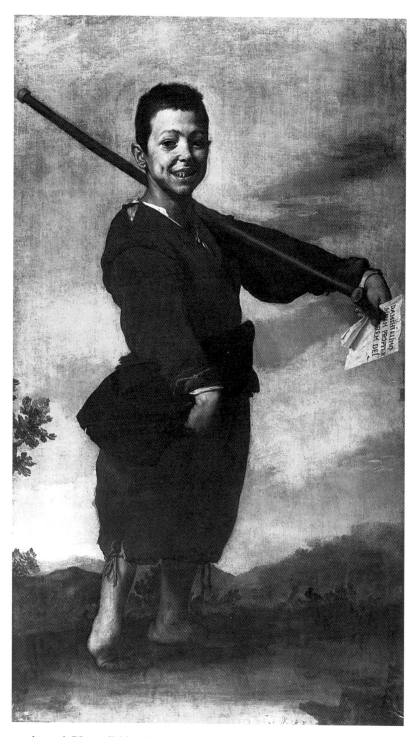

3.5 Jusepe de Riberas: *Clubfooted boy*, 1643

their legs.[50] Of course, Ribera's club-footed boy has an actual and not a manu-
factured deformity. But any type of deformity was viewed with disdain. As
Ambrose Paré remarked, the crippled, like other *terata*, were considered as
deviations from nature and accordingly adumbrated misfortune.[51]

Indeed, for all of Ribera's vivid naturalism, he may actually have used
Callot's mordant frontispiece to his series of beggars, the self-styled 'Captain
of the rogues' (Figure 3.6), as his point of departure.[52] Like Ribera's figure,
Callot's is set against a broad landscape. There are other analogues as well.
The twisted-legged pose is similar in both figures, and the banner slung over
the 'Captain's' left shoulder may have been transformed into the crutch held
by Ribera's beggar boy. But Callot's scruffy beggar, with his concealed hand
emblematic of idleness, is not cheerfully smiling.[53] Nor does he appeal to
Christian sentiments of charity. As Edward Sullivan has pointed out, Ribera's
picture relates to Counter-Reformation ideas concerning salvation through
charity. The boy's broad grin seems to refer to ideas articulated by Pierre de
Besse whose *Le Démocrite Chrétien* of 1615 counselled laughter as a way of
overcoming hardship.[54] Indeed, the happy cripple is the subject of one of the
stoical maxims of the Spanish Jesuit, Juan Nieremberger who wrote: 'A cripple
does not so much think of repining at his lameness when his heart is satis-
fied'.[55]

But if Ribera is extolling the virtues of charity to the less fortunate, he is also
underscoring traditional attitudes toward the poor. The boy's gleeful accep-
tance of his impoverished state also allows the aristocratic patron of this
picture a certain feeling of well-being. The destitute can be viewed as not
suffering. They are being cared for by 'trickle down' *noblesse oblige*. This con-
ceit finds an analogue in a contemporary Jesuit tract on poverty, Daniello
Bartoli's *La Povertà Contenta*. Published in 1650, but doubtless reflecting ideas
current in theological thought in the middle decades of the *seicento*, Bartoli
viewed the poor as idyllically contented since they were free from the sins
afflicting the rich. Indeed, 'the treasure of poverty' was a blessed state.[56]
Commensurately, the rich could receive God's mercy and salvation through
charity.[57] In light of these conceits, Ribera's genial malformed urchin embod-
ies an ideal of poverty. His plea for alms reinforces the generosity and ultimate
redemption of the donors. He is also among the deferential poor, as his doffed
hat, a traditional sign of respect, demonstrates.[58]

The painting of the *Clubfooted boy* has been linked to a now lost picture
depicting a *Dwarf and a dog* (Figure 3.7), dated 1643. To be sure, there are
compositional similarities. Both figures are seen from below and command a
wide expanse of landscape. But it is unlikely that this picture is a pendant to
the *Clubfooted boy*, as has been suggested.[59] The dimensions differ. The *Club-
footed boy* measures almost five and one-half feet by a little over three feet. The
Dwarf and a dog is smaller – only a little under five feet high and a little over

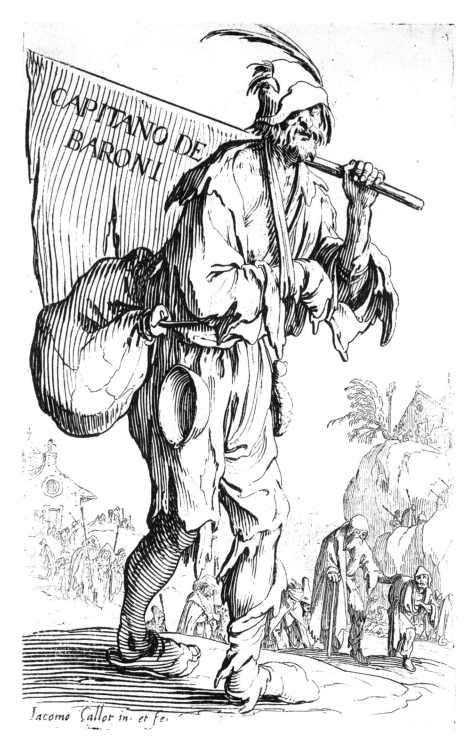

The flag reads: CAPITANO DE BARONI

Jacomo Callot in. et fe.

3.6 Jacques Callot: *Captain of the rogues*, 1622–3

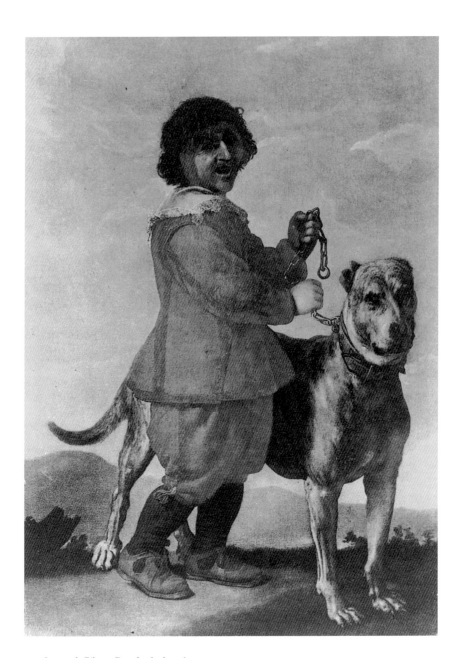

3.7 Jusepe de Ribera: *Dwarf and a dog*, 1643

two and one-half feet wide. And the intent of the two pictures is quite dissimilar. The *Dwarf and a Dog* is not meant to elicit thoughts of charity. Instead, in the piquant contrast of the large dog and small human, and in the complementary relationship of two 'pets' at court, Ribera is following a mirth-provoking formula practised by court artists North and South of the Alps. Accordingly, Karel van Mander III, who worked for the court in Denmark, depicted the bow-legged dwarf Giacomo Favorchi juxtaposed with a huge mastiff in a portrait dated c. 1650 and now in Copenhagen.[60] An anonymous seventeenth-century Spanish artist presents the same formula in a picture in the Prado.[61] And in the sixteenth century, Antonio Moro, the noted portraitist at the Spanish court, depicted the churlish dwarf of Cardinal Granvilla further reduced in size by juxtaposition with his huge canine companion.[62] Indeed, Moro's numerous depictions of dwarfs at the Spanish court establish an interest in the sixteenth century that culminates in the great portraits of the mentally and physically disabled by Velázquez. It is to the court of Spain that we must now turn our attention.

Notes

1. B. de Dominici, *Vite de'Pittori, Scultori, ed Architetti Napoletani*, Naples, 1742, III, 17.

2. W. Jordan and C. Felton, *Jusepe de Ribera, Lo Spagnoletto*, Fort Worth, 1982, 75, figure 66.

3. K. Clark, *Leonardo da Vinci*, Harmondsworth, 1961, 70. See also K. Clark and C. Pedretti, *Leonardo da Vinci Drawings at Windsor Castle*, London, 1968, I, 82–84. It has been suggested recently that these drawings were to be part of an anatomical handbook; M. Kwakkelstein, *Leonardo as a Physiognomist, Theory and Drawing Practice*, Leiden, 1994. Of course, Leonardo's depiction of deformity can also be tied to the comic. See B. Meijer, 'Esempi del Comico figurativo nel rinascimento Lombardo', *Arte Lombarda*, 16, 1971, 259–66.

4. J. Brown, *Jusepe de Ribera: Prints and Drawings*, Princeton, 1973, figure 31.

5. On these studies see A. Bayer in A.E. Pérez Sánchez and L. Spinosa, *Jusepe de Ribera*, New York, 1992, 182, and L. Konecny, 'Shades of Leonardo in an Etching by Jusepe de Ribera', *Gazette des Beaux Arts*, 95, 1980, 91–94.

6. Cf. Jordan and Felton, *Jusepe de Ribera*, 105 on Ribera's affinity with Bolognese art, and J. Milicua in A.E. Pérez Sánchez and L. Spinosa, *Jusepe de Ribera*, 12, for connections to the Farnese.

7. C.C. Malvasia, *Felsina Pittrice* (1678), M. Brascaglia ed., Bologna, 1971, 246.

8. L. Thorndike, *A History of Magic and Experimental Science*, Columbia, 1941, VI, 166–7, VIII, 449. On Polemo, a first century A.D. philosopher, see E. Evans, 'Physiognomy in the Ancient World', *Transactions of the American Philosophical Society*, 59, 1969, 11–15.

9. Thorndike, *op. cit.*, VIII, 449–50, 453.

10. G. della Porta, *Della Fisionomia dell' Uomo*, 258, 434. R. Muzzi in A.E. Pérez Sánchez and L. Spinosa, *Jusepe de Ribera*, 206, also considers the impact of Della Porta.

11. Evans, 'Physiognomy in the Ancient World', 80.

12. See, for example, Caravaggio's *Ecce Homo* in Genoa, and pictures by Valentin, Terbrugghen and Ribera himself. The head-dress and its association with malevolence in Ribera's work has been pointed out by A. Bayer and by J. Brown in A.E. Pérez Sánchez and L. Spinosa, *Jusepe de Ribera*, 169, 183.

13. R. Mellinkoff, *Others: Signs of Otherness in Northern European Art*, I, 164–7. The Dürer may have been inspired by Leonardo's interest in physiognomy. See E. Panofsky, *The Life and Art of Albrecht Dürer*, Princeton, 1955, 115.

14. Tacitus, *Annals*, IV, 57, M. Grant trans., 186, and L. Konecny, 'Shades of Leonardo in an Etching by Jusepe de Ribera', 92.

15. D. Cavalaca, *Specchio di Croce*, Rome, 1738, 213.

16. F. Berni, *Rime*, G, Squarotti ed., Turin, 1969, 190–1.

17. M. Buonarotti il Giovane, *La Fiera* (1618), III, iv, P. Fanfani ed., Florence, 1860, II, 603.

18. J. Brown, *Jusepe de Ribera: Prints and Drawings*, 70.

19. W. Jordan and C. Felton, *Jusepe de Ribera*, 74, figure 64.

20. P. Duchartre, *Italian Comedy*, 214–7.

21. R. Mellinkoff, *Others: Signs of Otherness in Northern European Art*, I, 17 and II, i, 19, iii, 114. See also I.Q. Van Regteren Altena, *Jacques de Gheyn*, I, 52, figure 44 for a drawing by Van Mander depicting a fool reading.

22. C. Bartsocas, 'Goiters, Dwarfs, Giants and Hermaphrodites', *Endocrine Genetics and Genetics of Growth*, C. Papandatos and C. Bartsocas eds, New York, 1985, 3.

23. C. Gaignebet and J.D. Lajou, *Art Profane et Religion Populaire au Moyen Age*, Paris, 1985, 113.

24. F. Merke, *History and Iconography of Endemic Goiter and Cretinism*, Boston, 1984, 266–7, 272.

25. F. Sacchetti, *Il Trecentonovelle*, E. Faccioli ed., Turin, 1970, no. CLXXXII, 496–500. For the interest in Sacchetti in the seventeenth century see *ibid.*, xxiii.

26. B. Castiglione, *Il Cortegiano*, II, xxviii, Novara, 1968, 211, and Merke, *History and Iconography of Endemic Goiter*, 196.

27. U. Aldrovandi, *Monstrorum Historia*, 257.

28. Merke, *History and Iconography of Endemic Goiter*, 260, 328.

29. M. Marqués in A.E. Pérez Sánchez and L. Spinosa, *Jusepe de Ribera*, 213, has called attention to the *commedia dell'arte* features of this drawing, but I believe has misidentified the soldier as Punchinello. L. Konecny, 'An Unexpected Source for Jusepe Ribera', *Source*, XIII, 1994, 24, n. 6, unconvincingly suggests a reworking of the theme of Hercules and the pygmies. Ribera's drawing of a *Standing Figure with Small Figure Holding Banner on His Head* (Metropolitan Museum) has been linked by Konecny (*ibid.* 21–24) to the medieval metaphor of 'dwarfs standing on the shoulders of giants'. Ribera's drawing differs in almost all ways from this conceit. Not only is there no mention of a banner, but the tiny figure also does not stand on the shoulders of the alleged giant. One heel remains on his shoulder, but he is actually sitting on his head. The iconography of the drawing remains problematic.

30. J. Moreno, *Don Fernando Enríquez de Ribera*, Seville, 1969, 74, 76.

31. J. Brown, *Images and Ideas in Seventeenth-Century Spanish Painting*, Princeton, 1978, 38.

32. *Ibid.*

33. Perhaps the duke was aware of other images of bearded marvels and wished to have one for his own collection. See, for example, Sánchez Cotán's portrait of Brígida del Río, the 'Bearded Woman' of Peñaranda, in the Prado. For this painting see E. Orozco Díaz, *El Pintor Fray Juan Sánchez Cotán*, Granada, 1993, 314. Other portraits of this famed 'barbuda' also existed, including one in the collection of the archbishop of Valencia, Juan de Ribera. See L. Konecny, 'Una pintura de Juan Sánchez Cotán, Emblematizada por Sebastián de Covarrubias', *Actas del I Simposio Internacional de Emblemática*, Teruel, 1994, 826. See also the popular print depicting the renowned bearded Helena Antonia dated c. 1600, reproduced in H. Scheugl, *Show Freaks and Monster*, Cologne, 1974, figure 49.

34. Quoted from A.E. Pérez Sánchez and L. Spinosa, *Jusepe de Ribera*, 93.

35. On the identification of the bobbin and spindle as feminine attributes see *ibid.*, 95.

36. Burchardus de Bellevaux, *Apologia de Barbis, Corpus Christianorum*, LXII, G. Constable and R.B.C. Huygens eds, Turnholt, 1985, 59, 86.

37. *Ibid.*, 149.

38. J. Indagine, *Brief Introduction both Naturall, Pleasant and also Delectable unto the Art of Chiromancy or Manual Divination and Physiognomy*, F. Withers trans., London, 1558, n.p.

39. H. Scheugl, *Show Freaks and Monster*, figure 81.

40. J. Evelyn, *The Diary*, A. Dobson ed., London, 1908, 194–5.

41. G. della Porta, *Della Fisionomia dell' Uomo*, 440.

42. A. Henkel and A. Schöne, *Emblemata: Handbuch zur Sinnbildkunst des XVI. und XVII. Jahrhunderts*, Stuttgart, 1967, 977. Cf. L. Konecny, 'Una Pintura de Juan Sánchez Cotán', 827–9, who views the emblem in light of the conceit of hermaphroditism. J. Clifton, '*Ad vivum mire depinxit*: Toward a Reconstruction of Ribera's Art Theory', *Storia dell'Arte*, 83, 1995, 111–32, views the portrait as a paradigm of Ribera's naturalism and does not consider the deeper implications of the picture.

43. A.E. Pérez Sánchez, 'Las Colecciones de pintura del conde de Monterrey', *Boletín de la Real Academia de la Historia*, 174, 1977, 451.

44. *Ibid.*, 445 for the valuation of the Raphael.

45. On the documentary history of the painting see D. Pagano in A.E. Pérez Sánchez and L. Spinosa, *Jusepe de Ribera*, 149.

46. Medical opinion concerning the boy's condition is divided. Some physicians believe that he is suffering from stroke, trauma or a condition known as *amyoplasia congenita*. See G. Simons, *The Clubfoot*, New York, 1994, xi.

47. C.J. Ribton Turner, *A History of Vagrants and Vagrancy and Beggars and Begging*, London, 1887, 555.

48. P. Camporesi, *Il Paese della Fame*, Bologna, 1978, 165.

49. *Il picariglio castigliano, cioe vita del cativello Lazariglio di Tormes*, B. Barezzi trans., Venice, 1635, 74–75.

50. Ribton Turner, *A History of Vagrants and Vagrancy*, 557–60.

51. A. Paré, *On Monsters and Marvels*, 3.

52. On Callot's series see P. Chone et al, *Jacques Callot*, 276.

53. On the 'idle hand' motif see S. Koslow, 'Frans Hals' Fisherboys; Exemplars of Idleness', 418–32.

54. E. Sullivan, 'Ribera's Club-Footed Boy: Image and Symbol', *Marsyas*, 19, 1977–78, 17–21.

55. J. Nieremberger, *Prudential Reflections, Moral Considerations And Stoical Maximes*, London, 1674, VI, 130.

56. Camporesi, P., *Il Paese della Fame*, 12–14.

57. G. Briganti in G. Briganti, L. Trezzani, L. Laureati, *I Bamboccianti*, Rome, 1983, 13.

58. Sullivan, 'Ribera's Club-Footed Boy', 21, believes that the hat is a gift from a charitable donor. But the indigent, as Callot's suite of scruffy beggars demonstrates, often wear hats. See P. Chone *et al.*, *Jacques Callot*, 276–81. Callot's reverent beggar with a rosary also doffs his hat. *Ibid.*, 279 no. 328.

59. A. Mayer, *Jusepe de Ribera*, Leipzig, 1923, 146. J. Baticle, *Trésors de la peinture espagnole*, Paris, 1963, 193.

60. E. Tietze-Conrat, *Dwarfs and Jesters in Art*, New York, 1957, 38.

61. J. López-Rey, *Velázquez, A Catalogue Raisonné of His Oeuvre*, London, 1963, 270 and pl. 414. But cf. A.E. Pérez Sánchez, *Juan Carreño de Miranda*, Avila, 1985, 82, who suggests an attribution of this painting to Carreño.

62. Tietze-Conrat, *Dwarfs and Jesters in Art*, 38.

Spain and the 'hombre de placer'

The Spanish court in the seventeenth century bristled with blemished human-ity – the dwarf, the mentally incompetent court fool, and the morbidly corpu-lent. In his learned catalogue of Spanish court dwarfs and jesters, José Moreno Villa lists over one hundred of them, and a number of first-rate artists, includ-ing Juan van der Hamen and Juan Carreño, were called into service to portray these human oddities either individually or as part of a courtly retinue.[1] Of course, by far the most important artist to paint these court denizens-cum-entertainers was Velázquez, whose renditions of court fools and dwarfs culminated in the magisterial *Las Meninas* of 1656. The art-historical literature devoted to this artist is extensive, and it is full of sympathetic readings of these portraits. Camón Aznar, for example, viewed the portrait of the simpleton Calabazas, now in the Prado (Figure 4.1) as an image rendered with emotional acuity begging for the viewer's sympathy.[2] In the portrait of the dwarf Sebastián de Morra, also in the Prado (Figure 4.2), he saw intelligence and con-centration, nobility and human dignity.[3] Moffitt elaborated on these ideas, suggesting that Velázquez's sympathy for the deformed was allied to his Catholic 'compasio'. Accordingly, the cretinous Calabazas is meant to be per-ceived as 'a tragic individual'.[4]

In his moving description of the jester and dwarf portraits Jonathan Brown epitomizes the empathetic view. The portrait of Calabazas is 'subtle, haunting, and strangely moving, uncompromisingly realistic, but tinged with feeling'. The portrait of the dwarf Acedo in the Prado (Figure 4.3) radiates 'dignity and stature'.[5] And in a long and passionate discussion of Velázquez's portrayal of dwarfs and jesters Gudiol concluded:

In facing this suffering, deformed aspect of humanity he shows the feeling of protest that Goya, in very different ways, was to make one of the principal signs of his art. Velázquez's humanism always led him to treat the portrait of the figures of fun with as much objectivity and even dignity, as if they were ordinary normal people or even

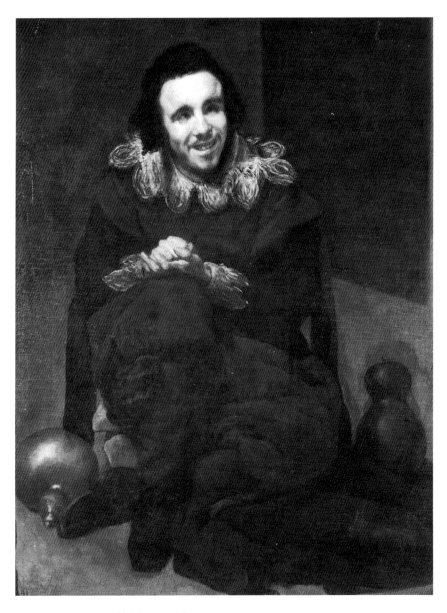

4.1 Velázquez: *Portrait of Calabazas*, c. 1638

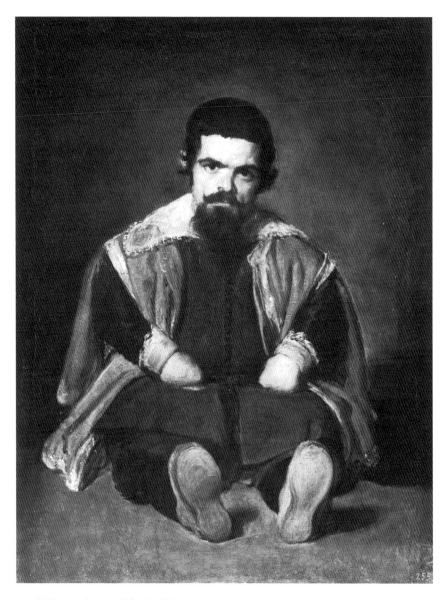

4.2 Velázquez: *Portrait of Sebastián de Morra*, c. 1645

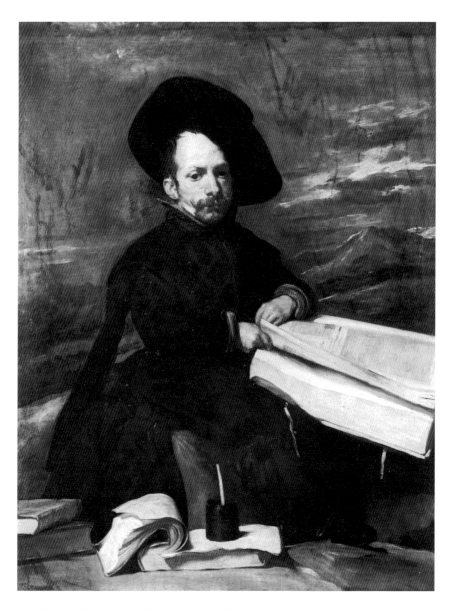

4.3 Velázquez: *Portrait of Don Diego de Acedo*, c. 1636–8

important personages. In not one of these pictures do we find the slightest trace of irony or of an attempt to ridicule the sitter.[6]

These eloquent testimonies to Velázquez's empathy, prompted perhaps by his sober presentation, are at odds with the predominant historical view of the dwarf and court fool. Indeed, there are a number of mocking references in Spanish texts to both the dwarf and the fool. The early seventeenth-century lexicographer and emblematist Sebastián Covarrubias, who held the canonry at Cuenca and was surely no less Catholic in his attitudes than Velázquez, soberly defined the Spanish attitude toward the dwarf and the clown in his *Tesoro de la Lengua Castellana* published in 1611. For 'buffoon', the term used to characterize the images of Acedo and the dwarf Francisco Lezcano in the early inventories, Covarrubias listed as synonyms 'truhán' (knave), 'chocarrero' (low jester), 'morrián' (empty-headed), or 'bobo' (fool). The word's derivation is to be found in the Latin 'bufo', signifying 'sapo' (toad) or 'rana terrestre' (earth frog). The buffoon, accordingly, was associated with a 'useless thing, lacking in judgement and wisdom'.[7] For Covarrubias the dwarf was no less reprehensible. Indeed, the very oddity of the dwarf allowed for jocularity:

The dwarf has much that is monstrous. Therefore it is natural to wish to make of it a plaything of mockery like other monsters. These monsters, like all the others that are bred for curiosity, are for your pleasure: they are in point of fact a nauseating thing and abominable to any man of intelligence.[8]

Covarrubias' comments, freighted with value judgements and flavoured with the conceits of mockery, suggest that cruel and derisive laughter was commonplace in seventeenth-century Spain when appraising the dwarf and court fool. Indeed, laughter at the expense of physical or mental misfortune was apparently a rather ordinary occurrence in the 'Golden Age'. The royal family clearly took fun in the 'hombres de placer' (men of pleasure) and 'sabandijas' (worms or little people).[9] Indeed, dwarfs and buffoons were presented to the Princess Mariana for her amusement. I must add that she was rebuked, but not because she had laughed. She had laughed too loudly and thus violated Spanish demands for decorous restraint.[10] The poignant account of the humiliation and self-debasement of the jester Mosen Borra at the coronation of Fernando el Honesto in 1414, which resulted in the monarch's 'great pleasure', indicates that there was a long tradition of cruel amusement.[11]

Indeed, Spanish literature also took a perverse turn at malign fun. Consider, for instance, the picaresque novel *Lazarillo de Tormes*. In this comic tale of roguish adventure, little Lazarus undergoes a variety of physical torments from his blind master. First, outside of Salamanca, Lazarillo is told that he will hear a wondrous noise inside a stone bull. Unsuspecting, the youth bends to hear this sound and has his ear bashed against the statue. The blind man

laughs malevolently at this joke.[12] In a later episode he maliciously knocks some of Lazarillo's teeth out with a wine jug.[13] These cruel incidents are referred to as 'burlas' (jokes).[14] But Lazarillo is not simply a hapless victim. The blind man is cruelly repaid in the mud-drenched streets of Toledo where during a violent rainstorm Lazarillo deliberately leads him into a stone post. The blind man is left gurgling in the puddles.[15] This is flinty humour indeed, and so is Quevedo's amused delight in describing deformity in *El Buscón*. In Book II, chapter ii, Pablos, the young *pícaro*, has found his way to a flophouse inhabited by scrofulous and limbless beggars whose contorted antics in getting dressed provoked amusement. The very deformity that resulted from their patching themselves together – one looked like an upside down five, another like a backward L – reminded Quevedo of the comic distortions of pictures by Bosch.[16] Quevedo, indeed, could be especially virulent in his characterization of deformity. Accordingly, in his satiric skewering of the hunchbacked Juan Ruiz de Alarcón, Quevedo compared him to a pitchfork, a bundle of pressed wool, and cat dregs.[17]

It was the dwarf, particularly, that bore the brunt of unsympathetic literary epithets. Góngora, a poet well-known by Velázquez, derided the dwarf Bonami in a mocking epitaph:

> the dwarf could not avail
> himself of more space in a worm
> than Jonah in the whale.[18]

Don Antonio de Solis y Rivadeneyra, playwright and poet in mid-seventeenth-century Madrid, ridiculed a bow-legged dwarf as an orthographic mistake of nature, merely a period placed between two commas.[19] Luis de Antonio's poem of 1658, *Contra un enano muy enamorado*, clearly articulated the court attitude towards such deformity:

> No good should be expected
> from those who are so low,
> from thoughts so very little
> Nothing big can grow.[20]

These mean-spirited cultural mores, fostered in an age of fatalistic cruelty and random violence, intrude upon Velázquez's imagery.[21] The portrait of the young heir to the throne, Baltasar Carlos, accompanied by a dwarf (Figure 4.4), now in the Museum of Fine Arts, Boston, is a case in point. The prince is rigidly vertical, his immobilely erect posture a sign of his élite status.[22] The dwarf, in contrast, lolls his head to the side, a traditional characteristic of the indolent.[23]

If Velázquez's intent to counterpoise the firm with the infirm is clear, the

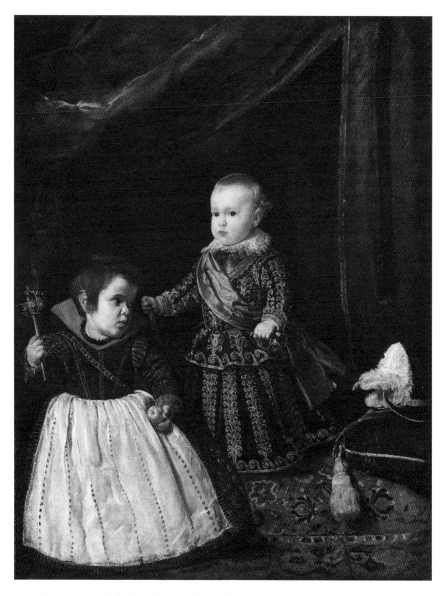

4.4 Velázquez: *Portrait of Baltasar Carlos with dwarf*, 1631

portrait is the subject of some controversy regarding date and purpose. The traditional date of 1631, suggested by the inscription AEtatis AN. . . Mens 4, a presumed allusion to the prince's age of sixteen months, has been challenged by Jonathan Brown. He argues that the inscription, fragmented in the middle of the word Annus, reveals no number to demonstrate Baltasar Carlos' age. In fact, he believes that the prince appears older than sixteen months. Accordingly, Brown suggests a date of 1632 for the portrait, allying it to the 'juramento' – the oath of allegiance sworn by the prince in the church of San Jeronimo at the age of two years and four months. Velázquez's representation of the prince in military garb apparently conforms to the costume worn by Baltasar Carlos at this ceremony. He also had a black hat with white feathers. Velázquez has depicted this hat lying conspicuously at his side. According to Brown, the dwarf holding an apple and a rattle represent the childish world that the prince renounced as heir to the throne.[24]

There are, however, arguments that counter Brown's seductive hypothesis. The erect, stiffly postured prince may appear to adopt a pose beyond the capabilities of a child of sixteen months of age, but his rigid verticality is, as we have seen, conventional. Indeed, his pose is echoed in Velázquez's portrait of Prince Felipe Prosper dated 1659, now in Vienna. Felipe Prosper, born 20 November 1657, is approximately the same age as Baltasar Carlos if the Boston portrait is correctly dated 1631.[25] Also, the costume worn by Baltasar Carlos is not in complete accord with the one the prince wore at the 'juramento'. There is one important discrepancy; the prince lacks the jewelled dagger mentioned in an eyewitness account of the ceremony.[26] Moreover, the black hat with white feathers is not solely associated with the 'juramento'. An identical cap appears in Velázquez's portrait of the young Baltasar Carlos, now in the Wallace collection.[27] Accordingly, the hat may be merely part of the prince's standard costume. Finally, the dwarf does not necessarily represent the childish world that the prince will forsake. Instead, I believe, Velázquez is elaborating upon a formula of contrast used with some frequency in Spanish court portraiture. Consider, for example, Sánchez Coello's portrait of Doña Juana Mendoza, Duchess of Bejar, with her dwarf, of c. 1585, in a private collection.[28] The duchess, perhaps six or seven years old, towers over her dwarf attendant. She stands in a pose of upright propriety while her submissive dwarf attendant, looking up at her with canine adoration, offers her an elegant little pitcher. In a portrait of the Infanta Isabel Clara Eugenia with the court dwarf Magdalena Ruiz (Figure 4.5), datable c. 1585–1590 and now in the Prado, the formula is reiterated.[29] The princess, erect and elegant in her Belgian lace collar, looms over the benighted Magdalena. She places her hand atop Magdalena's head, a gesture that implies not only protection but also dominance. Magdalena is like some court pet, and the monkeys that alight on her arms confirm the dwarf's base nature. Similarly, a portrait of Philip IV by

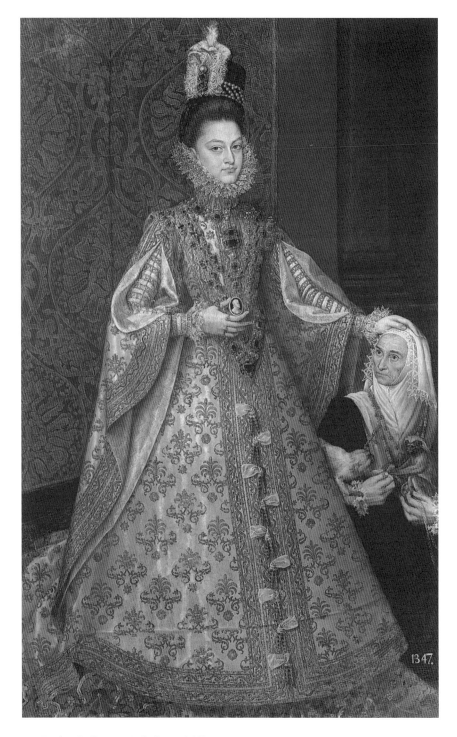

4.5 Sánchez Coello: *Portrait of Infanta Isabel Clara Eugenia*, c. 1585–90

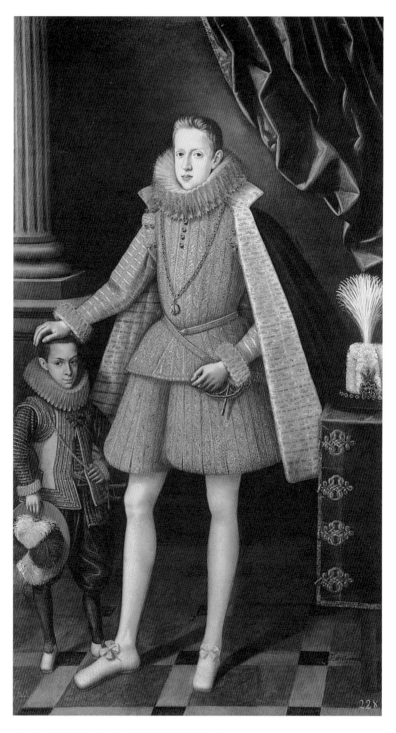

4.6 Roderigo Villandrando: *Portrait of Philip IV*, c. 1621

Roderigo Villandrando, c. 1621, in the Prado (Figure 4.6), presents the court dwarf, derogatively named Soplillo (Bellows), as being under his dominion.[30] In Velázquez's portrait the conceit of dominance is not as overt. But the idea of the prince's superiority is manifest in innumerable ways. The dwarf is placed on a lower physical plane. He holds an apple and a rattle, no doubt mocking refractions of the royal orb and sceptre. Velázquez may be following an established court tradition in this derisive contrast. Francesco Laurana's medal of the foolish jester Triboulet carries the inscription: 'The regal vestments mock me the king's fool with office and they clothe me, the laughing-stock with alluring charm'.[31] Velázquez probably did not know this medal, but the conceit it expressed was doubtless a commonplace. The apple and rattle also relate to the prince's attributes of military power, the baton and sword. But they invert these regal symbols. Indeed, Velázquez may be using the apple in a punning sense, since 'manzana', apple, is also equivalent to the pommel of a sword.[32] The rattle, because of its hollowness, was traditionally a sign of emptiness.[33] And as parodic inversions of royal accoutrements the apple and rattle call attention to the traditional metaphor of the world in reverse. Indeed, the dwarf is a quintessential part of that world, as the Spanish writer Baltasar Gracián revealed in his vast allegory of human folly, *El Criticón*, where a dwarf wishes to be a giant.[34]

The contrast of prince and dwarf, magnificence and insignificance, is also found in *Baltasar Carlos in the Riding School* of c. 1635, in the Duke of Westminster's collection (Figure 4.7). This picture has had its detractors, but the vivacious brushwork is clearly in accord with Velázquez's style.[35] The painting aggrandizes the prince as noble horseman. His proper training is depicted under the guidance of the minister Olivares, the master of the hunt Juan Mateos, and an aide, Alonso de Martínez de Espinar, the author of a book devoted to hunting and riding.[36] The royal family looks on from the balcony. The dwarf in this picture serves as an interlocutor. He gazes out at the spectator and points to the future sovereign, suggesting by his own reverence what the viewer's response should be.

The portrait of the moronically grinning fool Calabazas, now in Cleveland (Figure 4.8), is also a controversial picture. Rejected by, among others, Brown, Steinberg, Moffitt and Trapier, the portrait also has its supporters, including most recently Gállego.[37] Perhaps the eighteenth-century writer Ponz was correct when he discussed this painting as 'in the manner of Velázquez'.[38] Indeed, the handling of the painting calls the attribution to Velázquez into question. Consider the painting of the figure's hands. His left hand does not hold the pinwheel, a symbol of madness, in a convincing way. His right hand, which is further back in space, is illogically almost as large as the figure's feet, which are in the foreground.

As a type, however, the picture reflects traditional derisive presumptions.

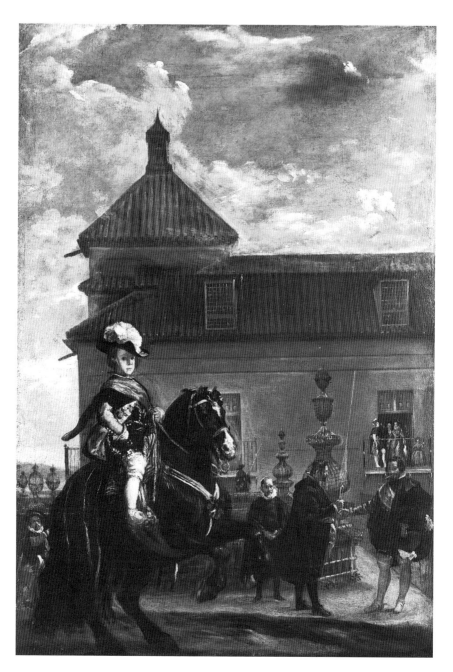

4.7 Velázquez: *Baltasar Carlos in the Riding School*, c. 1635

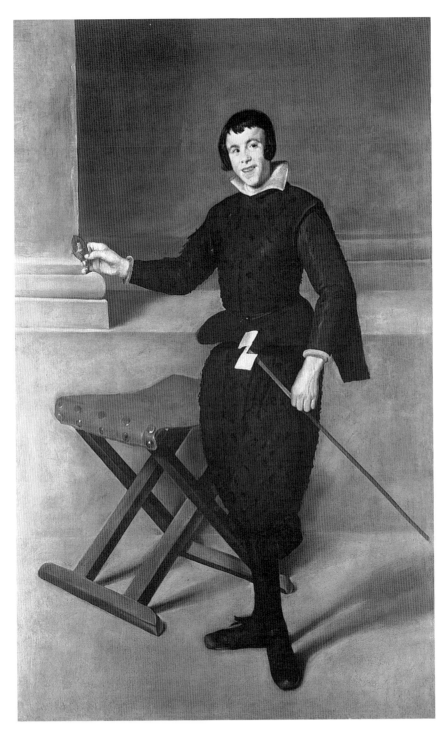

4.8 Velázquez (attrib): *Portrait of Calabazas*, n. d.

Indeed, Moffitt's rejection of the painting on the basis of the image's reliance upon Ripa's emblem of madness, a motif which he believes is not in accord with Velázquez's sympathetic approach to the 'hombre de placer', is, in the light of court attitudes, untenable.[39] A mentally enfeebled character like Calabazas is part of the cast of human oddities that could bring pleasurable amusement to the court. Indeed, Calabazas is given a little folding chair which, by contrast with the elaborate armchair reserved for royalty and depicted so frequently in juxtaposition with the king and prince underscores his lowly status.

If the attribution of the Calabazas portrait in Cleveland is moot, it is unanimously agreed that Velázquez painted a portrait of Calabazas in the late 1630s (Figure 4.1) which may have been in the Torre de la Parada, the king's royal hunting lodge.[40] Hung in the royal pleasure retreat, Calabazas' image could remind the king and his fun-loving retinue of the amusement that the real Calabazas provided. Calabazas is seated on a low stool, emphasizing his low status. His head is turned upward and his eyes are clouded, as if he is perceiving us through a dim fog. Since he cranes his head to look up, presumably at us, we are above him physically, and by implication intellectually and morally as well. And Velázquez's witty augmentations underscore Calabazas' character. Calabazas is juxtaposed with a gourd, a derisive reference to the vegetable that serves as his namesake. Indeed, the upright gourd takes on an anthropomorphic shape, echoing in its contours the bell-like form of Calabazas. The mockery is heightened by the symbolic associations of the nickname. For Covarrubias the calabash gourd was an emblem for those who sought protection or favour from a powerful person, but one who fell into disfavour and withered.[41] In the foreground is a glass of wine. Doubtless this refers to the custom of making the court fools inebriated for the amusement of the courtiers. A Florentine dispatch from the court at Madrid, dated 1636, records that the clowns were 'plied with drink in order to make them more apt for jesting and being made fun of'.[42] The tipped-over gourd near Calabazas may suggest his own near-tipsy state. Velázquez adds a mocking and ironic touch in his depiction of Calabazas' hand gesture. With his right fist clasped in the palm of his left hand, Calabazas is using the gesture associated with chiding, brawling, reproach, and foul language.[43] His action is appropriate to the 'truhán', who according to Covarrubias is 'without shame, honour, and respect', and says things to suit his whims with impunity.[44] Velázquez has captured the essence of this moronic clown, and with reportorial accuracy depicts the irony of mockery offered by the mocked. Once again the world has been turned upside down.

Ironic contrast also lies behind Velázquez's depictions of the dwarfs Francisco Lezcano (Madrid, Prado, Figure 4.9), 'El Primo' (Don Diego de Acedo) and Sebastián Morra. Lezcano's dwarfishness is emphasized. His

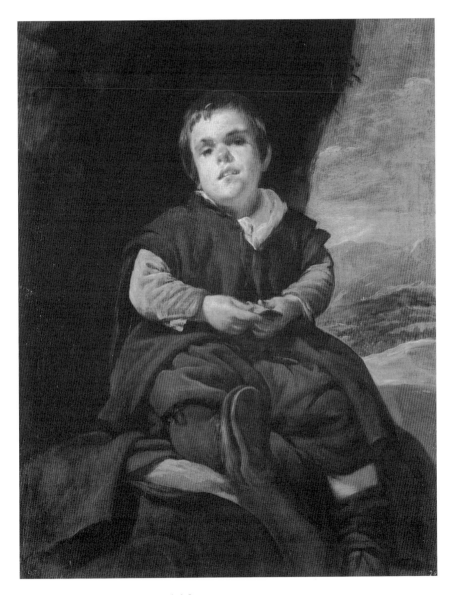

4.9 Velázquez: *Francisco Lezcano*, c. 1636–8

too-short legs are contrasted with his large head and stumpy body. This is a torpid figure. His head lolls and he mindlessly handles a deck of cards. Since his small hands make it difficult to handle and shuffle a deck, the cards call attention to his handicap. Cards, as Spanish proverbs tell us, are also associated with folly.[45] Since the inventory reference to this painting lists it as a 'buffoon with a pack of cards', the cards are an appropriate attribute for this foolish clown.[46] Indeed, this is a commonplace. Velázquez may be following the precedent established in Moro's portrait of Pejerón (Madrid, Prado, Figure 4.10) where the buffoon's serious mien is contrasted with his attribute of folly, the cards.[47] Unlike Pejerón, Lezcano is posed against a dark precipice. This may localize the figure in the mountainous region around the Torre de la Parada. A rocky abutment, likewise, provides a pictorial contrast, as the dwarf's luminous head is highlighted against the dark background. But since Covarrubias places his definition for precipice, 'despeñadero', under the rubric 'despeñarse' which he defined as a foolish undertaking, the juxtaposition against a precipice may have a punning significance alluding to the dwarf's folly.[48]

The portrait of Don Diego de Acedo, the so-called 'El Primo' (Figure 4.3), was meant to hang as a complement to the Lezcano portrait at the Torre de la Parada.[49] Here, along with the portrait of Calabazas, these images could provide visual amusement for the king and his retinue while they relaxed at the royal pleasure retreat. Acedo's serious demeanour seems to belie any mocking content. Indeed, surrounded by his books and writing paraphernalia, he seems to radiate the dignity associated with his position in the secretaryship. But it is likely that his position in that office was not one of great responsibility. Instead, he served as a handler of correspondence. Indeed, as Moreno Villa points out, an elaborate costume was made for the dwarf so that he could serve as a kind of elegant mailman. Thus the file of the Tailors and Particular Accounts records: 'He made for the dwarf D. Diego de Hacedo, to dress as handler of correspondence, a campaign cloak, decorated with broad passementerie of false gold . . .'[50] Additionally, as we have already seen in the portrait of Pejerón, solemnity can be consonant with the clown's persona. It serves as a parodic means to convey mocking intent and the conceit of the world turned topsy-turvy.

Velázquez reminds us of Acedo's handicap in a variety of derisive ways. His dwarfishness is clearly emphasized by the contrast of the huge books sliding off his diminutive lap, and his tiny hands. And his dwarfishness is given an ironic visual twist through the juxtaposition of the looming, apparently monumental shape of Acedo and the tiny mountain in the background. True scale has been wittily compromised here and a humour based upon contrary relationships has been emphasized. For the arbiter of literary theory in Golden Age Spain, Alonso López Pinciano – a copy of his book on poetic

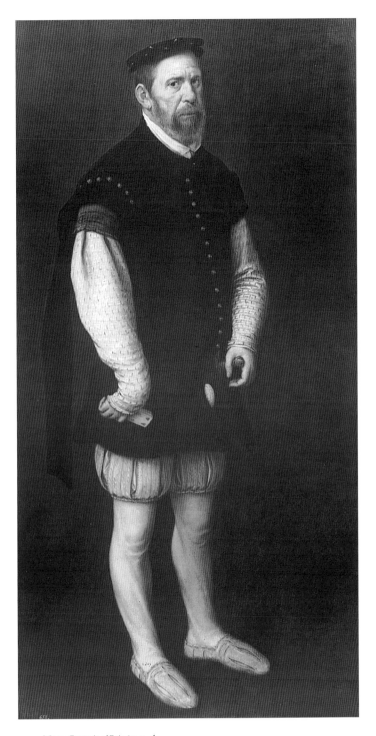

4.10 Moro: *Portrait of Pejerón*, n. d.

CENTVRIA II. 118

EMBLEMA. 18.

4.11 Sebastián Covarrubias: *'Abeunt in Nubila Montes'*, from the *Emblemas Morales*, 1610

theory was in Velázquez's library – it is this type of unexpected and ridiculous juxtaposition that provokes laughter.[51] The oxymoronic appellation 'El negro Juan Blanco' (the black John White), a clear manifestation of 'the world turned upside down', belongs to this type.[52] And Lucian's comic *The Fly*, also cited by López Pinciano, is another example. In this ludicrous contrast of the diminutive and the huge, the humorous reversal results in 'making an elephant out of a fly'.[53] But Velázquez may have used the mountain for other mocking reasons. Perhaps he was aware of how a mountain was derisively linked to the court dwarf of Philip II who was given the twitting sobriquet 'Montagna'.[54] And the conceit of 'the world turned upside down', so strongly in evidence in this picture, is underscored by an emblem in the *Emblemas Morales* published in 1610 which uses the mountain made small to exemplify the reversible world.[55] Or, again, the anthropomorphic associations of the mountain cited in Covarrubias could have provided Velázquez with another point of departure. For Covarrubias a mountain possessed a head, shoulders, and was even,

presumably, dressed in 'faldas' (a train). Accordingly, the metaphor of expecting to be a mountain, but being born a small rat, 'pequeño ratón', was commonly used as a derisive contrast to signify a man who seemed more than he actually was.[56] In the *Emblemas Morales* (Figure 4.11) we find a similar conceit. The text of the emblem recounts that mountains are barren. Their cloud-covered peaks are synonymous with fools who cover their simplicity with their presumed grandeur.[57] We are reminded that the inventory reference to the Acedo portrait referred to it as 'un bufón' dressed as a philosopher.[58] This description of a clown decked out to simulate a scholar defines the meaning of the portrait.

Acedo's nickname, 'El Primo', has been translated as cousin, a jocular reference to a putative relationship to Velázquez himself.[59] But this name has a number of other connotations. It also refers colloquially to the royal family, and thus 'El Primo' may suggest an ironic allusion to Acedo's pretentiousness. Additionally, 'El Primo' means silly or foolish, a sobriquet that is also applicable to the dwarf.[60]

Acedo's character provided another form of amusement for the court. A notorious ladies' man, he reputedly even had a romantic liaison with the wife of a courtier.[61] The comic possibilities of this affair would have appealed to a court that delighted in visual and literary examples of cuckolding. This aspect of Acedo's proclivities may be suggested by the pen in the inkwell, boldly illuminated in the foreground. To be sure, these are instruments that can be associated with the dwarf-cum-philosopher. But the metaphor of pen and inkwell has libidinous connotations. Indeed, it takes on a highly charged sexual significance in the anonymous erotic poem from the seventeenth-century riddle book, *Libro de diferentes Cosicosas*. Here the pen is 'large, smooth, and hard' and is placed in 'a concavity deep and dark'.[62] Additionally, the phrase 'la pluma en tintero' (the pen in the ink) was sometimes used synonymously with copulation.[63]

The character of Sebastián de Morra is also wittily suggested in Velázquez's portrayal of the dwarf (Figure 4.2). Known for his attraction to military paraphernalia – he was left a knife, a dagger, and two swords by Baltasar Carlos – his pose reflects his truculent manner.[64] With his arms placed akimbo, Morra apes the aggressive poses given to military figures.[65] But this is a parody of the traditional military type, and Velázquez's point of departure may have been a comic print by Hopfer, where the famous sixteenth-century German clown Kunz von der Rosen (Figure 4.12) adopts a bellicose stance.[66]

Velázquez may have conflated these conceits with the comic idea of the militant dwarf found in literature. Philostratus conjured up an image of the comic pygmy warrior in the *Imagines*.[67] Doubtless Juan Van der Hamen's portrait of a belligerent dwarf (Madrid, Prado, Figure 4.13) was also known to Velázquez.[68] Both figures, whose sham bravado is contrasted with actual physical capability, represent the world inverted. Velázquez underscores

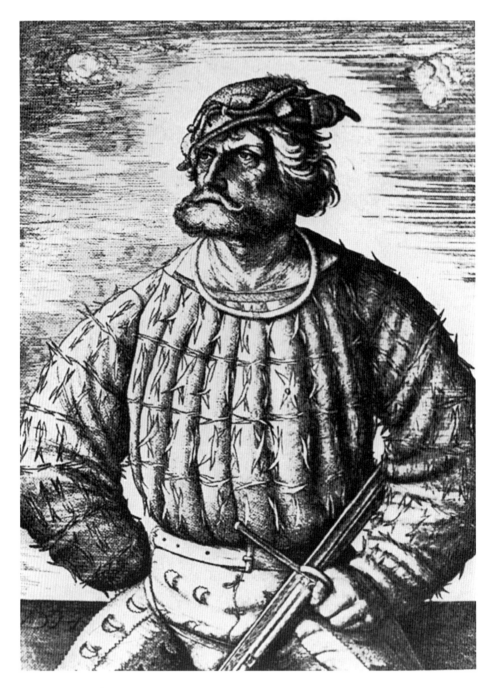

4.12 Hopfer: *Kunz von der Rosen*, c. 1515

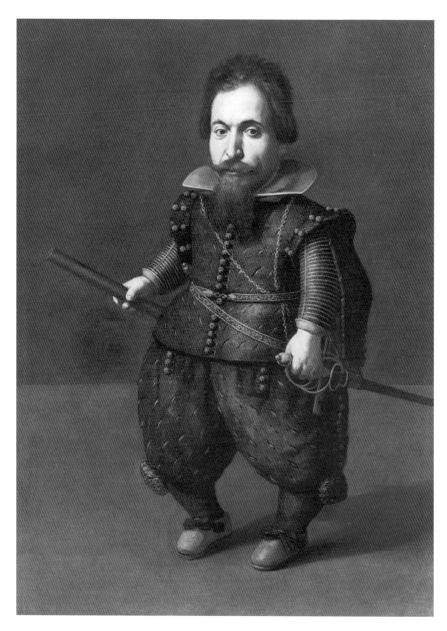

4.13 Juan Van der Hamen: *Portrait of a dwarf*, c. 1625

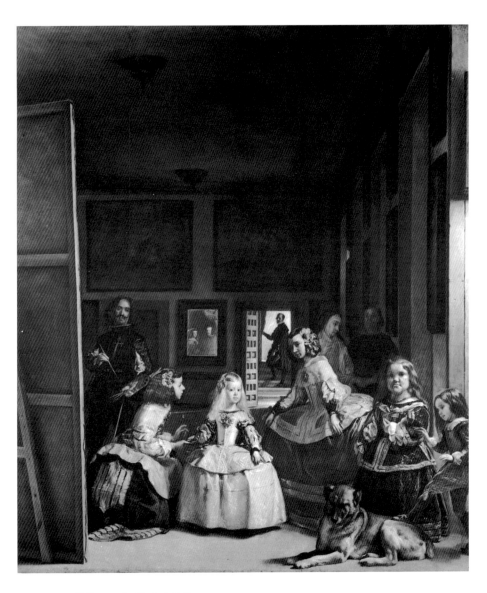

4.14 Velázquez: *Las Meninas*, 1656

Morra's dwarfishness by the foreshortening of his legs, and thus his fierceness is undermined by his obvious physical shortcomings. Ironic paradox is meant to provoke laughter. Indeed, when seen in its unaltered state – unfortunately the picture has been cropped – the comic aspects must have been emphasized. A replica shows this bellicose dwarf accompanied by a large wine jug, reminding us how the court viewed the drunken dwarf as a source of amusement.[69]

Velázquez returned to the painting of dwarfs in one of his late, great works, *Las Meninas* of 1656 (Figure 4.14). Much has been written of this painting, concerning its ambiguities, its setting and its possible references to Velázquez's aspirations to nobility.[70] To be sure, with the chamberlain's key at his side – a symbol of his influential position at court – and his inclusion among the royal family, Velázquez's important status is revealed. This status is embellished by Velázquez's palette bearing the colours of Apelles, red, black, yellow and white.[71] And if Velázquez is the new Apelles, his Alexander in the persona of Philip IV visits the studio. But why has Velázquez included portraits of the midget Nicolas Pertusato, playfully treading on the mastiff's haunch, and the solemn dwarf María Bárbola? One could argue that they, like the maids of honour who give the painting its present name, are part of the *infanta*'s retinue, and thus are yet another manifestation of Velázquez's concern for quotidian reality. Perhaps they are there to amuse the *infanta*. But in a painting freighted with metaphors concerning the skill and status of the artist, this explanation seems simplistic. Perhaps, as in other images, the traditional formula of antithesis between firm and infirm is presented. Perhaps, too, the dwarfs are present to show Velázquez's facility in portraying all facets of nature, ranging from the lower life-forms – the dog, Bárbola, and Pertusato – to the august – the *infanta*, and the king and queen, who are reflected in the mirror on the wall. There is an analogue for this conceit in Northern art. In Jan Molenaer's *Artist's studio* of 1631, in Berlin, Staatliche Museum (Figure 4.15), an array of diverse characters – a dwarf, a dog, a hurdy-gurdy player, a jester, and a woman – are depicted on the canvas hanging on the easel and within the space of the artist's studio itself. Velázquez probably did not know this picture, but the conceit of the artist's mastery over various aspects of nature must have been a commonplace.

Of course, since dwarfs were an integral part of courtly life in Spain, they were often depicted as faithful retainers or as accessories to the royal persona. For example, dwarfs are relegated to the background of two portraits, Doña Margarita of Austria and Doña Mariana of Austria, by Velázquez's son-in-law, Mazo.[72] And among the welter of figures in Francesco Rizi's monumental *Auto de Fe*, dated 1680, are dwarf buffoons.[73] Portraits of individual dwarfs were still produced in the closing decades of the seventeenth century. Carreño's portrait of the dwarf Michol (Figure 4.16), dated c. 1680 and now in the Meadows Museum, Dallas, continues the conceit of the dwarf as laughable

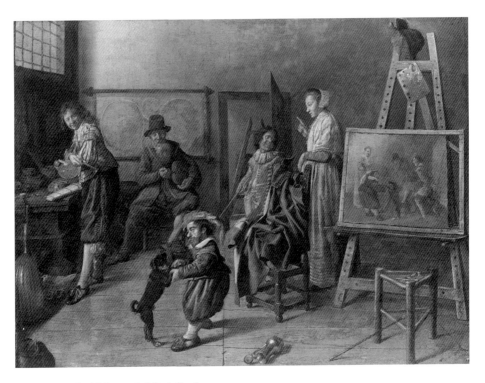

4.15 Jan Molenaer: *Artist's studio*, 1631

curiosity. Surrounded by exotic birds, toy dogs, and luscious fruits, the dwarf holds a cockatoo that is nearly half his size.[74]

But the Spanish taste for *terata* extended beyond dwarfs and the mentally feeble. In 1680 an enormously corpulent young girl, Eugenia Martínez Vallejo, known as *La Monstrua*, arrived at court. She was viewed as a wondrous curiosity – the six year old weighed five *arrobas* (125 pounds) – and because of her unusual girth the court painter Juan Carreño was commissioned to paint two portraits of her.[75] Carreño's student, the painter and biographer Antonio Palomino, discussed one of these portraits (Figure 4.17), a nude image of the girl in the guise of Bacchus which was hung in the king's apartments with other pictures of 'the Palace lowlife'.[76]

Hefty women were not unusual in the seventeenth century. Indeed, some fleshiness was viewed as a desirable trait. Accordingly, William Sanderson in the treatise *Graphice*, published in 1658, noted that a beautiful woman was to have 'a noble neck, round rising, full and fat…brawny arm of good flesh. Such a lady possesses a goodly plump fat'.[77] But on a child colossal corpulence was freakish. And in her enormity 'La Monstrua' could serve as a human analogue

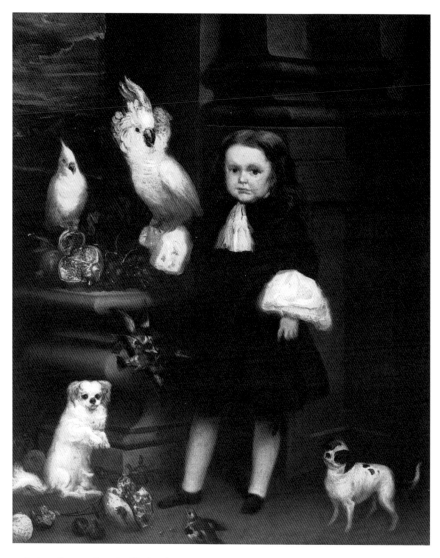

4.16 Juan Carreño: *Portrait of the dwarf Michol*, c. 1680

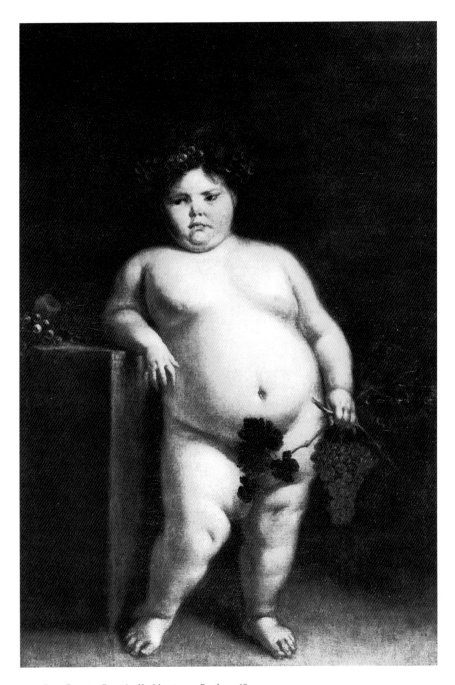

4.17 Juan Carreño: *Portrait of La Monstrua as Bacchus*, 1680

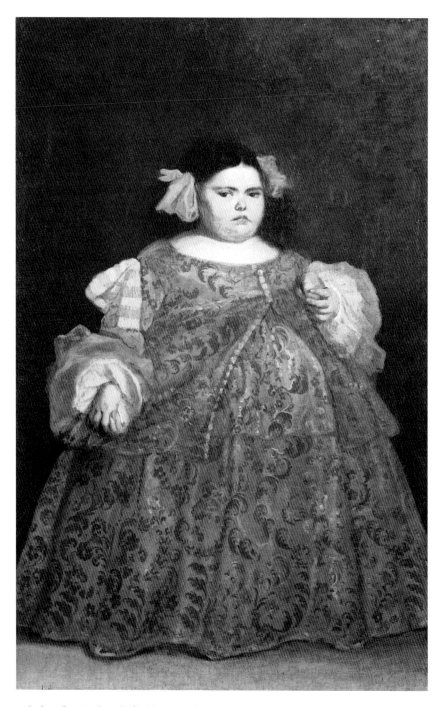

4.18 Juan Carreño: *Portrait of La Monstrua,* 1680

to allegorical figures of 'Gula', traditionally presented as monstrously fat.[78] As Bacchus she also provides a witty counterpoint to the obese image of the wine god in the *Triumph of Bacchus* designed by Rubens for the Torre de la Parada.[79] When she is dressed, 'La Monstrua's' girth is no less demonstrable (Figure 4.18). She squeezes out the empty space of the canvas. Her appetite may be alluded to by the two fruits she carries in her fleshy hands.[80]

It is ironic, however, that the king who commissioned these portraits, Charles II, was himself feeble and retarded. Known as 'Carlos the Bewitched' because of his sickly constitution, he was unable to walk until he was more than four years old. In 1686, at the age of twenty-five, he was vividly described by the papal nuncio:

He cannot stand upright except when walking, unless he leans against a wall, a table or somebody else. He is as weak in body as in mind. Now and then he gives signs of intelligence, memory, and a certain liveliness, but not at present. Usually he shows himself slow and indifferent, torpid and indolent, and seems to be stupefied.[81]

Through an accident of birth, this slack-jawed specimen of infirmity escaped inclusion among the 'palace lowlife'.

Notes

1. J. Moreno Villa, *Locos, enanos, negros y niños palaciegos*, Mexico City, 1939, 45–51.

2. J. Camón Aznar, *Velázquez*, Madrid, 1964, II, 614.

3. *Ibid.*, 668.

4. J.F. Moffitt, 'Velázquez, Fools, Calabacillas and Ripa', *Pantheon*, XL, 1982, 308.

5. J. Brown, *Velázquez, Painter and Courtier*, New Haven and London, 1986, 154.

6. J. Gudiol, *Velázquez*, New York, 1974, 207. Many other scholars hold similar views. M. Serullaz, *Velázquez*, New York, 1981, 126, claimed that the dwarf portraits were painted with 'a certain feeling for humanity'. E. du Gué Trapier, *Velázquez*, New York, 1948, 319, contended that Velázquez 'was not famed for his wit'. Only López-Rey, *Velázquez, A Catalogue Raisonné*, 77–78 and reiterated in *Velázquez The Artist as Maker*, Lausanne-Paris, 1979, 90, recognized a humorous aspect in the portraits of the court dwarfs and fools. According to López-Rey the artist emphasized the 'comical and stupid traits and gestures', presenting us with an image of the court's delight in 'cloddish zanies'. But cf. L. Steinberg's emphatic rejection of this idea in his review of López-Rey's book, *Art Bulletin*, XLVII, 1965, 293.

7. S. Covarrubias, *Tesoro de la Lengua Castellana* (1611), M. de Riquier ed., Barcelona, 1943, 243.

8. *Ibid.*, 511. Cf. *Diccionario de la Lengua Castellana*, III, Madrid, 1732, 423, where the dwarf is equated with a 'mistake of nature'.

9. J. Deleito y Pinuela, *El rey se Divierte*, Madrid, 1964, 121.

10. M. Hume, *The Court of Philip IV*, New York and London, 1907, 414.

11. N.D. Shergold, *A History of the Spanish Stage from Mediaeval Times until the End of the Seventeenth Century*, Oxford, 1967, 121.

12. *La Vida de Lazarillo de Tormes*, J. Cejado y Frauca ed., Madrid, 1941, i, 77.

13. *Ibid.*, 98.

14. *Ibid.*, 103.

15. *Ibid.*, 105.

16. F. Quevedo, *Obras (Prosa)*, I, F. Buendía ed., Madrid, 1961, 324.

17. Quevedo, *Obras (Verso)*, II, F. Buendía ed., Madrid, 1961, 437.

18. L. Góngora, *Obras Completas*, J. Mille y Giménez and I. Mille y Giménez eds, Madrid, 1967, 360.

19. A. de Solis y Rivadeneyra, 'A un enano estevado', in *Biblioteca de Autores Españoles, Poetas Líricos de los Siglos XVI y XVII*, 42, A. de Castro ed., Madrid, 1951, 444.

20. L. de Antonio, *Nuevo Plato de Varios Manjares Para Divierto el Ocio*, Zaragoza, 1658, 9–10.

21. For a discussion of the harsh tone of humour in the period see H. Miedema, 'Realism and Comic Mode: The Peasant', *Simiolus*, 9, 1977, 205–19. Distancing from human suffering is, in fact, quite common in Quevedo's description of deformity. J. Iffland, *Quevedo and the Grotesque*, London, 1978, 102.

22. On body positioning and status see G. Vigarello, 'The Upward Training of the Body from the Age of Chivalry to Courtly Civility', *Fragments for a History of the Human Body*, New York, 1989, II, 141–96. Gállego's suggestion, (A. Ortiz, A.E. Pérez Sánchez, J. Gállego, *Velázquez*, New York, 1989, 171) that the rigid pose underscores the conceit that the prince is depicted as a 'picture within a picture' is untenable. However, to my mind he is correct to dismiss Brown's (*Velázquez, Painter and Courtier*, 290, n. 31) suggestion that the dwarf is female. The apron is standard costume for both males and females in the period. Cf. for example, Velázquez's portrait of the aproned Felipe Prosper in Vienna.

23. Vigarello, *op.cit.*, 152.

24. J. Brown and J.H. Elliot, *A Palace for a King*, New Haven and London, 1980, 253–4 and reiterated in *Velázquez, Painter and Courtier*, 83.

25. On this portrait see J. López-Rey, *Velázquez, A Catalogue Raisonné*, 234.

26. Brown, *A Palace for a King*, 254.

27. For this painting see López-Rey, *Velázquez, A Catalogue Raisonné*, 226.

28. For this portrait see A.E. Pérez Sánchez and J. Gállego, *Monstruos, Enanos y Bufones en la Corte de los Austrias*, Madrid, 1986, 62.

29. On this painting see *ibid.*, 64.

30. *Ibid.*, 72.

31. E. Tietze-Conrat, *Dwarfs and Jesters in Art*, figure 8, 89.

32. *Diccionario de la Lengua Castellana*, Madrid, 1732, IV, 491.

33. J. Iffland, *Quevedo and the Grotesque*, 153.

34. B. Gracián, *El Criticón*, II, 6, E. Calderón ed., Madrid, 1971, II, 6, 144.

35. See Brown, *Velázquez, Painter and Courtier*, 124–5 and Gállego, in A. Ortiz, A.E. Pérez Sanchez, J. Gállego, *Velázquez*, 179–85 for a summary of the arguments.

36. Gállego, *ibid.*, 184.

37. Opinions concerning this picture are summarized in *ibid.*, 198–201.

38. A. Ponz, *Viaje de España*, VI, Madrid, 1793, 119.

39. Moffitt, 'Velázquez, Fools, Calabacillas and Ripa', 304–9.

40. J. López-Rey, *Velázquez, A Catalogue Raisonné*, 265. S. Alpers, *The Decoration of the Torre de la Parada*, New York and London, 1971, 129.

41. Covarrubias, *Tesoro*, 265.

42. C. Justi, *Velázquez und Sein Jahrhundert*, Bonn, 1923, II, 310 n. 1.

43. J. Bulwer, *Chirologia*, 36–37. This text, probably unknown to Velázquez, depends upon easily accessible sources. The fist-grinding gesture is discussed in relation to texts in the Bible and Ovid.

44. Covarrubias, *Tesoro*, 981.

45. F. Rodríguez Marín, *12,600 Refranes Más*, Madrid, 1930, 217.

46. S. Alpers, *The Decoration of the Torre de la Parada*, 129.

47. For this portrait see A.E. Pérez Sánchez and J. Gállego, *Monstruos, enanos y bufones*, 58. The cards are discussed in terms of a reference to idleness.

48. Covarrubias, *Tesoro*, 462. The broad brushwork used here, and in other dwarf and jester portraits, may underscore the crassness of the sitters, as López-Rey, *Velázquez, A Catalogue Raisonné*, 77–78, points out. However, this idea is vehemently denied by Steinberg's review, *Art Bulletin*, 1965, 293.

49. J. Brown, *Velázquez, Painter and Courtier*, 148, 274–7, has plausibly paired the portraits and dated them c. 1636–1638.

50. For the documents relating to Acedo see Moreno Villa, *Locos, enanos, negros, y niños palaciegos*, 55–57.

51. A. López Pinciano, *Philosophía Antigua Poética*, 1596, A.C. Picazo ed., Madrid, 1953, III, 46. On Velázquez's library see F.J. Sánchez Cantón, 'Los Libros Españoles Que Poseyó Velázquez', *Varia Velazqueña*, I, Madrid, 1960, 642.

52. López-Pinciano, *ibid.*, II, 207.

53. *Ibid.* For Lucian's comic reversal see *The Fly*, Loeb Classical Library ed., A. M. Harmon trans., London and New York, 1927, I, 95

54. A. Canel, *Recherches sur les Fous*, 132.

55. S. Covarrubias, *Emblemas Morales*, Madrid, 1610, no. 79.

56. Covarrubias, *Tesoro*, 812–3. Similar conceits, contemporaneous with Velázquez, concerning dwarfs who attempt to elevate their stature, are found in Manuel de León Marchante's satiric poem 'A un Hombre Chiquito', *Antología de Humoristas Españoles*, J. García Mercadal ed., Madrid, 1964, 415, and Gabriel Rollenhagen's emblem of a dwarf in *Nucleus Emblematum Selectissimorum*, Utrecht, 1613, 22.

57. S. Covarrubias, *Emblemas Morales* in A. Henkel and A. Schöne, *Emblemata*, 60.

58. Alpers, *The Decoration of the Torre de la Parada*, 128–9.

59. J. López-Rey, *Velázquez, A Catalogue Raisonné*, 263.

60. Cf. the definitions in *Diccionario General Etimológico de la Lengua Española*, Madrid, 1889, IV, 947.

61. Moreno Villa, *Locos, enanos, negros y niños palaciegos*, 58.

62. *Libro de diferentes cosicosas* in *Poesía Erótica*, J.M. Diez Borque ed., Madrid, 1977, 178.

63. C.J. Cela, *Diccionario Secreto*, Madrid, 1974, II, 417. Shakespeare uses a similar metaphor in *The Merchant of Venice*, V, i.

64. On Morra's inheritance see Moreno Villa, *Locos, enanos, negros y niños palaciegos*, 120.

65. Cf. this pose in Veit Thieme's portrait of Count Johan Wilhelm von Sachsen, illustrated in G. Hirth, *Picture Book of the Graphic Arts*, New York, 1972, III, 793.

66. For the purported military inclinations of Kunz von der Rosen see F. Nick, *Die Hofnarren*, Stuttgart, 1861, I, 187. On the Hopfer print see E. Panofsky, 'Conrad Celtes and Kunz von der Rosen: Two Problems in Portrait Identification', *Art Bulletin*, XXIV, 1942, 44–50.

67. Philostratus, *Imagines*, II, 22, Loeb Classical Library ed., A. Fairbanks trans., Cambridge, 1940, 229–31.

68. For this portrait, dated in the 1620s, see A.E. Pérez Sánchez and J. Gállego, *Monstruos, enanos y bufones*, 28.

69. On the condition of the Prado picture see López-Rey, *Velázquez, The Artist as Maker*, 89. The replica is reproduced in *ibid.*, figure 194. Since the picture of this dwarf was described in an inventory of 1690 as 'El Primo', López-Rey (*ibid.*, 445) suggested that the picture may not depict Morra. However, as we have seen, the name of 'primo' was associated with fools.

70. S. Alpers, 'Interpretation without Representation or the Viewing of *Las Meninas*', *Representations*, I, 1983, 31–42. J. Moffitt, 'The Meaning of the Mise-en-Scène of *Las Meninas*', *Art History*, VI, 1983, 271–300. J. Brown, *Velázquez, Painter and Courtier*, 253–64.

71. B. Wind, *Velázquez's Bodegones: A Study in Seventeenth-Century Spanish Genre Painting*, Fairfax, 1987, 106 n. 9.

72. For this painting see A.E. Pérez Sánchez and J. Gállego, *Monstruos, enanos y bufones*, 104–5.

73. *Ibid.*, 116.

74. For this painting see A.E. Pérez Sánchez, *Juan Carreño de Miranda*, Avila, 1985, 81.

75. A.E. Pérez Sánchez and J. Gállego, *Monstruos, enanos y bufones*, 110.

76. A. Palomino, *Lives of the Eminent Spanish Painters and Sculptors*, N. Mallory trans., Cambridge and New York, 1987, 278.

77. E. Goodman, *Rubens: The Garden of Love as 'Conversatie a la Mode'*, Amsterdam and Philadelphia, 1992, 44.

78. Cf. for example, Brueghel's *Fat Kitchen* illustrated in H.A. Klein, *Graphic Worlds of Pieter Brueghel the Elder*, New York, 1963, 165.

79. S. Alpers, *The Decoration of the Torre de la Parada*, figure 72 and 185. The type of fat Bacchus may derive from a Hellenistic relief depicting a corpulent Dionysos visiting Icarius. See M. Bieber, *The Sculpture of the Hellenistic Age*, New York, 1967, figures, 656, 657.

80. A.E. Pérez Sánchez, *Carreño, Rizi, Herrera y la Pintura Madrileña de su Tiempo*, Madrid, 1986, 224. He also suggest a reference to Rubens in this work.

81. H. Kamen, *Spain in the Later Seventeenth Century*, 21.

Courtiers and Burghers:
the depiction of 'freaks' north of the Alps

Terata were the amusements of the privileged class. The number of images of deformity depicted for the courts of Italy and Spain demonstrate this. On the other hand, images of *terata* are not as extensive in Northern Europe. The Northern artists Rubens and Van Dyck, of course, worked for courtly patronage in the south as well as north of the Alps. They, like their southern counterparts, portrayed dwarfs as foils to elegant mistresses, thereby aggrandizing their aristocratic sitters. Yet in contrast to many of the images of the malformed found in Italian and Spanish art, Rubens painted but two known portraits and Van Dyck only one in this vein. And in the Northern Netherlands, where the court was not so firmly established, the traditional derisive portrait of the misshapen is not in evidence.[1] To be sure, this court, like others in the seventeenth century, displayed a taxonomic interest in the unusual. A letter written in 1625, describing a tour of North Holland taken by the Winter King and Queen, Frederick I and Elizabeth, relates how the party was amazed at Enkhuizen by an elephant's penis and at Edam by a nine-year-old of great height.[2] But the incorporation of *terata* into portraits to satisfy the whims of aristocratic patronage is not found in Holland. The Dutch artists, Van de Venne, Molenaer, Hals and Steen, did portray dwarfs and hunchbacks. However, with the exception of Hals, whose vivid depiction of the militiaman Nicolas Le Febure, a dwarf who is included in the group portrait of the *Banquet of the Officers of the Militia Company of St George*, Dutch artists chose to present the dwarf within a narrative or symbolic context. In this chapter we will consider the Dutch and Flemish responses to deformity.

Rubens, serving at the court of Mantua in Italy and working as well for Spanish and Genoese aristocracy, was no stranger to fashionable society. In two of his portraits he captured an aspect of that society through the inclusion of court dwarfs. In the stratified 'beau monde' of Genoa, Rubens painted a portrait of Caterina Grimaldi (Figure 5.1), dated 1606. Sitting in an armchair

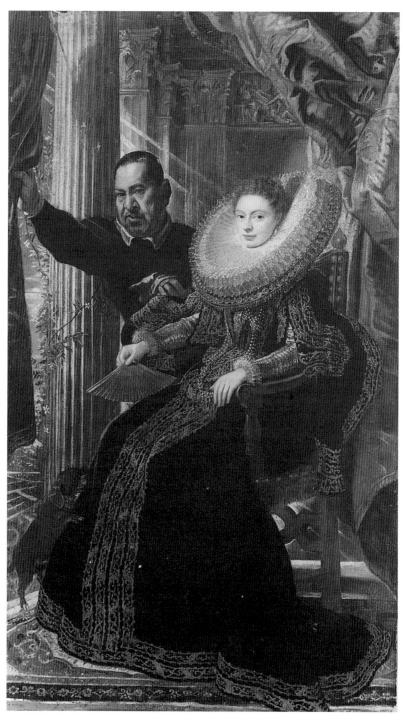

5.1 Rubens: *Portrait of Caterina Grimaldi*, 1606

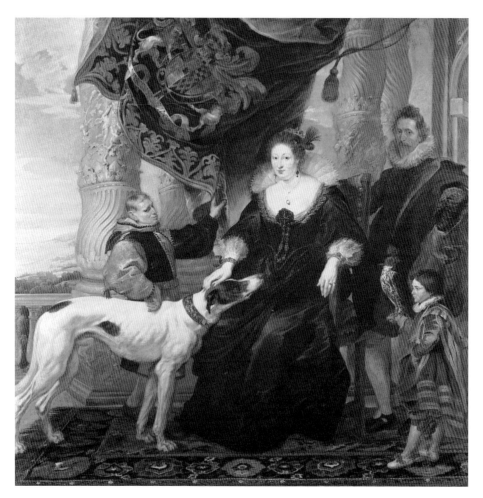

5.2 Rubens: *Aletheia Talbot and her retinue*, 1620

and juxtaposed with a curtain alluding to a cloth of honour, the Marchesa radiates power and prestige. Her elaborate costume is ornamented with silver and gold threads. Her enormous ruff, requiring a considerable amount of wheat to achieve the starched effect, signals conspicuous consumption and she is bedecked with pearls. But she is juxtaposed with two inferior life forms. On the right, a little dog clambers at her knee, looking up at her with canine devotion. A dwarf, also on her right, pulls aside a curtain to reveal the Marchesa to the spectator. He presents the perfect foil to the elegant loveliness of Marchesa Grimaldi. Her smooth white skin, the ideal of the beautiful woman, is contrasted to his swarthy face and twisted misshapen mouth.[3] Doubtless Rubens is following a formula already established in the sixteenth

century. His stay in Spain would have acquainted him with such prototypes. The portrait of the Infanta Isabel Clara Eugenia with the dwarf Maria Ruiz is a case in point (Figure 4.5).

Rubens replicates this formula of contrast in a more elaborate group portrait representing Aletheia Talbot, Countess of Arundel, and her retinue (Figure 5.2), dated 1620. The countess was renowned for her wealth and luxury. Her acquisitive nature was legendary. When she departed from Venice, she left with over thirty horses and a gondola.[4] Her retinue obviously included *terata*, as shown in Rubens' fluidly painted portrait. In the centre of the composition, the countess reigns flanked by two dwarfs. One, the midget Robin, holds a falcon. In his role as attendant-cum-hunter he complements the large whippet, the hunting dog which the countess affectionately pets. Behind the dog stands a dwarf attired as a jester. His close-cropped hair is the traditional sign of the fool.[5] Indeed, he is described as 'Il Pazzo' in a letter to the Earl of Arundel, dated 17 July 1620.[6] Like the dwarf in the Grimaldi portrait, he pulls at a curtain as if to reveal the spectacular figure of the countess to the viewer.[7]

Rubens praised Van Dyck as his 'best pupil'. Absorbing the master's style with facile ease, Van Dyck was also an accomplished courtier. In 1632 he arrived in London, was proclaimed the 'principall paynter in ordinary to their Majesties', and was knighted on 5 July.[8] Among his portraits brilliantly capturing the aura of the Caroline Court is his depiction of Queen Henrietta with the midget Jeffrey Hudson (Figure 5.3), dated 1633. Van Dyck is doubtless following an established precedent in this portrait. The Queen is dressed in an elegant hunting costume, similar to that in an ambitious portrait by Daniel Mytens, dated c. 1630. In this latter she is accompanied by King Charles and by the diminutive Hudson attempting to restrain eager dogs.[9] But in Van Dyck's portrait hunting is secondary to traditional conceits of aggrandizement. The Queen is juxtaposed with a column – a symbol of fortitude – and a cloth of honour. The crown, resting on the cloth, conspicuously reminds the viewer of her royalty. Behind her is an orange tree growing from a pot with an embossed lion's head. The lion's head decoration may have monarchical significance, since the lion formed part of the royal coat of arms. The lion's head was also emblematic of custody, suggesting the Queen's proprietary rights over her exotic entourage, the dwarf and the monkey.[10] Her hand resting on the monkey confirms her dominance. Of course, the monkey picking at Hudson's head denotes the midget's traditional role as a fool.[11] The orange is also an appropriate symbol of the Queen. Alluding to purity, virtue, and magnanimity as well as to the Virgin, it further enhances the Queen's eminence.[12] Since the Queen was short and not particularly well-proportioned – Duchess Sophia of Hanover noted her smallness, her long skinny arms and teeth that 'projected from her mouth like defence works' – the necessity to aggrandize her with various emblematic props was obvious.[13]

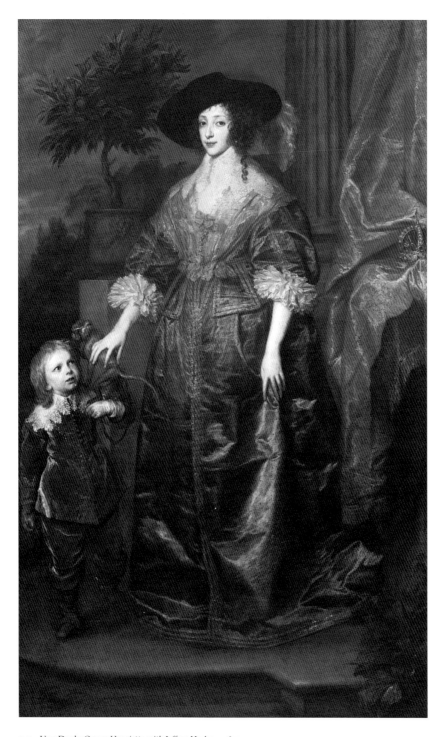

5.3 Van Dyck: *Queen Henrietta with Jeffrey Hudson*, 1633

5.4 Adriaen Van de Venne: *The fishing for souls*, 1614

If dwarfs and other *terata* were the playthings of aristocratic courts, in the United Provinces of the Northern Netherlands, where sober merchants held sway, the exploitation and depiction of deformity was not so prevalent. Indeed, there are no elaborate emblematic portraits of courtiers or aristocratic ladies juxtaposed with dwarfs. Perhaps this type of portrait was seen as a Spanish conceit and therefore anathema to the Protestant hegemony dearly won in the War of Independence. But if *terata* did not appear in official portraits as foils to elegant aristocrats, they did intrude upon Dutch allegorical and emblematic scenes.

Adriaen Van de Venne, for example, working in Middelburg and The Hague, depicted dwarfs in two large allegorical paintings and in a water colour illustration that was part of an extensive collection of emblematic miniatures. In one, *The fishing for souls* of 1614 (Figure 5.4), in the Rijksmuseum, a panel over six feet wide portrays an allegorical conflict between Protestants and Catholics. Aligned on opposite sides of an expansive river, grave and dignified Protestants are contrasted to frenetic Catholics, whose eager efforts to haul in a catch of converts result in a tipping boat. On the Protestant side of the river are such ardent defenders of Dutch Protestantism as Prince Maurice and Prince Frederick Henry of Orange, whereas Archduke Albert and Duchess Isabella of Flanders and Spinola, the general responsible for many Catholic victories in the Netherlands, are among the figures who populate the Catholic side.[14] But an important place on the Catholic strand is given to an elegantly dressed dwarf whose brightly coloured costume and position in the very foreground of the composition

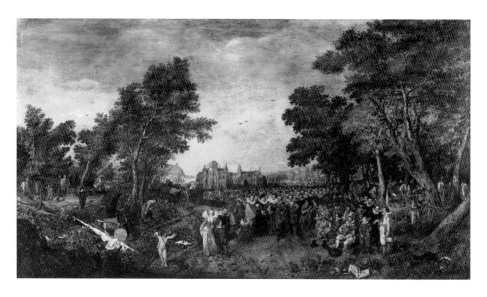

5.5 Adriaen Van de Venne: *Allegory of the twelve years' truce*, 1616

ensure his prominence. His appearance not only relates to the court preference for keeping human oddities, but since the dwarf is emblematic of vice he also underscores Van de Venne's explicit contrast between Catholic and Protestant.[15] The haughty dwarf is accompanied by a dog standing on its hind legs. Van de Venne has used the motif of the dog on hind legs in other works to suggest docility or pretence.[16] In light of the negative connotations associated with the dwarf in *Fishing For Souls*, it is more than likely that his dog companion alludes to the latter. Indeed, Gabriel Rollenhagen's emblem of a fancy dwarf from the *Nucleus Emblematum Selectissimorum* also presents the dwarf as a paradigm of vain pretence.[17] Additionally, as we have already seen, Velázquez's portrait of Don Diego de Acedo suggests a similar conceit and underscores the shared attitudes of the period.

In 1616 Van de Venne painted another large panel, almost four feet wide, now in the Louvre, depicting an allegory of the twelve years' truce (Figure 5.5). As discord and envy are set aside, the happy unification of the Northern and Southern Netherlands is symbolized by a bridal couple. Among the witnesses are Archduke Albert, the Duchess Isabella, and the Princes Maurice and Frederick. The dwarf who appeared in *Fishing for Souls* is part of this retinue. But unlike the latter work, here there may be no negative connotations conveyed by his presence. His appearance simply may be a taxonomic recording of the court penchant for oddities.[18]

Van de Venne's patron for these two large pictures is unknown. The size,

74

5.6 Adriaen Van de Venne: *Dancing dwarf*, 1626

the inclusion of figures from the court of Orange, and the virulent anti-Catholic tenor of the painting suggest that the *Fishing for Souls* was painted for The Hague. Indeed, in 1757 *Fishing for Souls* was listed at Het Loo, the stadtholder's palace, as 'a fine piece'. The *Allegory of the Twelve Years' Truce* was in the Enghelgraeff collection in Antwerp in 1661. A malignant view of Catholics is absent, suggesting that it was commissioned by someone from Flanders.[19]

In a little emblematic water colour from an album possibly commissioned by the Winter King, Van de Venne depicted a dancing dwarf (Figure 5.6). Martin Royalton-Kisch plausibly suggests that his capering to a peasant's rustic tune alludes to folly.[20] I suspect that this conceit is reinforced by the contrast with the staid onlookers in the background. A child points to the dancing dwarf as if to remind the viewer that a bad example is being set for children.

Van de Venne expanded his repertoire of *terata* in the illustrations for Jacob Cats' emblem books. Two emblems from Cats' *Spiegel van den Ouden ende Nieuwen Tijdt* of 1632 deal with deformity. In one, the maxim 'Cripple will always lead the dance' (Figure 5.7) is illustrated by a sprightly clubfoot directing dancers around a maypole. The text of the emblem associates the clubfoot with vain folly, since the incapable fool believes that he should be a leader.[21] Perhaps Van de Venne had Brueghel's *Peasant Dance* (Vienna, Kunsthistoriches Museum) ultimately in mind. The central figure in this

Krepel wil altiidt voor danſen.

5.7 Adriaen Van de Venne: *'Cripple will always lead the dance'*; illustration for Jacob Cats' *Spiegel van den Ouden ende Nieuwen Tijdt*, 1632

well-known painting, marred by a distorted leg, is emblematic of lack of judgement and restraint.[22] Van de Venne's other emblem for Cats' book, representing two hunchbacks, is far less derisive (Figure 5.8). Indeed, the text associated with the emblem counsels empathy.

> A Hunchback here, brimfull of self-conceit,
> Derides a fellow-Hunchback passing by:
> And points to him that every one they meet
> May ridicule the man's deformity.

El corcobado ne vee su corcoba, y vee la de su compañon.

5.8 Adriaen Van de Venne: *Two hunchbacks;* illustration for Jacob Cats' *Spiegel van den Ouden ende Nieuwen Tijdt,* 1632

> Yet he himself; the Jeerer, what is he?
> A crooked Dwarf, misshap'd from head to toe,
> With boss behind of such enormity,
> As though a mountain on his back did grow!
> And what is Man, that he should censor be
> Of that which Nature gave his fellow-man! . . .
> Shall we assume in figures of our own
> To reckon up another man's account!
> And carp at him for flaws and faults alone
> When our own ledger shows no small amount! . . .

And though so keen our neighbor's humps to see
We're blind to that upon our back alone
Even though that hump by far the greater be!
It was not thus, my friends, that we were taught
That practice sweet of Love and Charity
By which the Man-God our Redemption bought
In Pity for our mortal frailty!
Look not to scorn upon thy brother's shape,
If nature chose to vary it from thine:
For though it may resemble the Ape,
It may have light within far more divine! . . .
Who ridicules his neighbor's frailty,
Scoffs at his own in more or less degree;
Much wiser he who others' lets alone
And tries his talent to correct his own.[23]

In this plea for tolerance and self-understanding the customary derisive and malign view of deformity has been set aside. Here Cats is the quintessential Christian moralist, reiterating the sentiments of Matthew 7:1–5 and the parable of the mote and the beam. The account begins with the trenchant phrase: 'Judge not, that you be not judged'.

In the *Militia Company of St George* of 1627 (Figure 5.9) Frans Hals also presents a more benign view of deformity. In this depiction of boisterous militiamen, the dwarf Nicolas Le Febure standing on the extreme right is in the company of his equals. His gesture of right hand placed at his chest, a kind of declarative self-affirmation, is echoed by his co-captain, Nicolas Verbeck, seated at the left.[24] Additionally, Hals has subverted the rules of military protocol to negate Le Febure's deformity. He is not seated with his fellow officers. If he were, his diminutive size would be evident. He is, instead, standing next to seated militiamen and thus appears to be virtually the same size.[25] Since militiamen comprised the sovereign regent class, Hals was doubtless responding to the power of status and money in this obvious attempt at flattering this sitter.[26]

But Le Febure was an exception, a dwarf of the upper class who could afford a flattering portrayal. Dwarfs not of the upper class were not patrons, and thus were consigned to roles which emphasized negative attitudes toward deformity. Three paintings by the Haarlem painter Jan Molenaer, an artist frequently associated with Hals, underscore these associations.[27] In the *Denial of St Peter* of 1636 in Budapest, for example, a dwarf is part of the company of scornful soldiers, drunks and gamblers who threaten the saint with exposure.[28] In a painting in Bonn a dwarf fiddler, accompanied by a dog on hind legs, a familiar motif, plays a tune for a frolicsome peasant couple.[29] They set a bad example for the children, whose palpable amusement at their antics is demonstrated by their broad grins. And the group serves as a moralizing reminder of folly to the elegantly dressed couple on the left. This pair – the

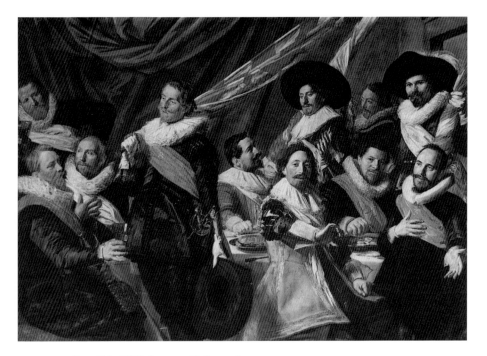

5.9 Frans Hals: *Militia Company of St George*, 1627

young man smiling, the young woman more severe – are simultaneously amused and repelled by the action. Molenaer also depicts a dwarf in an enigmatic picture dated 1646 (Figure 5.10). Here the dwarf, beset by raucous children, pelts them with stones in retaliation. The picture has defied interpretation. Sutton suggests that it is a depiction of 'idle cruelty's permanence as a feature of human nature', although he readily admits that the prevailing opinion of the period was not sympathetic to deformity.[30] Haecht considers the picture a comment on immoderate behaviour.[31] And Schama finds this 'strange and disturbing picture' a paradigm of malevolence.[32] The stone-throwing motif finds an analogue in an emblem by Florentius Schoonhovius of 1618.[33] This text, which derides useless squabbling, may have some relevance for Molenaer's image, but no dwarf is present in the emblem. Molenaer's painting also includes a signboard with the inscription 'the benumbed peasant', a fashionably dressed young couple, and an old man. The old man is a type that Molenaer has used before to represent stupidity.[34] He may serve as a complement to the 'benumbed' peasant on the signboard. The fancy young couple are, as we have seen, also a part of Molenaer's iconographic repertoire. These details doubtless provide clues to a scene that has been rightly characterized as one depicting a now forgotten message.[35]

5.10 Jan Molenaer: *Stone-throwing dwarf,* 1646

In light of the hostile attitudes towards dwarfs, it is probable that Molenaer's stone-flinging dwarf is meant to elicit a negative response. Similarly, Jan Steen uses dwarfs in his paintings to underscore pernicious conceits. A bedraggled dwarf, his tattered costume rent with a large hole, is placed in the mid-ground of Steen's elaborate portrait-cum-allegory in the Mauritshuis (Figure 5.11), dated 1660. Cast as a barnyard labourer, the dwarf carries a basket of fowl in one hand and a cock in the other. His glance is directed at a young girl, probably Bernadina Magriet van Raesfeld, the adopted daughter of a member of the Van Mathenesse family whose coat of arms appears above the archway.[36] His face is wreathed in a perverse grin. Another servant, but of normal size, approaches the young girl. He carries a pitcher and a basket of eggs, The juxtaposition of the girl, whose innocence is manifested by the lamb drinking from her bowl of milk, and the two servants, presents a palpable contrast of good and evil. The withered tree on the right, with its few sprouts of foliage, recalls a Roemer Visscher emblem concerning

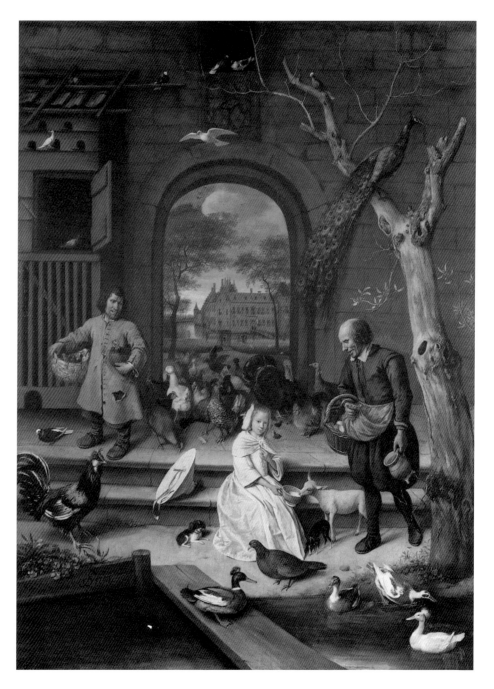

5.11 Jan Steen: *Portrait-cum-allegory*, 1660

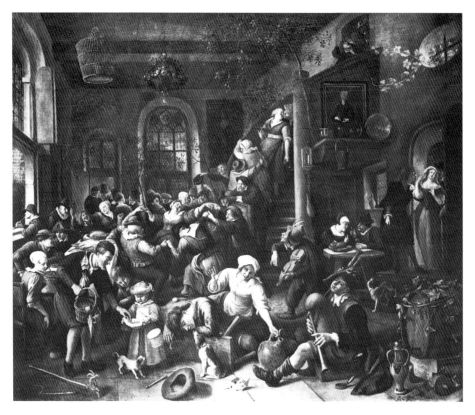

5.12 Jan Steen: *The Egg Dance*, n. d.

the choice between innocence and vice that underscores this contrast.[37] Other motifs in the painting, I believe, reinforce this conceit. The girl is flanked by two small dogs who may be metaphors for docility.[38] The white dove, hovering below the coat of arms of the Van Mathenesse family, is a traditional symbol of innocent purity.[39] Conversely, the servants carry attributes traditionally linked to licentiousness. The eggs held by the elderly bald-pated servant, and the rooster clutched by the grinning dwarf, while appropriate to a farmyard, also have long associations with sensuality.[40] Accordingly, in this ostensibly benign environment, the young innocent is beset by malign intruders. The dwarf is one of them.

Dwarfs as well as hunchbacks also appear in some of Steen's religious and genre pictures. In *The Egg Dance* (Figure 5.12), in Apsley House, Steen depicts a rollicking tavern scene which resonates with hedonistic indulgence. In the background couples embrace on the stairs. In the centre foreground a young boy has fallen asleep, overcome by the narcotic effects of tobacco. Next to him

is a young woman holding an open jug indicating her sexual promiscuity.[41] In the mid-ground, merry-makers enjoying a dance that has carnal associations are capering to the tune of a bagpiper and a dwarf fiddler.[42] These musicians reinforce Steen's taxonomic depiction of intemperance. The bagpipe is a 'dunce's instrument' and the dwarf, of course, is traditionally freighted with negative connotations.[43] Steen's portrayal of this fiddler could have been based upon naturalistic observation, since dwarfs were street entertainers.[44] But it is more likely that Steen has imaginatively adapted Callot's violin-playing *gobbo*, decked out in a feathered cap, for this figure (Figure 5.13).

As Gudlaugsson has perceptively suggested, it is likely that Callot's *gobbo* with an improbable stove-pipe hat served as a point of departure for the dwarf in Steen's *Rich Man and Lazarus* of 1667.[45] In this picture the dwarf belongs to the rich man's retinue. He is an aristocrat's plaything, who is as much a part of the callous self-indulgence that this parable exemplifies as the rich man himself.[46] Steen turned to Callot once again for the hunchbacked innkeeper who seems to plead ineffectually with the inebriated reveller dancing on the table in the *Wedding feast*, dated 1667 (Figure 5.14). The innkeeper's high-crowned feathered hat recalls the costume of some of the *gobbi*, and his awkward stance suggests that Steen was looking at Callot's guitar-playing *gobbo* for inspiration. Gudlaugsson may well be correct in relating this figure to Punchinello, who sometimes assumed the role of 'innkeeper' in the *commedia dell'arte*.[47]

Steen's comically reviled dwarfs and hunchbacks are part of a common pictorial repertoire. But what if the artist himself is among the legion of the misshapen? The Dutch painter, Pieter van Laer, was a hunchback whose twisted shape gave rise to his nickname, 'Bamboccio' (Big Baby). Some seventeenth-century biographies of the artist present a traditionally unflattering view of his deformity. Passeri described Van Laer as 'humpbacked, badly figured, and of disconcerting proportion . . . He was a ridiculous figure, and as was said hunchbacked with a large head and a very terrible nose so that he appeared a true Bamboccio'.[48] His works were disparaged as 'bambocciate' (baby things) and his followers were known as 'Bamboccianti' (Big Babies). However, Van Laer's friend, Joachim Sandrart, wrote more empathetically. 'His conduct of life was linked with mine since I was his true comrade. I knew him well for many years, partly in Rome and partly in Holland. I can report with the basis of truth about his life.' Yet he, too, remarked upon Van Laer's deformity, presenting it in a comically anecdotal light. 'He was extremely skillful in dancing, raising himself aloft abruptly, and then landing with his long legs and quickly bringing them about over the heads of others, just as if only half of him were hopping about on the floor.' Indeed, just as others laughed at his misshapen body, likening him to a baboon, Van Laer, according to Sandrart, took fun in and poked fun at himself, thereby increasing the

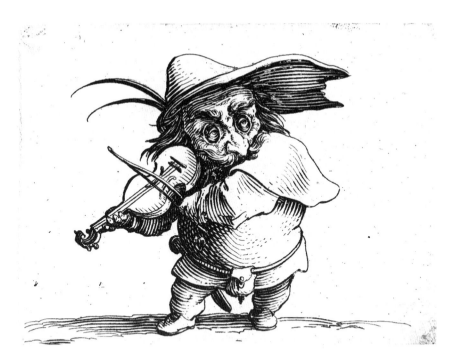

5.13 Jacques Callot: *'Gobbo' with a violin*, c. 1622

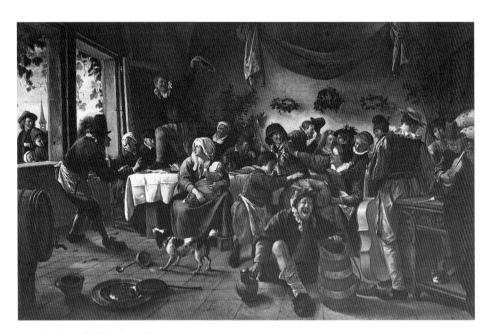

5.14 Jan Steen: *Wedding feast*, 1667

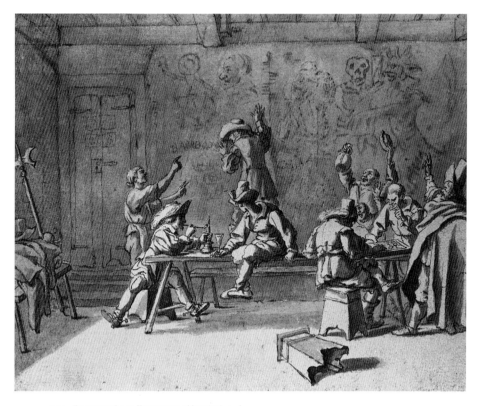

5.15 Pieter van Laer: *Tavern scene (drawing)*, n. d.

amusement. And Sandrart delighted in recounting how Van Laer's hunchback was a clearly distinguishable feature. Sandrart, Claude, Poussin and Van Laer made a trip to Tivoli to 'paint and draw from nature'. The artists were suddenly confronted with a fearsome storm. Terrified, Van Laer decided to ride back in haste to Rome. When the storm abated, Sandrart, Poussin and Claude worried about the fate of their friend, inquired of a guard at the city gate if he had seen a rider. He had not. But he had seen a horse with a hat, a knapsack, and a pair of boots tied to the saddle. From the guard's description of this unusual sight the friends were readily assured of Van Laer's safe arrival. They retold the tale to Van Laer and laughed heartily about it.[49]

The self-deprecatory nature of Bamboccio's response to his deformity is reflected in an amusing drawing in Berlin (Figure 5.15). The tavern scene presents a compendium of dissolution, as figures drink, gamble and smoke. The wall is defaced with drawings, including on the far right a demonic form and a skeleton holding an hourglass. On the far left is a curiously deformed figure who seems to consist of a hat and large round back. Analogous to Sandrart's

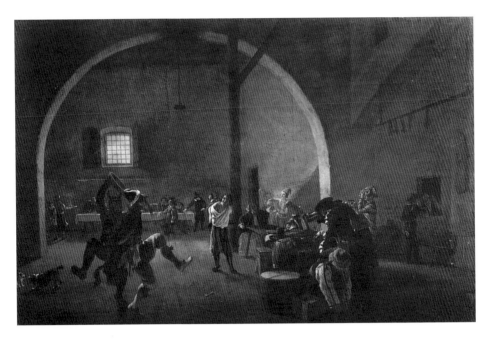

5.16 Pieter van Laer: *Interior of a tavern*, n. d.

5.17 Pieter van Laer: *Self-portrait as a conjurer*, n. d.

description of the 'riderless horse', this is doubtless a caricatural image of Van Laer. His nickname in Dutch, BAMBOOTS, is scrawled underneath. The burlesque tenor of this work belies the recent suggestion that it is a piece which comments on the origins of art and divine Bacchic inspiration.[50] Indeed, taverns must have provided ready wall space for artists' caricatural self-images. In the *Interior of a tavern* in Munich (Figure 5.16), a picture populated with carnival revellers, Van Laer's caricatural presence – the hat and swollen back – is found once again on the far right, furnishing a kind of figural signature for the painting.

Van Laer presents another humorous self-image in a portrait in a private collection in New York (Figure 5.17). He has cast himself as a conjuror behind a table laden with occult objects – a skull, a book inscribed with a pentagram, and a type of knife used in sorcery.[51] The demonic claws that appear to threaten him, and his terrified expression, demonstrate that his conjury has been successful. The song book with the fragmentary inscription, 'il diavolo no burla no il dia . . .', comically suggests that sorcery has got out of hand. The painter may be a joker, but the devil does not jest. Yet since the devil can also appear in the guise of a carnival reveller, as the Munich *Interior of an Inn* demonstrates, this may add another jocular and paradoxical dimension to the portrait. But if Van Laer's animated spirit and his love of high jinks are depicted in this self-portrait, an important aspect of his persona is not. His deformity, the hunchback to which his biographers call particular attention, is not discernible. Nor is it found in two other self-portraits, one in the Uffizi and the other in the Galleria Pallavicini, Rome. In the Uffizi portrait (Figure 5.18) Van Laer confronts us head on, and by looking down at the spectator he actually appears to elongate his torso. In the Pallavicini self-portrait (Figure 5.19), a profile view, one would expect to see the notorious hump clearly. But it is cleverly masked by the back of a chair. Van Laer sits upright, intent upon his work, and he wears a beret, a hat that in the seventeenth century was associated with genius and poetic inspiration.[52]

It is unclear for whom these pictures were intended. It is possible, following traditional ideas connecting portraiture and friendship, that Van Laer gave these self-images to his comrades as mementos.[53] Whatever the circumstances, in these portraits the artist known for his devotion to accurate portrayal, 'la verità schietta', has refashioned himself.[54] He may have delighted in his own deformity, but because of the prejudice against imperfect humanity he has decided to show himself for posterity as gloriously unblemished.

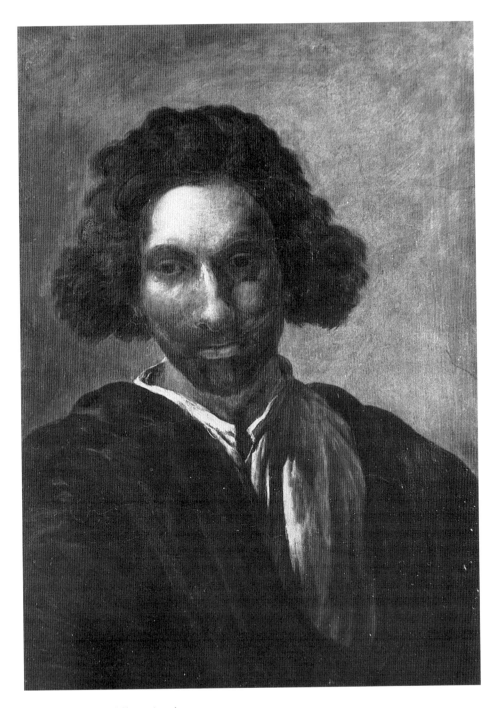

5.18 Pieter van Laer: *Self-portrait*, n. d.

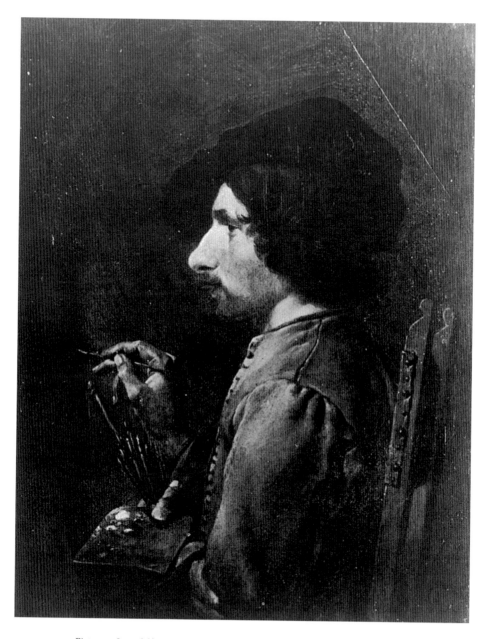

5.19 Pieter van Laer: *Self-portrait (profile view)*, n. d.

Notes

1. On the relative weakness and the numerical insignificance of the Dutch nobility see J. Huizinga, *Dutch Civilization in the Seventeenth Century*, New York, 1968, 30 and P. Geyl, *The Netherlands in the Seventeenth Century*, New York, 1961, I, 246, II, 191–2.

2. M. Royalton-Kisch, *Adriaen Van de Venne's Album*, London, 1988, 349.

3. On the importance of whiteness of skin for a beautiful woman see G. della Porta, *Natural Magick*, (1658), D. Price ed., New York, 1957, 229. This could be achieved through a variety of concoctions, including distilled lilies, turpentine, mercury sublimate and egg whites.

4. F. Huemer, *Portraits, I, Corpus Rubenianum*, Brussels, 1977, 86.

5. B. Wind, 'Pitture Ridicole: Some Late Cinquecento Comic Genre Paintings', *Storia dell'Arte*, 20, 1974, 29.

6. H. Vlieghe, *Portraits, II, Corpus Rubenianum*, Oxford, 1987, 51, n. 1.

7. On the identification of the figures in the painting see *Catalogue, Alte Pinakothek München*, Munich, 1983, 439.

8. O. Millar, 'Van Dyck in London', in A. Wheelock *et al.*, *Anthony Van Dyck*, Washington, 1990, 53.

9. A. Wheelock, *ibid.*, 264, fig. 2.

10. G.P. Lomazzo, *Trattato*, VI, lvi, 459.

11. Cf. Annibale Carracci's depiction of this motif in D. Posner, *Annibale Carracci*, II, 26. Wheelock, *Anthony Van Dyck*, 264, however, refers to this motif as 'inexplicable'. J. Douglas Stewart, 'Pin-ups or Virtues? The Concept of the "Beauties" in Late Stuart Portraiture', *English Portraits of the Seventeenth and Eighteenth Centuries*, Los Angeles, 1974, 18, implausibly suggests that the 'dwarf is either Paris or Hercules'.

12. On the orange and its association with the Virgin see Wheelock, *Anthony Van Dyck*, 265.

13. A. Korcher, *Mémoires de la Duchesse Sophia*, Leipzig, 1879, 38.

14. For this picture see L.J. Bol, *Adriaen Pietersz. Van de Venne Painter and Draftsman*, Doornspijk, 1989, 34–41.

15. M. Royalton-Kisch, *Adriaen Van de Venne's Album*, London, 1988, 104.

16. *Ibid.*, 104, 180.

17. G. Rollenhagen, *Nucleus Emblematum Selectissimorum*, 22.

18. For this picture see Bol, *Adriaen Pietersz. Van de Venne*, 41–43.

19. Royalton-Kisch, *Adriaen Van de Venne's Album*, 42–45.

20. *Ibid.*, 104, 288, and on the circumstances of the commission, 110.

21. J. Cats, *Moral Emblems*, R. Fairlie trans., London, 1860, 205–7.

22. On the negative connotations of this deformed dancer see M. Sullivan, *Brueghel's Peasants*, Cambridge, 1994, 66.

23. Cats, *Moral Emblems*, 125–7.

24. On the significance of this gesture see Bulwer, *Chirologia*, 179.

25. On this picture see S. Slive, *Frans Hals*, London, I, 1970, 70, III, 1974, 29–31.

26. On the make-up of the militia see *ibid.*, I, 20.

27. On Molenaer see P. Sutton *et al.*, *Masters of Seventeenth Century Dutch Genre Painting*, Philadelphia, 1984, 260.

28. Illustrated in M. Mojzer, *Dutch Genre Paintings*, Budapest, 1967, 9.

29. For this painting see Sutton *et al.*, *Masters of Seventeenth Century Dutch Genre Painting*, 264–5 and figure 2.

30. *Ibid*, 265.

31. P. Haecht, 'The Debate on Symbol and Meaning in Dutch Seventeenth-Century Art: An Appeal to Common Sense', *Simiolus*, 16, 1986, 184–5.

32. S. Schama, *The Embarrassment of Riches*, New York, 1988, 554–5.

33. Henkel and Schöne, *Emblemata*, 960.

34. J. Welu *et al.*, *Judith Leyster, A Dutch Master and Her World*, Worcester and Zwolle, 1993, 280.

35. Sutton *et al.*, *Masters of Seventeenth Century Dutch Genre Painting*, 265 and Haecht, 'The Debate on Symbol and Meaning', 184–5.

36. The girl is also identified as Jacoba Maria van Wassenaer, whose family also resided in the castle depicted in the background. But Jacoba was only six in 1660, and since the girl in the portrait appears older, her age would be more in accord with Bernadina, who was ten. For the controversy surrounding the identity see B. Broos, *De Rembrandt a Vermeer*, The Hague, 1986, 318–20.

37. Broos, *Ibid.*, 321.

38. On dogs and docility in children see W. Franits, *Paragons of Virtue*, Cambridge, 1993, 154.

39. C. Ripa, *Iconologia,* Rome, 1603, 421 and G. de Tervarent, *Attributs et Symboles dans L'Art Profane 1450–1600*, Geneva, 1958, 105–6.

40. A. Grosjean, 'Toward an Interpretation of Pieter Aertsen's Profane Iconography', *Konsthistorisk Tidskrift*, XLIII, 1974, 126–7.

41. On the jug and its sexual implications see E. de Jongh, 'Erotica in vogelperspectief. De dubbelzinnigheid van een reeks 17de eeuwse genrevoorstellingen', *Simiolus,* III, 1968–69, 45–47.

42. On the associations of the egg dance with an orgy see M. Sullivan, *Brueghel's Peasants*, 31.

43. For the symbolism of the bagpipe see Sullivan, *Ibid.*, 81.

44. Sutton et al, *Masters of Seventeenth Century Dutch Genre Painting*, 264.

45. S.J. Gudlaugsson, *The Comedians in the Work of Jan Steen and his Contemporaries*, Soest, 1975, 52.

46. A dwarf *gobbo* also appears with the wanton revellers in the *Banquet of Antony and Cleopatra* attributed to Steen. See B. Kirschenbaum, *The Religious and Historical Paintings of Jan Steen*, New York and Montclair, 1977, figure 125.

47. Gudlaugsson, *The Comedians in the Work of Jan Steen*, 51. The type also appears in Steen's *Marriage at Cana* in the Beit collection. See Kirschenbaum, *op. cit.* figure 62.

48. Passeri, *Vite*, 54, 56.

49. J. Sandrart, *Academie der Bau-Bild-und Mahlerey Künste*, 1675, A.R. Peltzer ed., Munich, 1925, 183–4.

50. For this suggestion see D. Levine, 'Pieter Van Laer's *Artist's Tavern:* An Ironic Commentary on Art', *Jahrbuch Preussicher Kulturbesitz*, IV, Berlin, 1987, H. Bock and T.W. Gaehtgens eds, 169–91.

51. On the knife, an 'athame', see J. Davidson, *David Teniers the Younger*, Boulder, 1979, 43. I am indebted to Mary Catherine Meyer, who is preparing a study on Teniers' images of witchcraft under my direction, for calling my attention to this reference.

52. H.P. Chapman, *Rembrandt's Self Portraits*, Princeton, 1990, 50.

53. On these ideas, stemming from Alberti's *Della Pittura*, see O. Bätschmann, *Nicolas Poussin, Dialectics of Painting*, London, 1990, 49–51.

54. Passeri, *Vite*, 55.

Enlightened attitudes: the eighteenth century and beyond

In his comprehensive enumeration of the mentally and physically infirm kept at the Spanish court in the seventeenth century, Moreno Villa lists nearly one hundred dwarfs and fools.[1] Only five are found in the eighteenth century: Miguelilo who died in 1700; Bernarda Blasco who died in 1702; Juan and Ana Blasco, husband and wife, who died in Seville in 1717; and at the end of the century, the 'pygmy' Don José Cañizares sent to the court in 1786 by the Viceroy of Santa Fe.[2] It is clear that the dwarf and the mentally incompetent are no longer the playthings of the idle courtier. Indeed, the pious Philip V banned dwarfs from the Spanish court in 1701.[3] His grandfather Louis XIV, far less concerned with moral probity, also expelled dwarfs from the French court.[4]

These courtly responses to *terata* suggest that the old attitudes toward human deformity were beginning to disappear. To be sure, some eighteenth-century courts still kept dwarfs. The courts of Germany had them, and even as late as 1751 the court of Lorraine delighted in the midget Nicolas Ferry, the so-called *Le Bebé*.[5] In the early eighteenth century the fascination with human oddities is attested by their continuing exhibition. In early eighteenth-century London, for example, a variety of *terata* were shown at fairs and taverns. A family of midgets was exhibited in the spring of 1711, and gave 'great satisfaction to the Quality'.[6] There was a plethora of other human curiosities, including a boy with bristles like a hedgehog, a young man with breasts for legs, and the 'Bold Grimace Spaniard', capable of extending his mouth six inches and turning 'it into the shape of a Bird's Beak, and his eyes like to an owl's'.[7] At Bartholomew Fair there was a woman with three breasts and a midget, the so-called 'Little Farey'. At May Fair a dwarf was exhibited.[8] Bartholomew Fair also served as a venue for misshapen entertainers. The peripatetic Ned Ward recorded in his journal a 'jovial' dance of cripples and a 'Dwarf comedy, sirnam'd a Droll'.[9]

Of course, there were still powerful voices linking the misshapen to the noxious, ludicrous and repulsive. Eighteenth-century posture manuals, for example, counsel the importance of 'bodily grace'. Associating bodily perfection with God's favour for humanity, Nicolas Andry in his L'Orthopédie of 1741 remarked: 'We are born for one another: we must avoid possessing anything shocking, & even if one were alone in the world, it would not be proper to neglect one's body to the point of allowing it to become deformed: this would be going against the very intention of the creator'.[10] And Samuel Johnson's authoritative dictionary, first published in 1755, defined deformity as 'Ridiculousness; the quality of something worthy to be laughed at'.[11] With the publication of Johann Lavater's treatise Physiognomische Fragmente (1775–1778), prejudices toward deformity were sanctioned even at the end of the eighteenth century. Lavater claimed that 'the moral best' was 'the most beautiful' whereas the 'morally worst' was the 'most deformed'.[12]

However, equally eloquent voices rejected these notions. Human oddity was viewed in less pejorative terms, and such ideas as terata being a product of God's punishment were abandoned.[13] Accordingly, the old belief in the malformed body as a sign of the malformed soul was supplanted. The body of any shape was not a predictor of deeds or disposition.

For example, in his delightful paean to human eccentricity, Tristram Shandy, Lawrence Sterne denied that character could be read through the human body.[14] And Lavater's association of morality and beauty was challenged soon after it was published by the philosopher Moses Mendelssohn. In his Random Ideas on the Harmony of Inner And Outer Beauty, Mendelssohn admitted that there may be a correspondence between outward and inner appearances. But the conceit that beauty and 'interior' fitness were commensurate was clearly erroneous.[15] The taste for human oddity, in fact, was criticized by more than one enlightened observer. In a letter addressed to her sister, 16 January 1717, Lady Mary Wortley Montagu questioned why the German courts retained their dwarfs.[16] And the eighteenth-century Italian writer, Gian Battista Casti, also condemned this practice, allying the keeping of dwarfs and the misshapen with a court that was interested in pompous display.[17] Diderot also considered deformity in a more compassionate way. Beauty and ugliness were relative terms. The clubfoot, the hunchback, or a compilation of 'all of the deformities that one could imagine' are types neither more beautiful nor more ugly than others.[18] In Le Rêve de D'Alembert of 1769 these ideas are elaborated. D'Alembert remarked that men and monsters are all part of the natural order of the universe.[19] Deformity becomes a necessary part of 'diversité' and the deformed – the hunchback and the clubfoot – are neither evil nor the product of a 'vice héréditaire'.[20]

The Fairs, long the venues for terata, as we have already noted, were also now commanded to change their attractions. On 2 June 1708 the Common

Council of London decided that Bartholomew Fair should be devoted solely to the 'sale of leather and cattle according to its antient custome'. May Fair, however, was completely abolished in 1709.[21]

In a treatise published by William Hay in 1754, deformity actually took on a positive aspect. Hay, a member of Parliament, and himself dwarfish and misshapen, claimed that deformity not only signalled a high degree of temperance, since the deformed had to preserve their strength, but it also allowed for 'improvement of mind'.[22] The deformed person can make use of an agile mind to teach, to be a military adviser, and to write plays and poetry. He 'may not be crowned at the Olympic Games: but may be the Pindar to celebrate them'.[23]

Derisive attitudes towards deformity are now regarded as bad manners. It is no longer people of 'quality' who find amusement in *terata*. Hay was not derided by 'polite people', but he could 'scarce pass without hearing some Affront' from the vulgar mob.[24]

Such contempt in general joined with Ridicule of the Vulgar, is another consequence of bodily Deformity. For men naturally despise what appears less beautiful or useful: and their Pride is gratified when they see such Foils to their own Persons. It is this sense of superiority which is testified by Laughter in the lower sort: while their Betters . . . are restrained by good sense and good Breeding from such an Insult.[25]

Ultimately Hay suggested that the deformed could overcome obstacles through force of character and even attain a personal superiority.

Deformed persons set out in the world to a Disadvantage, and they must first surmount the Prejudices of Mankind, before they can be on a Par with others. And must obtain by a Course of Behaviour that Regard, which is paid to Beauty at first sight. When this point is once gained, the Tables are turned: and the Game goes in their Favour: for others sensible to their first Injustice to them, no sooner find them better than they expected, than they believe them better than they are.[26]

As the attitudes towards deformity shifted in the eighteenth century, representations of *terata* diminished. There continued, of course, a scientific fascination with *terata*. But the illustrations changed in context, becoming more lavish and accompanied by a lucid non-judgemental text authenticating each example. *Les écarts de la nature*, published in 1775, serves to typify this genre.[27] Only a few examples of court portraiture survive. In Spain, the last court portrait of a dwarf was painted by Michel Ange Houasse. The picture, in the Prado, must post-date the banishment of the dwarfs from the Spanish court since Houasse did not begin working for Philip until 1715.[28] Perhaps the painting was commissioned by a private family. Houasse juxtaposes the dwarf with a cockatoo, and thus follows an old formula uniting the exotic with presumably lower life forms. But this dwarf, swaggering with hand on hip, has

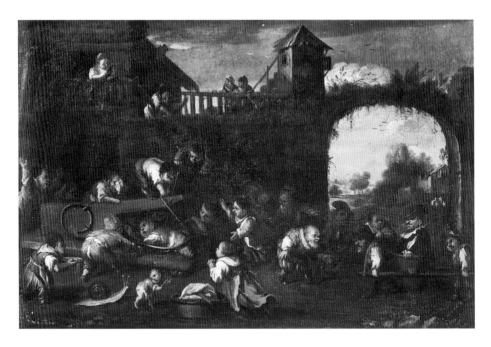

6.1 Faustino Bocchi: *Dwarf in a trap*, n. d.

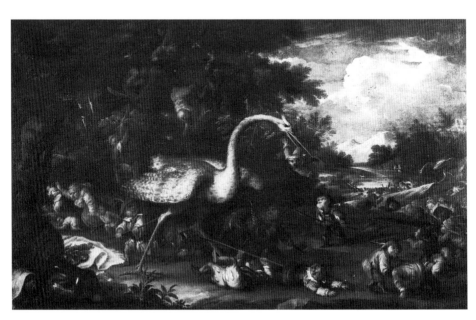

6.2 Faustino Bocchi: *Battle with the heron*, n. d.

adopted the pose of a macho gentleman. In this aristocratic pose, combined with the dwarf's self-confident gaze, Houasse articulates a more noble view of *terata*.[29] Early in the eighteenth century the dwarf Perkeo, who belonged to Archduke Philip of Heidelberg, was painted by Adriaen Van der Werff. This portrait is less flattering. Although Perkeo is elegantly dressed, he vulgarly places his finger to his nose, thus revealing his grossly comic character.[30]

There was, however, an interest in north Italy in elaborate narratives depicting dwarfs. Faustino Bocchi was the most notable specialist in this genre.[31] Indeed, no less a critic than Luigi Lanzi deemed him 'eccellente' in the depiction of dwarfs.[32] Bocchi had a long and prolific career which extended into the fourth decade of the eighteenth century. At the close of the seventeenth century he spent time in Florence, and this may have predisposed him to depictions of dwarfs. But most of his surviving work was painted for Lombard patrons who hung the pictures in country retreats.[33] The paintings range in subject from dwarf concerts and picnics to battles with threatening birds and crabs. Only one of his pictures is signed and dated, but recently it has been demonstrated that some paintings, dependent upon a securely dated print by Hogarth, must post-date 1726.[34] One of these is the *Dwarf in a trap* in the Museo Civico in Padua (Figure 6.1), where Bocchi has presented a traditional image of 'the world turned upside down'. A dwarf has been ensnared by an ordinary clothespin. In the foreground a dwarf child has been intimidated by a snail. But Bocchi has also intruded a note of pathos. A dwarf woman weeps as the unfortunate dwarf struggles in the trap. The child threatened by a snail is an image traditionally associated with puerile terror. Nearby, a woman wrings her hands in distress.

Similarly, in the *Battle with the heron*, in a private collection in Brescia (Figure 6.2), Bocchi depicts real terror. The menacing bird dangles a dwarf in its bill. A dwarf warrior hangs from a tree, his face contorted in a frightened grimace. In the mid-ground an anxious mother and child try to escape the melée. Bocchi seems to have recast Juvenal's account of the battle of pygmies and birds for his depiction.

The pygmy warrior marches forth in his tiny arms to encounter the sudden swoop and clamorous cloud of Thracian birds, but soon, no match for his foe, he is snatched up by the savage crane and borne in his crooked talons through the air. If you saw this in our own country you would shake with laughter; but in the land where the whole host is only one foot high, though like battles are witnessed every day, no one laughs.

It is likely that Bocchi's other depictions of battles – dwarfs fight a crab, a frog, and a chicken – are variations on this theme.

Bocchi's terror-fraught pictures of dwarfs in battle, tinged with a more humane sentiment and sympathetic feeling, doubtless relate to Juvenal and to eighteenth-century ideas as well. As an anonymous mid-eighteenth-century

writer noted: 'What can be more nobly human than to have a tender sentimental feeling of our own and other's misfortunes.'

And the comic was to be infused with this conceit as well. In his random exegeses on the properties of comedy the settecento playwright Carlo Goldoni advised on injecting pathos, satisfying the requirement that 'the comic combined with the pathetic'. Weeping, as Voltaire noted in a letter of 1772, was common practice at a comedy, and Bachaumont commented on 'the present disposition of the spectators towards emotions and tears at our comic plays'. In his conflation of amusing juxtapositions with sensitivity to human suffering Bocchi has created a more poignant image of *terata*.

This image is manifest in other eighteenth-century depictions. The Bergamesque artist Enrico Alberici, the most notable of Bocchi's imitators, assiduously painted pictures of dwarfs from 1763 until his death in 1775.[35] Pictures like the *Dwarf Kermess* in a private collection are jolly and benign depictions.[36]

At the very close of the eighteenth-century Giovanni Domenico Tiepolo created the *Divertimento*, 104 sheets devoted to the hunchbacked carnival character Punchinello. But in accordance with new ideas concerning the misshapen, Punchinello's proportions have become more elongated and his deformity in many of these drawings is far less noticeable. Indeed, in the drawing depicting a young Punchinello watching farm labourers, thereby learning the value of hard work, a Punchinello farmer industriously digging the land is derived from the sturdy and well-proportioned shoveller in the mid-ground of Tintoretto's *Crucifixion* in the Scuola da San Rocco.[37] Tiepolo's series is clearly intended to amuse – after all it is a 'divertimento' – but it also has its moments of tragedy and empathy. Consider, for example, Punchinello's tender protection of his young son at school or the tragic depiction of the dying Punchinello surrounded by weeping mourners.[38]

Punchinello was, of course, a favoured disguise of carnival revellers in Venice. Thus, like Tiepolo's images of Punchinello, the boundary between the well-formed and the malformed, human oddity and human normality, becomes somehow blurred.[39]

The interest in oddity continues through the nineteenth and into the twentieth century. The side-show typifies an enduring human curiosity for the unusual. But both high and low culture manifest a sympathy for *terata* that is lacking in the seventeenth century. A few notable examples demonstrate this clearly. Consider, for instance, Victor Hugo's description of the monstrous Quasimodo in *Notre Dame de Paris*. His hump, his distorted body, his one glaring eye elicit responses from the crowd: 'Oh! what a horrid looking hunchback. Oh! the evil soul.'[40] But these are responses predicated on a late fifteenth-century 'Weltanschauung', the setting for the novel. When Hugo intrudes nineteenth-century concerns we view Quasimodo as a Christ-like martyr, and

his irregular body is conflated with Hugo's beloved cathedral of Notre Dame itself.[41]

The hunchback is a creature of such powerful emotional resonance that he intrudes upon the popular culture of the cinema. Lon Chaney and Charles Laughton present both a terrifying and yet movingly sympathetic portrayal of Quasimodo in the two cinematic versions of the novel.

Other aspects of twentieth-century cinema culture explore the world of *terata* with compassion or with light-hearted gaiety. In Tod Browning's dark vision of circus life, *Freaks* of 1932, a long prologue pointedly instructs the viewer.

Before proceeding with the showing of the following HIGHLY UNUSUAL ATTRAC-TION, a few words should be said about the amazing subject matter. BELIEVE IT OR NOT – – – – STRANGE AS IT SEEMS. In ancient times anything that deviated from the normal was considered an omen of ill luck or representative of evil. Gods of misfortune and adversity were invariably cast in the form of monstrosities . . . The accident of abnormal birth was considered a disgrace and malformed children were placed out in the elements to die. If perchance, one of these freaks of nature survived, he was always regarded with suspicion. Society shunned him because of his deformity, and a family so hampered was always ashamed of the curse put upon it. Occasionally, one of these unfortunates was taken to court to be jeered at or ridiculed for the amusement of the nobles. Others were left to eke out a living by begging, stealing, or starving. For the love of beauty is a deep seated urge which dates back to the beginning of civilization. The revulsion with which we view the abnormal, the malformed and the mutilated is the result of long conditioning by our forefathers. The majority of freaks themselves, are endowed with normal thoughts and emotions. Their lot is truly a heartbreaking one . . . With humility for the many injustices done to such people (they have no power to control their lot) we present the most startling horror story of the ABNORMAL and THE UNWANTED.

On a more playful note, Disney's *Snow White* of 1937 favours us with endearing dwarfs who provide a cozy sanctuary for the innocent, beautiful princess. And in the *Wizard of Oz* of 1939, cute dancing dwarfs welcome a visitor to a strange land. With the delightful, comforting 'munchkins' we are no longer in Kansas, and we are equally distant from the seventeenth-century depiction of *terata*.

Notes

1. J. Moreno Villa, *Locos, enanos, negros y niños palaciegos*, 45–51.

2. *Ibid.*, 80–81, 87–88, 117.

3. *Ibid.*, 80.

4. E. Chamorro, *El Enano del Rey*, Barcelona, 1991, 188.

5. *The Letters and Works of Lady Mary Wortley Montagu*, I, London, 1837, 324 and P. Darmon, 'Autrefois les Nains', *L'Histoire*, 19, 1980, 55.

6. A. Taylor, 'Sights and Monsters and Gulliver's Voyage to Brobdingnag', *Tulane Studies in English*, VII, 1957, 63.

7. J. Ashton, *Social Life in the Reign of Queen Anne*, London, 1882, 278–9.

8. *Ibid.*, 263.

9. *Ibid.*, 250, 259.

10. B. Stafford, *Body Criticism*, Cambridge and London, 1991, 219–20.

11. S. Johnson, *Dictionary*, E. McAdam and G. Milne eds, New York, 1963, 147.

12. J. Lavater, *Essays on Physiognomy: Designed to Promote the Knowledge and Love of Mankind*, T. Holcroft trans., London, 3rd ed., 1840, 99.

13. J. Kunze and I. Nippert, *Genetics and Malformation in Art*, Berlin, 1986, 9–10.

14. L. Sterne, *The Life and Opinions of Tristram Shandy*, G. Petrie ed., London, 1985, 97.

15. A. Altmann, *Moses Mendelsohn: A Biographical Study*, University of Alabama, 1973, 318–9.

16. *The Letters and Works of Lady Mary Wortley Montagu*, I, 324.

17. *Grande Dizionario della Lingua Italiana*, XI, S. Battaglia ed., Turin, 1981, 171, s.v. 'nano'.

18. D. Diderot, *Encyclopédie, Oeuvres Complètes*, 15, J. Assezar ed., Paris, 1876, s.v. 'laideur', 410.

19. Diderot, *Oeuvres Complètes*, XVII, J. Varloot ed., Paris, 1987, 138.

20. *Ibid.*, 149, 151.

21. Ashton, *Social Life in the Reign of Queen Anne*, 260.

22. W. Hay, *Deformity, An Essay*, London, 1754, 22, 68–70.

23. *Ibid.*, 28–29.

24. *Ibid.*, 8–9.

25. *Ibid.*, 34.

26. *Ibid.*, 30–31.

27. Kunze and Nippert, *Genetics and Malformation in Art*, 9–10.

28. Pérez Sánchez and Gállego, *Monstruos, enanos y bufones*, 125.

29. For the hand on hip pose and its association with the upper class see J. Spicer, 'The Renaissance Elbow', *A Cultural History of Gesture*, J. Bremer and H. Roodenburg eds, Ithaca, 1992, 99. Cf. Pérez Sánchez, *Monstruos, enanos y bufones*, 126, who also notes the dignity of the figure.

30. On this comically mocking gesture see also Brouwer's raucous *Smokers* in the Metropolitan Museum, illustrated in G. Knuttel, *Adriaen Brouwer*, The Hague, 1962, pl. V. For Perkeo see E. Tietze-Conrat, *Dwarfs and Jesters in Art*, 70 and figure 74. The gnomish figures depicted in the caricatures of Ghezzi and Tiepolo belong to a different genre.

31. For Bocchi and his imitators in this genre see M. Olivari, *Faustino Bocchi*.

32. L. Lanzi, *Storia Pittorica dell'Italia*, III, 276.

33. On Bocchi's patrons see M.A. Baroncelli, *Faustino Bocchi ed Enrico Alberici, Pittori di Bambocciate*, Brescia, 1965, 11.

34. The following material on Bocchi, his literary sources, and his relationship to eighteenth-century ideas of sentiment is dependent upon Wind, 'Piccolo Ridicolo: A Little Bit on Bocchi', 124–7.

35. F.M. Tassi, *Vite de'Pittori, Scultori e Architteti Bergameschi*, II, Bergamo, Locatelli, 1793, 112.

36. Illustrated in Baroncelli, *Faustino Bocchi*, figure 54.

37. This drawing is illustrated in A. Gealt, *Domenico Tiepolo, The Punchinello Drawings*, New York, 1986, no. 8.

38. *Ibid.*, nos. 19, 74.

39. J. Lelande, *Voyage en Italie*, Geneva, 1790, 50–51.

40. V. Hugo, *Notre Dame de Paris*, I, v, A. Krailsheimer trans., Oxford, 1993, 59. In Umberto Eco's evocation of the seventeenth century, *The Island of the Day Before*, (New York, 1996, 94–95) deformity is presented from the Baroque point of view. A dwarf is described as 'feo, e infeliz, y ridículo . . . Crumb of a Man'.

41. R. Killick, *Notre Dame de Paris*, Exeter, 1994, 58–61.

Excursus: two clowns at the Spanish Court

The *hombres de placer* at court did not include only cretins and dwarfs. Clowns were also part of this amusing retinue. Among Velázquez's surviving portraits of these figures are Don Juan (Madrid, Prado, Figure 1) and Barbarroja (Madrid, Prado, Figure 2). Both paintings were hung in the so-called 'room of the jesters', a section of the queen's private chambers.[1]

The image of Don Juan pokes fun at military pretensions. He is certainly posed like any traditional military figure. His left hand rests on his sword and his right hand holds a staff of authority. Velázquez may have used Venetian images of power and command as a point of departure. A case in point is Veronese's portrait of an unknown military leader, where like Velázquez's Don Juan the commander stands on a tiled floor.[2] An image of bold authority would have been consonant with the reputation of the real Don Juan who was known for skill, courage and daring audacity.[3] But this is a clown simulating Don Juan, and Velázquez parodies the traditional portrait of military strength. The musket, helmet and breastplate – the very material that one should employ in combat – lie scattered uselessly at Don Juan's feet. Instead of moving to action he makes no attempt to confront the raging naval conflagration that takes place in the background. He poses in splendour, and his benign countenance, creased with a foolish half-grin, betrays an inept paralysis in the face of military disaster. Not only does he reflect the conceit of the world turned topsy-turvy – the military hero as ineffectual fool – but he also refers to the clownish martial figures of comic literature. This type, the blustering *capitano*, was full of false bravado. His promise of action only resulted in the paralysis of fear. As silly soldiers the *capitani* strutted and fretted upon the stage, sporting names like Captain Fear from Hell Valley. One depiction of the type shows a posturing swordsman whose dislike of swordplay is indicated by the spider's web woven around the blade.[4] Or in Martinelli's *Rhetorical compositions of Don Harlequin* of 1601 (Figure 3), the Spanish captain

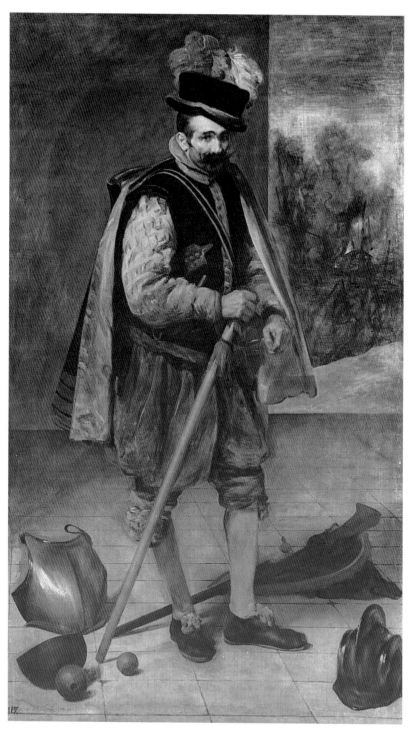

1 Velázquez: *Portrait of Don Juan,* c. 1632

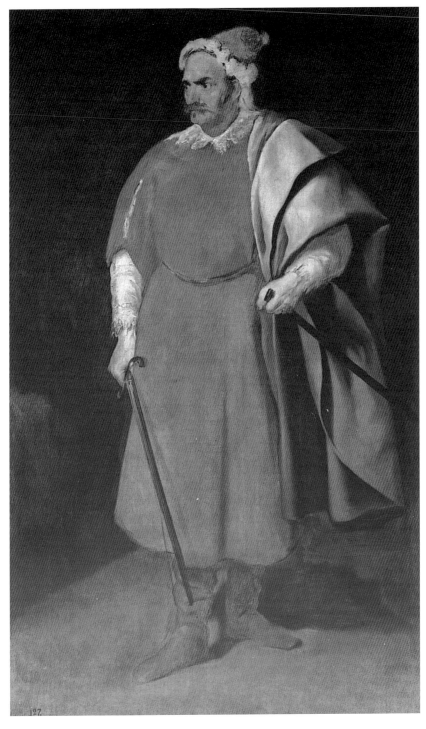

2 Velázquez: *Portrait of Barbarroja*, c. 1632

is represented with a plumed square cap similar to the type worn by Don Juan. Since the Ganassa company of *commedia* players toured Spain as early as the 1580s, this character was doubtless well-known there.[5] Indeed, the comic soldier was readily adapted by Velázquez's great literary contemporaries, Cervantes and Quevedo. Quevedo's trenchant description of the type in *El Buscón*, published in 1626, provides a literary parallel to Velázquez's image.

This fellow's name was Magazo . . . a leading man in comedy and a famous fighter of Moors – in a sword dance . . . he extolled the memory of Don Juan de Lepanto . . . he knew by heart the names of notable Turks . . . knowledge that he acquired from a popular ballad; as a matter of fact he was so thoroughly unacquainted with maritime affairs that if he happened to be discussing about Don Juan of Lepanto's famous encounter he would say that Lepanto was a very brave moor. The poor wretch was such an ignoramus that he served as an excellent butt for our wits.[6]

The portrait of Don Juan was paired with another comic military image, the clown Cristóbal de Casteñada y Pernia, who affected the name of the pirate Barbarroja, Don Juan's notorious enemy.[7] Barbarroja's portrait provides a droll counterpoint to the image of Don Juan. Don Juan's sword is sheathed, Barbarroja brandishes his. Don Juan is spindly, Barbarroja is robust. Don Juan looks sheepish, Barbarroja seems fierce. Even the intense bricky red of Barbarroja's costume complements his apparently irascible nature. But for all of his ferocity Barbarroja still wears a clown's cap; and his bright red costume may allude to another aspect of his activity as a buffoon, his appearance at the bullfight as a clownish matador. There he was attacked by a bull, perhaps incensed by the clown decked out in red.[8] His appearance in the bull ring in such a costume again calls into question empathetic approaches to these buffoons. Was Barbarroja dressed as a human target?

In Book III Chapter 8 of the *Arte de La Pintura*, that wonderful rambling compendium of art theory, self-puffery, and praise for his son-in-law Velázquez, Pacheco discussed a type of portraiture which aroused laughter. His reference to a portrait of the grotesque comic performer Grillos decked out in 'a ridiculous costume' gives humorous portraiture of the 'other' the imprimatur of antique authority.[9] Indeed, even the great Apelles portrayed a court fool.[10] Velázquez, as the new Apelles, could do no less, and his images of court entertainers, pictorial essays in a humorous vein, reveal an objective record of a Golden Age that did not always glitter.

3　Martinelli: *Rhetorical compositions of Don Harlequin*, 1601

Notes

1. J. Brown and J.H. Elliot, *A Palace for a King*, 255.

2. For this military portrait, now in a private collection in Paris, see T. Pignatti, *The Golden Century of Venetian Painting*, Los Angeles, 1979, 114–5.

3. On Don Juan's daring bravery see J. Beeching, *The Galleys of Lepanto*, New York, 1983, 118, 191, 213.

4. For the literary depiction of this type see M. Sand, *The History of the Harlequinade*, London, 1915, 135–57. The foolish Capitano Spavento is depicted with spider web and sword in J. Kennard, *The Italian Theater*, New York, 1964, 32–33.

5. N.D. Shergold, 'Ganassa and the Commedia dell'Arte in Sixteenth Century Spain', *Modern Language Review*, 51, 1956, 359–68.

6. F. Quevedo *El Buscón*, II, ii in *Obras (Prosa)*, I, 327–8. The sword dance, of course, pitted Spaniards against putative Moors. See V. Alford, *Sword Dance and Drama*, Philadephia, 1965, 155. J. Brown, *Velázquez, Painter and Courtier*, 101, also recognized the comic aspects of this figure, but has not pointed out the analogues to literary and theatrical prototypes.

7. For the notorious Barbarroja see A. Papell, *Reyes y Corsarios. Los Barbarroja*, Madrid, 1935. Hassan, son of Barbarroja, battled Don Juan. See M. Yeo, *Don Juan of Austria*, New York, 1934, 224.

8. C. Justi, *Velázquez und Sein Jahrhundert*, II, 313.

9. F. Pacheco, *Arte de La Pintura* (169), F.J. Sánchez Cantón ed., Madrid, 1956, II, 136.

10. Pliny, *The Elder Pliny's Chapters on the History of Art*, K. Jex-Blake and E. Sellers eds, Chicago, 1982, xxxv, 89, 127.

Bibliography

A Collection of Advertisements, British Museum Library

The Age of Correggio and the Carracci, Washington, 1986

Aldrovandi, U., *Monstrorum Historia*, Bologna, 1642

Alford, V., *Sword Dance and Drama*, Philadelphia, 1965

Alpers, S., *The Decoration of the Torre de la Parada*, New York and London, 1971

Alpers, S., 'Interpretation without Representation or the Viewing of *Las Meninas*', *Representations*, I, 1983, 31–42

Altmann, A., *Moses Mendelssohn: A Biographical Study*, University of Alabama, 1973

Antología de Humoristas Españoles, J. García Mercadal ed., Madrid, 1964

de Antonio, L., *Nuevo Plato de Varios Manjares Para Divierto el Ocio*, Zaragoza, 1658

Ariosto, L., *Opere Minori*, C. Segre ed., Milan and Naples, 1954

Aristotle, *Generation of Animals*, (Loeb Classical Library ed.), A.L. Peck trans., Cambridge and London, 1963

Aristotle, *Problemata*, (Loeb Classical Library ed.), W.S. Hett trans., Cambridge and London, 1961

Ashton, J., *Social Life in the Reign of Queen Anne*, London, 1882

Augustine, *The City of God*, (Loeb Classical Library ed.), B.M. Dods trans., New York, 1950

Bacon, F., *Essays*, M. Scott ed., New York, 1908

Bakhtin, M., *Rabelais and His World*, Cambridge and London, 1968

Baldinucci, F., *Notizie de'Professori del disegno*, V, Florence, 1847 ed.

Baroncelli, M.A., *Faustino Bocchi ed Enrico Alberici, Pittori di Bambocciate*, Brescia, 1965

Barton, C., *The Sorrows of the Ancient Romans*, Princeton, 1993

Bartsocas, C., 'Goiters, Dwarfs, Giants, and Hermaphrodites', *Endocrine Genetics and Genetics of Growth*, C. Papandatos and C. Bartsocas eds, New York, 1985, 1–18

Baticle, J., *Trésors de la peinture espagnole*, Paris, 1963

Bätschmann, O., *Nicolas Poussin, Dialectics of Painting*, London, 1990

Bax, D., *Hieronymus Bosch: his picture writing deciphered*, Rotterdam, 1979

Bean, J., 'Johann Liss', *Master Drawings*, XIV, 1976, 64–66

Beeching, J., *The Galleys of Lepanto*, New York, 1983

Bellori, G., *Vite de'pittori, scultori e architetti moderni*, Rome, 1672

Bernheimer, R., *Wild Men in the Middle Ages*, Cambridge, 1952

Berni, F., *Rime*, G. Squarotti ed., Turin, 1969

Bieber, M., *The Sculpture of the Hellenistic Age*, New York, 1967
Boaistuau, P., *Histoires Prodigieuses*, F. de Belleforest ed., Paris, 1593
Boiteux, M. 'Carnaval annexé: Essai de lecture d'une fête romaine', *Annales Economies Sociétés Civilisations*, 32, 1977, 365–80
Bol, L.J., *Adriaen Pietersz. van de Venne, Painter and Draughtsman*, Doornspijk, 1989
Bolzoni, L., 'L'Invenzione dell'Aldobrandini per la sua Villa di Campagna', *Documentary Culture Florence and Rome from Grand Duke Ferdinand I to Pope Alexander VII*, E. Cropper, G. Perini, F. Solinas eds, Bologna, 1992, 316–48
Briganti, G., Trezzani, L., Laureati, L., *I Bamboccianti*, Rome, 1983
Broos, B., *De Rembrandt a Vermeer*, The Hague, 1986
Brown, J., *Jusepe de Ribera: Prints and Drawings*, Princeton, 1973
Brown, J., *Images and Ideas in Seventeenth-Century Spanish Painting*, Princeton, 1978
Brown, J., *Velázquez, Painter and Courtier*, New Haven and London, 1986
Brown, J., and Elliot, J.H., *A Palace for a King*, New Haven and London, 1980
Buchardus de Bellevaux, *Apologia de Barbis, Corpus Christianorum*, LXII, G. Constable and R.B.C. Huygens eds, Turnholt, 1985
Bulwer, J., *Chirologia: On the Natural Language of the Hand* (1644), J. W. Cleary ed., Carbondale and Edwardsville, 1974
Buonarotti il Giovane, M., *La Fiera* (1618), P. Fanfani ed., Florence, II, 1860
Burke, P., *Popular Culture in Early Modern Europe*, London, 1978
Camón Aznar, J., *Velázquez*, I, II, Madrid, 1964
Campanella, T., *Poesie*, M. Vinciguerra ed., Bari, 1938
Campbell, L., *Renaissance Portraits*, New Haven and London, 1990
Camporesi, P., *Il Paese della Fame*, Bologna, 1978
Canel, A., *Recherches sur les Fous des Rois de France*, Paris, 1873
Canti Carnascialeschi del Rinascimento, C. Singleton ed., Bari, 1936
Castiglione, B., *Il Cortegiano*, Novara, 1968
Catalogue. Alte Pinakothek München, Munich,1983
Cats, J., *Moral Emblems*, R. Fairlie trans., London, 1860
Cavalaca, D., *Specchio di Croce*, Rome, 1738
Ceard, J., *La Nature et les Prodiges*, Geneva, 1977
Cela, C.J., *Diccionario Secreto*, II, Madrid, 1974
Chamorro, E., *El Enano del Rey*, Barcelona, 1991
Chapman, H.P., *Rembrandt's Self Portraits*, Princeton, 1990
Charcot, J. and Richer, P., *Les Difformes et les Malades dans L'Art*, Paris, 1889
Chone, P. *et al.*, *Jacques Callot*, Paris, 1992
Cicero, *De Oratore* (Loeb Classical Library ed.), H. Rackham trans., Cambridge and London, 1942
Clark, K., *Leonardo da Vinci*, Harmondsworth,1961
Clark, K., and Pedretti, C., *Leonardo da Vinci Drawings at Windsor Castle*, I, London, 1968
Clifton, J., '*Ad vivum mire depinxit*: Toward a Reconstruction of Ribera's Art Theory', *Storia dell'Arte*, 83, 1995, 111–32
Cocchiara, G., *Il Mondo alla Rovescina*, Turin, 1963
Covarrubias, S., *Emblemas Morales*, Madrid, 1610
Covarrubias, S., *Tesoro de la Lengua Castellana* (1611), M. de Riquier ed., Barcelona, 1943
Darmon, P., 'Autrefois les Nains', *L'Histoire*, 19, 1980, 49–57
Davenant, W., *The Shorter Poems and Songs from the Plays and Masques*, A.M. Gibbs ed., Oxford, 1972
Davidson, J., *David Teniers the Younger*, Boulder, 1979
Deleito y Pinuela, J., *El Rey se Divierte*, Madrid, 1964

Diccionario de la Lengua Castellana, III, IV, Madrid, 1732, 1734

Diccionario General Etimológico de la Lengua Española, IV, Madrid, 1889

Diderot, D., *Encyclopédie, Oeuvres Complètes*, 15, J. Assezar ed., Paris, 1876

Diderot, D., *Oeuvres Complètes*, XVII, J. Varloot ed., Paris, 1987

Dio, *Roman History*, (Loeb Classical Library ed.), H. Foster trans., Cambridge and London, 1955

De Dominici, B., *Vite de'Pittori, Scultori, ed Architetti Napoletani*, Naples, 1745, III

Duchartre, P., *The Italian Comedy*, New York, 1929

Eco, U., *The Island of the Day Before*, New York, 1996

Evans, E.. 'Physiognomy in the Ancient World', *Transactions of the American Philosophical Society*, 59, 1969, 3–101

Evelyn, J., *The Diary*, A. Dobson ed., London, 1908

Félibien, A., *Entretiens sur les vies et sur les ouvrages des plus excellens peintres anciens et modernes*, Trevoux, 1725 ed.

Franits, W., *Paragons of Virtue*, Cambridge, 1993

Fransolet, M., *François Duquesnoy*, Brussels, 1941

Du Fresnoy, C.A., *De Arte Graphica (The Art of Poetry)*, W. Mason trans., York, 1783

Friedman, J. *The Monstrous Races in Medieval Art and Thought*, Cambridge and London, 1981

Gaignebet, C., and Lajou, J.D., *Art Profane et Religion Populaire au Moyen Age*, Paris, 1985

Garzoni, T., *Il seraglio de gli Stupori del Mondo*, Venice, 1613

Gealt, A., *Domenico Tiepolo, The Punchinello Drawings*, New York, 1986

Geyl, P., *The Netherlands in the Seventeenth Century*, I, New York, 1961

Góngora, L., *Obras Completas*, J. Mille y Giménez and I. Mille y Giménez eds, Madrid, 1967

Goodman, E., *Rubens: The Garden of Love as 'Conversatie a la Mode'*, Amsterdam and Philadelphia, 1992

Gracián, B., *El Criticón*, E. Calderón ed., Madrid, 1971

Grande Dizionario della Lingua Italiana, XI, S. Battaglia ed., Turin, 1981

Grant, H., 'Images et Gravures du Monde À L'Envers dans leur relations avec la pensée et la littérature Espagnoles', *L'Image du Monde Renversé et ses Représentations Littéraires et Para-Littéraires de la Fin du XVIᵉ Siècle du Milieu du XVIIᵉ*, J. Lafond and A. Redondo eds, Paris, 1979, 17–33

Gregori, M., 'Nuovi accertamenti in Toscana sulla Pittura Caricata e Giocosa', *Arte Antica e Moderna*, 13/16, 1961, 400–16

Grosjean, A., 'Toward an Interpretation of Pieter Aertsen's Profane Iconography', *Konsthistorisk Tidskrift*, XLIII, 1974, 121–43

Gudiol, J., *Velázquez*, New York, 1974

Gudlaugsson, S.J., *The Comedians in the Work of Jan Steen and his Contemporaries*, Soest, 1975

Gusinde, M., 'Kenntnisse und Urteile Pygmaen in Antike und Mittelalter', *Nova Acta Leopoldina*, 25, 162, 1962, 5–25

Haecht, P., 'The Debate on Symbol and Meaning in Dutch Seventeenth-Century Art: An Appeal to Common Sense', *Simiolus*, 16, 1986, 173–87

Hartt, F., *Giulio Romano*, New York, 1981

Hay, W., *Deformity, An Essay*, London, 1754

Heers, J., *Fêtes des Fous et Carnavals*, Paris, 1983

Henkel, A., and Schöne, A., *Emblemata: Handbuch zur Sinnbildkunst des XVI. und XVII. Jahrhunderts*, Stuttgart, 1967

Herklotz, I., 'Cassiano dal Pozzo's Bermerkungen zu Lorenzo Pignoria's *De Servis'*, *Documentary Culture Florence and Rome, from Grand Duke Ferdinand I to Pope Alexander VII*, E. Cropper, G. Perini, F. Solinas eds., Bologna, 1992, 109–25

Hirth, G., *Picture Book of the Graphic Arts*, III, New York, 1972

Horace, *Epistles, Complete Works*, C. Kraemer ed., New York, 1936

Huemer, F., *Portraits, I, Corpus Rubenianum*, Brussels, 1977

Hugo, V., *Notre Dame de Paris*, A. Krailsheimer trans., Oxford, 1993

Huizinga, J., *Dutch Civilization in the Seventeenth Century*, New York, 1968

Hume, M., *The Court of Philip IV*, New York and London, 1907

Il picariglio castigliano, cioe vita del cativello Lazariglio di Tormes, B. Barezzi trans., Venice, 1635

Iffland, J., *Quevedo and the Grotesque*. London, 1978

Indagine, J., *Brief Introduction both Naturall, Pleasant and also Delectable unto the the Art of Chiromancy or Manual Divination and Physiognomy*, F. Withers trans., London, 1558

Janson, H., *Apes and Ape Lore*, London, 1952

Johnson, S. *Dictionary*, E. McAdam and G. Milne eds, New York, 1963

Jongh, E. de, 'Erotica in vogelperspectief. De dubbelzinnigheid van een reeks 17de eeuwse genrevoorstellingen', *Simiolus*, III, 1968–69, 22–69

Jordan, W., and Felton, C., *Jusepe de Ribera, Lo Spagnoletto*, Fort Worth, 1982

Juvenal, *Satires of Juvenal and Persius* (Loeb Classical Library ed.), G.G. Ramsay trans., Cambridge and London, 1957

Justi, C., *Velázquez und Sein Jahrhundert*, I, II, Bonn, 1923

Kahan, G., *Jacques Callot, Artist of the Theater*, Athens, 1976

Kamen, H., *Spain in the Later Seventeenth Century*, London and New York, 1980

Kennard, J., *The Italian Theater*, New York, 1964

Keutner, H., 'Der Giardino Pensile der Loggia dei Lanzi und seine Fontane', *Kunstgeshichtliche Studien für Hans Kaufmann*, Berlin, 1956, 240–51

Killick, R., *Notre Dame de Paris*, Exeter, 1994

Kirschenbaum, B., *The Religious and Historical Paintings of Jan Steen*, New York and Montclair, 1977

Klein, H.A., *Graphic Worlds of Pieter Brueghel the Elder*, New York, 1963

Knuttel, G., *Adriaen Brouwer*, The Hague, 1962

Konecny, L., 'Shades of Leonardo in an Etching by Jusepe de Ribera', *Gazette des Beaux Arts*, 95, 1980, 91–94

Konecny, L., 'An Unexpected Source for Jusepe de Ribera', *Source*, XIII, 1994, 21–24

Konecny, L., 'Una pintura de Juan Sánchez Cotán, Emblematizada por Sebastián de Covarrubias', *Actas de I Simposio Internacional de Emblemática*, Teruel, 1994, 823–34

Korcher, A., *Mémoires de la Duchesse Sophia*, Leipzig, 1879

Koslow, S., 'Frans Hals' Fisherboys: Exemplars of Idleness', *Art Bulletin*, LVII, 1975, 418–32

Kunze, J. and Nippert, I., *Genetics and Malformation in Art*, Berlin, 1986

Kwakkelstein, M., *Leonardo as a Physiognomist, Theory and Drawing Practice*, Leiden, 1994

Landrey, J., *Tératologie*, Clermont, 1603

Lanzi, L., *Storia Pittorica dell'Italia*, III, Milan, 1825

La Vida de Lazarillo de Tormes, J. Cejado y Fracua ed., Madrid, 1941

Lavater, J., *Essays on Physiognomy: Designed to Promote the Knowledge and Love of Mankind*, T. Holcroft trans., London, 1840 (3rd ed.)

Lavin, I., 'Duquesnoy's "Nano di Créqui" and Two Busts by Francesco Mochi', *Art Bulletin*, LII, 1970, 132–49

Lavin, M.A., *Seventeenth Century Barberini Documents and Inventories of Art*, New York, 1975

Lea, K.M., *Italian Popular Comedy*, Oxford, 1934, I

Lelande, J., *Voyage en Italie*, Geneva, 1790

Levine, D., 'Pieter Van Laer's *Artist's Tavern*: An Ironic Commentary on Art', *Jahrbuch Preussicher Kulturbesitz*, IV, Berlin, 1987, H. Bock and T.W. Gaehtgens eds, 169–91

Liceti, F., *De La Nature, Des Causes, Des Differences des Monstres.*, F. Houssay trans., Paris, 1937

Lieure, J., *Jacques Callot*, New York, 1969, II

Lomazzo, G.P., *Trattato dell'arte de la Pittura*, Milan, 1584

Longinus, *On the Sublime*, (Loeb Classical Library ed.), A.O. Prickard trans., Oxford, 1926

López Pinciano, A., *Philosophía Antigua Poética* (1596), III, A.C. Picazo ed., Madrid, 1953

López-Rey, J., *Velázquez, A Catalogue Raisonné of His Oeuvre*, London, 1963

López-Rey, J., *Velázquez The Artist as Maker*, Lausanne-Paris, 1979

Lucian, *The Carousal, The Fly*, (Loeb Classical Library ed.), A.M. Harmon trans., London and New York, 1927, I

Malvasia, C.C., *Felsina Pittrice* (1678), M. Brascaglia ed., Bologna, 1971

Marino, G.B., *Opere*, A.A. Rosa ed., Milan, 1967

Martial, *Epigrams*, (Loeb Classical Library ed.), W.C.A. Ker trans., Cambridge and London, II, 1978

Martin, E., *Histoire des Monstres*, Paris, 1880

Mayer, A., *Jusepe de Ribera*, Leipzig, 1923

McMahon, A.P., *Leonardo's Treatise on Painting*, Princeton, 1965

Meijer, B., 'Esempi del Comico figurativo nel rinascimento Lombardo', *Arte Lombarda*, 16, 1971, 259–66

Mellinkoff, R., *Others: Signs of Otherness in Northern European Art of the Late Middle Ages*, Berkeley and Los Angeles, I, II, 1993

Merke, F., *History and Iconography of Endemic Goiter and Cretinism*, Boston, 1984

Miedema, H., 'Realism and Comic Mode: The Peasant', *Simiolus*, 9, 1977, 205–19

Moffitt, J.F., 'Velázquez, Fools, Calabacillas and Ripa', *Pantheon*, XL, 1982, 304–9

Moffitt, J.F., 'The Meaning of the Mise-en-Scène of *Las Meninas*', *Art History*, VI, 1983, 271–300

Moffitt, J.F., 'The Fifteen Emblematic "Genre Scenes" in the *Nova Poemata* (1624)', *Konsthistorisk Tidskrift*, LVIII, 1989, 157–65

Mojzer, M., *Dutch Genre Paintings*, Budapest, 1967

Monestier, M., *Les Nains*, Paris, 1977

Montagu, M., *The Letters and Works of Lady Mary Wortley Montagu*, I, London, 1837

Montaigne, M., *The Complete Works*, D. Frame trans., Stanford, 1957

Moreno, J., *Don Fernando Enríquez de Ribera*, Seville, 1969

Moreno Villa, J., *Locos, Enanos, Negros, y Niños Palaciegos*, Mexico City, 1939

Moschetti, A., 'Il Gobbo di Rialto', *Nuovo Archivo Veneto*, 5, 1893, 5–93

Mosco, M. and Trkulja, S., *Natura Viva in Casa Medici*, Florence, 1985

Nick, F., *Die Hofnarren*, I, Stuttgart, 1861

Nieremberger, J., *Curiosa y Oculta Filosofía*, Madrid, 1643

Nieremberger, J., *Prudential Reflections, Moral Considerations and Stoical Maximes*, London, 1674

Olivari, M., *Faustino Bocchi e l'arte di figurar pigmei*, Milan, 1991

Orozco Díaz, E., *El Pintor Fray Juan Sánchez Cotán*, Granada, 1993

Ortiz, A., Pérez Sánchez, A.E., Gállego, J., *Velázquez*, New York, 1989

Pacheco, F., *Arte de la Pintura* (1649), F.J. Sánchez Cantón ed., I, II, Madrid, 1956

Paleotti, G., *Discorso Intorno alle Imagine Sacre e Profane* (Bologna, 1582) in P. Barocchi, *Trattati d'Arte del Cinquecento*, Bari, II, 1960

Palomino, A., *Lives of the Eminent Spanish Painters and Sculptors*, N. Mallory trans., Cambridge and New York, 1987

Panofsky, E., 'Conrad Celtes and Kunz von der Rosen: Two Problems in Portrait Identification', *Art Bulletin*, XXIV, 1942, 44–50

Panofsky, E. *Idea, a concept in art theory*, J.S. Peake trans., Columbia, South Carolina, 1968

Panofsky, E., *The Life and Art of Albrecht Dürer*, Princeton, 1955

Papell, A., *Reyes y Corsarios. Los Barbarroja*, Madrid, 1935

Paré, A., *On Monsters and Marvels*, (1573), J.C. Pallister trans., Chicago and London, 1982

Parrondo, J. *et al.*, *Estampas, Cinco Siglos de Imagen Impresa*, Madrid, 1982

Passeri, G.B., *Le Vite de Pittori, Scultori ed Architetti*, Rome 1772 ed.

Pecchai, P., 'Nani e Buffoni in Roma nel Seicento, Botolino e Moreto', *Strenna dei Romanisti*, MMDCCI, April 1948, 101–5

Pérez Sánchez, A.E., 'Las Colecciones de pintura del conde de Monterrey', *Boletín de la Real Academia de la Historia*, 174, 1977, 417–59

Pérez Sánchez, A.E., *Juan Carreño de Miranda*, Avila, 1985

Pérez Sánchez, A.E. *et al.*, *Monstruos, Enanos, y Bufones en la Corte de los Austrias*, Madrid, 1986

Pérez Sánchez, A.E., *Carreño, Rizi, Herrera y la Pintura Madrileña de su Tiempo*, Madrid, 1986

Pérez Sánchez, A.E. and Spinosa, N., *Jusepe de Ribera*, New York, 1992

Philostratus, *Imagines*, (Loeb Classical Library ed.), A. Fairbanks trans., Cambridge, 1940

Pignatti, T., *The Golden Century of Venetian Painting*, Los Angeles, 1979

Plautus, *Stichus*, H. Petersmann ed., Heidelberg, 1977

Pliny, *The Elder Pliny's Chapters on the History of Art*, K. Jex-Blake and E. Sellers eds, Chicago, 1982

Pliny, *Natural History*, VII, (Loeb Classical Library ed.), H. Rackham trans., Cambridge and London, 1942

Plutarch, 'On Curiosity', *Complete Writings*, VII, N.W. Goodwin ed., New York, 1906

Poesía Erótica, J.M. Díez Borque ed., Madrid, 1977

Pomian, K., *Collectionneurs, Amateurs et Curieux, Paris, Venise: XVIᵉ-XVIIIᵉ Siècle*, Gallimard, 1987

Ponz, A., *Viaje de España*, VI, Madrid, 1793

Porcher, J., *Les Songes Drolatiques de Pantagruel*, Paris, 1959

Della Porta, G.B., *Della Fisonomia dell'Uomo* (1610), M. Cognari ed., Parma, 1988

Della Porta, G.B., *Natural Magick* (1658), D. Price ed., New York, 1957

Posner, D., *Annibale Carracci A Study in the Reform of Italian Painting Around 1590*, I, II, London and New York, 1971

Pulci, L., *Morgante*, F. Ageno ed., Milan and Naples, 1955

Quevedo, F., *Obras*, I, II, F. Buendía ed., Madrid, 1961

Rabelais, F., *Oeuvres de Rabelais, Songes Drolatiques de Pantagruel*, E. Johanneau ed., Paris, 1823

van Regteren Altena, I.Q., *Jacques de Gheyn, Three Generations*, I, II, The Hague, 1983

Richards, K. and Richards, L., *The Commedia Dell'Arte, A Documentary History*, Oxford, 1990

Richards, L.S., *Johann Liss*, Cleveland, 1975

Ripa, C., *Iconologia*, Rome, 1603

Rodríguez Marín, F. *12,600 Refranes Más*, Madrid, 1930

Rollenhagen, G., *Nucleus Emblematum Selectissimorum*, Utrecht, 1613

Rossi, *Ritratti in Barocco, La festa nella Caricatura toscana nel Seicento*, Locarno, 1985

Royalton-Kisch, M., *Adriaen Van de Venne's Album*, London, 1988

Russell, D., Blanchard, J., Krill, J., *Jacques Callot, Prints and Related Drawings*, Washington, 1975

Sacchetti, F., *Il Trecentonovelle*, E. Faccioli ed., Turin, 1970

Sánchez Cantón, F.J., 'Los Libros Españoles Que Poseyó Velázquez', *Varia Velazqueña*, I, Madrid, 1960, 640–8

Sand, M., *The History of the Harlequinade*, London, 1915

Sandrart, J., *Academie der Bau-Bild-und Mahlerey Künste* (1675), A.R. Peltzer ed., Munich 1925

Schama, S., *The Embarrassment of Riches*, New York, 1988

Schenk, J., *Monstrorum Historia*, Frankfort, 1609

Scheugl, H., *Show Freaks and Monster*, Cologne, 1974

Seneca, *Controversiae*, (Loeb Classical Library ed.), M. Winterbottom trans., Cambridge and London, III, 1974.

Serullaz, M., *Velázquez*, New York, 1981

Shakespeare, W., *The Complete Works*, G.B. Harrison ed., New York, 1952

Shergold, N.D., 'Ganassa and the Commedia dell'Arte in Sixteenth Century Spain', *Modern Language Review*, 51, 1956, 359–68

Shergold, N.D., *A History of the Spanish Stage from Medieval Times until the End of the Seventeenth Century*, Oxford, 1967

Simons, G., *The Clubfoot*, New York, 1994

Slive, S., *Frans Hals*, I, III, London, 1970, 1974

Solerti, A., *Musico, Ballo e Drammatica alla Corte Medicea dal 1600 al 1637*, New York and London, 1968

de Solis y Rivadeneyra, A., 'A un enano estevado', *Biblioteca de Autores Españoles, Poetas Líricos de Los Siglos XVI y XVII*, A. de Castro ed., 42, Madrid, 1951

Spear, R., *Domenichino*, New Haven and London, 1982, I, II

Spear, R., 'Johann Liss Reconsidered', *Art Bulletin*, LVIII, 1976, 582–93

Spicer, J., 'The Renaissance Elbow', *A Cultural History of Gesture*, J. Bremer and H. Roodenburg eds, Ithaca, 1992, 84–128

Spina, A.M., *Giulio Parigi e Gli Incisori della sua Cerchia*, Naples, 1983

Stafford, B., *Body Criticism*, Cambridge and London, 1991

Statius, *Silvae*, (Loeb Classical Library ed.), J.H. Mozley trans., Cambridge and London, 1961

Steinberg, L., 'Review of López-Rey, *Velázquez*', *Art Bulletin*, XLVII, 1965, 274–94

Sterne, L., *The Life and Opinions of Tristram Shandy*, G. Petrie ed., London, 1985

Stewart, J., *English Portraits of the Seventeenth and Eighteenth Centuries*, Los Angeles, 1974

Suetonius, *Lives of the Twelve Caesars*, A. Thomson and T. Forrester eds, London, 1914

Sullivan, E., 'Ribera's Club-Footed Boy: Image and Symbol', *Marsyas*, 19, 1977–78, 17–21

Sullivan, M., *Brueghel's Peasants*, Cambridge, 1994

Sumberg, S. *The Nuremberg Schembart Carnival*, New York, 1966

Sutton, P. et al., *Masters of Seventeenth Century Dutch Genre Painting*, Philadelphia, 1984

Swain, B., *Fools and Folly During the Middle Ages and the Renaissance*, New York, 1932

Tacitus, *Annals*, M. Grant trans., New York, 1993

Tassi, F.M., *Vite de'Pittori, Scultori e Architetti Bergameschi*, II, Bergamo, Locatelli, 1793

Taylor, A., 'Sights and Monsters and Gulliver's Voyage to Brobdingnag', *Tulane Studies in English*, VII, 1957, 29–82

Tempesti, A. 'Caramogi di Stefano della Bella', *Itinerari, Contributi alla Storia dell'Arte in memoria di Maria Luisa Ferrari*. I, Florence, 1979, 117–26

Ternois, D., *L'Art de Jacques Callot*, Paris, 1962

de Tervarent, G., *Attributs et Symboles dans L'Art Profane 1450–1600*, Geneva, 1958

Thieme-Becker, *Kunstler-Lexicon*, XXXI, Leipzig, n.d.

Thompson, C.J.J., *The Mystery and Lore of Monsters*, New Hyde Park, 1968

Thorndike, L., *A History of Magic and Experimental Science*, VI, VIII, Columbia, 1941

Tietze-Conrat, E., *Dwarfs and Jesters in Art*, New York, 1957

Trapier, E. de Gué, *Velázquez*, New York, 1948

Turner, C. J. Ribton, *A History of Vagrants and Vagrancy and Beggars and Begging*, London, 1887

Vandenbroeck, P., *Beeld Van de Andere Vertoog over Het Zelf*, Antwerp, 1987

Varey, J.E., *Historia de Los Títeres en España*, Madrid, 1957

De Vesme, A., and Massar, P., *Stefano della Bella*, New York, 1971

Viatte, F. 'Allegorical and Burlesque Subjects by Stefano della Bella', *Master Drawings*, XV, 1977, 347–62

Vigarello, G. 'The Upward Training of the Body from the Age of Chivalry to Courtly Civility', *Fragments for a History of the Human Body*, II, New York, 1989, 141–96

Virgil, *Aeneid*, V.P. Dickinson trans., New York, 1961

Vlieghe, H., *Portraits, II, Corpus Rubenianum*, Oxford, 1987

Wace, A.J.B., 'Grotesques and the Evil Eye', *The Annual of the British School of Athens*, X, 1903–4, 103–14

Welu, J. *et al.*, *Judith Leyster, A Dutch Master and Her World*, Worcester and Zwolle, 1993

Wheelock, A. *et al.*, *Anthony Van Dyck*, Washington, 1990

Wiles, B., *The Fountains of the Florentine Sculptors and Their Followers*, New York, 1973

Wilson, D., *Signs and Portents: Monstrous Births From the Middle Ages to the Enlightenment*, London and New York, 1993

Wind, B., 'Annibale Carracci's *Scherzo*: The Christ Church *Butcher Shop*', *Art Bulletin*, LVIII, 1976, 93–96

Wind, B., 'Piccolo Ridicolo: A Little Bit on Bocchi', *Arte Lombarda*, 108 / 109, 1994, 124–7

Wind, B., 'Pitture Ridicole: Some Late Cinquecento Comic Genre Paintings', *Storia dell'Arte*, 20, 1974, 25–35

Wind, B., *Velázquez's Bodegones: A Study in Seventeenth-Century Spanish Genre Painting*, Fairfax, 1987

Wölke, H., *Untersuchungen zur Batrachomyomachie*, Meisenheim am Glan, 1978

Wright, T., *History of Caricature and the Grotesque in Literature and Art*, (1865), New York, 1968

Yeo, M., *Don Juan of Austria*, New York, 1934

Zapperi, R., 'Arrigo le Velu, Pietro le Fou, Amon le Nain et Autres Bêtes: Autour D'Un Tableau D'Agostino Carrache', *Annales Economies Sociétés Civilisations*, 40, 1985, 307–27

Zapperi, R., *Annibale Carracci*, Turin, 1989

Index of names

Alberici, Enrico, 128
Albertus Magnus, 9
Aldorisio, Prospero, 51
Aldrovandi, Ulisse, 11, 53
Alexander of Hales, 9
Andry, Nicolas, 124
Antonio, Luis de, 72
Ariosto, 15, 20, 21
Aristotle, 5–6, 53
Augustine, 8

Baccio del Bianco, 38–9, 55
Bacon, Francis, 13
Barberini, Francesco, 11
Barezzi, Barezzo, 58
Baroni, Paolo, 26
Bartoli, Daniele, 60
della Bella, Stefano, 38, 40–1
Bellori, Giovanni Pietro, 24
Berni, Francesco, 53
Besse, Pierre de, 60
Blaise de Vigenère, 14
Boaistuau, Pierre, 13
Bocchi, Faustino, 43, 126
Bonifaccio, Baldassare, 58
Bronzino, 27
Browning, Tod, 129
Buchardus de Bellevaux, 56
Buonarotti the Younger, Michelangelo, 53

Callot, Jacques, 27–33, 36–7, 60–1, 114–15

Campanella, Tomasso, 13
Caravaggio, 51
Caro, Roderigo, 55
Carreño, Juan, 67, 89–93
Carracci, Agostino, 19–21
Carracci, Annibale, 21, 49
Cassiano dal Pazzo, 11
Castiglione, Baldassare, 53
Cats, Jacob, 106–9
Cavalaca, Domenico, 51
Charles, Sieur de Créqui, 26
Cicero, 7
Clement of Alexandria, 56
Cortes, Geronimo, 51
Covarrubias, Sebastiano, 58, 71, 82, 84

Davenant, William, 15
De Domenici, Bernardo, 49
Della Porta, Giovanni, 11, 51, 58
Deschamps, Eustache, 9
Diderot, Denis, 124
Disney, Walt, 129
Domenichino, 21–3
Dürer, Albrecht, 51
Dusquesnoy, Francesco, 25–6
Dyck, Anthony van, 102–3

Erasmus, 28
d'Estoile, Pierre, 11
Eyck, Jan van, 51
Evelyn, John, 57

Félibien, Andres, 27
Fenton, Edward, 14
Fernando Afán de Ribera y Enriquez, 55
Fiorimi, Giovanni, 29
Fruijtiers, Philip, 29, 53

Garzoni, Tomasso, 19, 24
Gervaise of Tilbury, 9
de Gheyn, Jacques, 29, 53
Goldoni, Carlo, 128
Góngora, Luis de, 72
Góngora, Ignacio, 55
Gracián, Baltasar, 77
Gryneus, Simon, 10

Hals, Frans, 109–10
Hamen, Juan van der, 67, 85, 87
Hay, William, 125
Hogarth, William, 127
Hopfer, Daniel, 85–6
Horace, 6
Houasse, Michel Ange, 125, 127
Hugo, Victor, 128

Juvenal, 7, 127

Laer, Peter van, 114, 116–20
Landrey, Jean, 12
Lanzi, Luigi, 127
Lavater, Johann, 124
Leonardo da Vinci, 11, 14–15, 49
Liceti, Fortunus, 10–11
Liss, Johann, 36
Livy, 8
Longinus, 6
López Pinciano, Alonso, 82
Lorrain, Claude, 116
Luccini, Antonio, 36
Lucian, 7

van Mander III, Karel, 63
Mantegna, Andrea, 19
Marino, Giambattista, 15
Marcus-Marci, Joannes, 12
Martial, 6
Martinelli, Tristano, 131, 135

Mazo, Juan Battista Martínez del, 89
Mazzina, Caterina, 56
Mendelssohn, Moses, 124
Mitelli, Agostino, 41–3
Molenaer, Jan, 89–90, 109–11
Montagu, Mary Wortley, 124
Montaigne, 10
Montecuccoli, Carolus, 51
Moro, Antonio, 63, 82–3

Nieremberger, Juan, 11, 60
Nobili, Giacinto de, 58
Nuñez de Llerena, Alonso, 55

Pacheco, Francisco, 134
Paleotti, Gabriele, 20
Palomino, Antonio, 90
Paré, Ambrose, 11–12
Parigi, Alfonso, 27
Passeri, Giovanni Battista, 23, 114
Pepys, Samuel, 11
Piero della Francesca, 51
Plautus, 7
Pliny, 6–7
Polemo, 51
Poussin, Nicolas, 116

Quevedo, Francisco, 72

Rabelais, François, 29
Raphael, 23
Roeff, Jacob, 12
Ribera Jusepe de, 49–63
Rizi, Francesco, 89
Rollenhagen, Gabriel, 105
Rubens, Peter Paul, 99–102

Sacchetti, Francesco, 53
Sadler, John, 13
Sánchez Coello, Alonso, 74–5
Sanderson, William, 90
Sandrart, Joachim, 114
Seneca, 6
Schenk, Johan, 10–11
Schoonhovius, Florentius, 110
Shakespeare, 5–6, 12

Solis y Rivaseneyra, Antonio de, 72
Sorbin, Arnaud, 12
Spada, Valerio, 36, 38
Statius, 7
Steen, Jan, 111–15
Sterne, Lawrence, 124
Suetonius, 8

Tacitus, 7
Tiberio di Tito, 27
Tiepolo, Giovanni Domenico, 128
Tintoretto, 128

Vega, Lope de, 55
Venne, Adriaen van de, 104–8
Velázquez, 67–89, 131–4
Villadrando, Roderigo, 76–7
Visscher, Roemer, 111
Voltaire, 128

Ward, Ned, 123
Weinrich, Martin, 12
Werff, Adriaen van der, 127

Subject index

Antiquity, the ancient world, 6–8, 28–9,
 53
apes and monkeys, 5, 15, 19, 21, 102

ballads, 13–14
beards, 55–8
beggars, 58, 60, 72
births, aberrant/monstrous, 6, 11, 13
buffoon, 71

Canards, 11
carnival, 21, 40, 53
cats, 21, 43
charity, 60
charms, 8
children
 exhibited, 7, 11–12
 horned, 11
 maimed, 6, 7
 monstrous, put to death, 8
Church, Christian attitudes and beliefs,
 8–9, 10, 12–13, 56, 58
cinema, 129
clowns, 53
 at Spanish court, 131–4
club foot, 58–63, 106–7, 124
cockatoo, 90, 125
commedia dell'arte, 27, 29, 36, 38, 40, 43,
 53–5
corpulence, 67, 90–4
crane, heron, 27, 127

cripples, 60
 see also club foot; legless girl
cyclopes, 21

deformity, the monstrous
 attitudes to, 5–6, 9–11
 derision, mockery, disdain, 6, 7, 8–9,
 12, 14–15, 19, 23–4, 26, 27, 43, 71–2,
 77–80, 125
 fascination, 5, 19
 revulsion, dread, 5, 6, 8–9, 19
 sympathy, compassion, 43, 67–71,
 107–9, 123–9
 taxonomic interest, 6, 10–11, 19, 99
 and folly, 28, 53, 82, 106
 and mental agility, 125
 and sin, moral shortcomings, 5, 9, 11,
 12–14, 28, 51–3, 58, 124
dogs, 19, 21, 60–3, 101, 102, 105, 109, 113
dove, 113
dwarfs
 in antiquity, 6, 7, 8, 28–9
 early modern attitudes to, 11, 12, 13, 14,
 15
 in eighteenth century, 123, 124, 125–8
 in Italy, Italian art, 19–43
 in Middle Ages, 9
 in Northern European art, 99–118
 a Ribera painting, 60–3
 at Spanish court, 63, 67–90, 123, 125–7
 Walt Disney, 129

eggs, 113
entertainment, exhibitions, 7, 11–12, 26, 123
evil eye, 8

facial deformity, 49–58
 see also hairiness, excessive; snub noses; women, pig-faced
fools, court, 67, 71, 77–80, 123
frogs, 127

gobbi, 27–36
goitres, 49, 53–4

hairiness, excessive, 11, 19–20, 21, 57
hats, various, 53, 74, 118
hermaphrodites, 7
heron, *see* crane
hombre de placer, 71, 131
hunchbacks, 7, 26, 27, 28–9, 72, 107–9, 113–18, 124, 128–9

idiots, imbeciles, 6

jesters, 67
 see also fools, court
juramento, 74

legless girl, 56–7

medical texts, 13, 28, 51
Middle Ages, 6, 8–9, 53
monkeys, *see* apes and monkeys
monsters, *see* deformity

natural law, cosmic order, violated by deformity, 5, 8, 12, 14, 124

 see also world turned upside down
nature, variety of, 9–10

omens, portents, 6, 7–8, 9, 12, 58
orange, 102
owls, 27

parrots, 19
playing cards, 82
portents, *see* omens
portraiture, two purposes of, 20–1
poverty, the poor, 60
Punchinello, 38, 43, 53, 128
pygmies, 9

rabbits, 43
Romans, 6–8, 28–9, 53
rooster, 113

'sabandijas', 71
sin, *see under* deformity
snub noses, 28

terata, 6, and *passim*
tracts, popular, 14

warts, 49, 51, 53
wild men, 21
women
 bearded, 55–8
 pig-faced, 14
world turned upside down, 5, 14, 20, 21, 26, 29–36, 41, 56, 77, 80, 82, 84, 85, 127, 131

zanni, 55